CU00919955

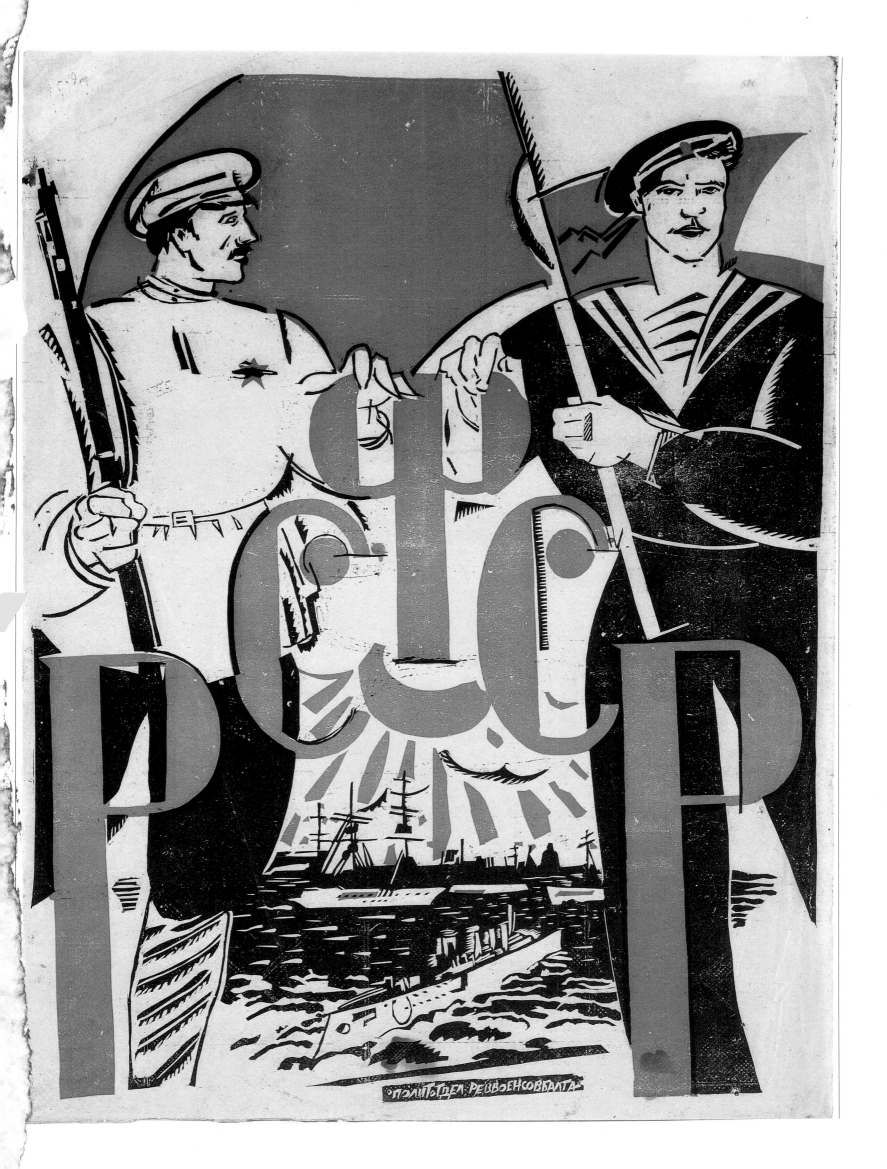

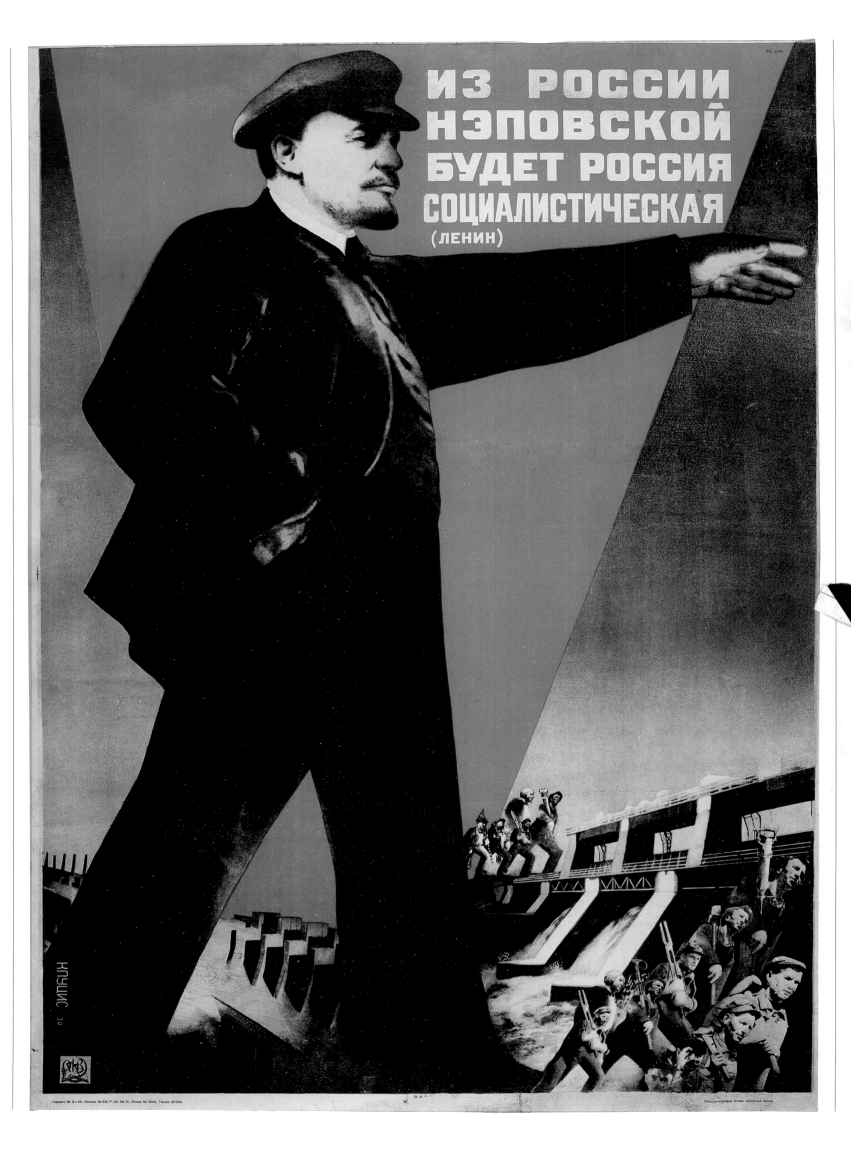

DAVID KING

RUSSIAN REVOLUTIONARY POSTERS

FROM CIVIL WAR TO SOCIALIST REALISM, FROM BOLSHEVISM TO THE END OF STALIN

FROM THE DAVID KING COLLECTION AT TATE MODERN

TATE PUBLISHING

КЛИНОМ

КРАСНЫМ

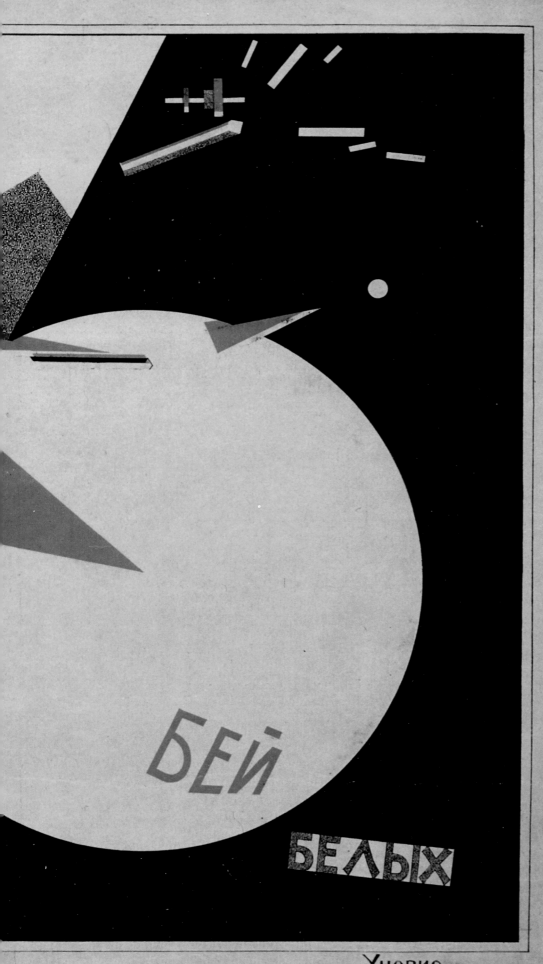

БЕЙ

БЕЛЫХ

A FAT MAN IN A TOP HAT

"A man emerged from the carriage of a nearby agitprop train. He was half-dressed, half-asleep and barefooted. He had an impressive mop of dishevelled hair and an unkempt beard. He dragged out a lump of plywood along with some paint and brushes, leaned the plywood sheet against the side of the carriage, spat on his hands and grabbed a brush. In what seemed like a single stroke he outlined the figure of a fat man in a top hat whose belly was being ripped open by a Red Army bayonet. Out of the belly poured forth a stream of coins. The scruffy fellow scratched his ear and added a slogan in red paint: 'What an Unexpected Embarrassment for Such a Fat Belly!' The sailors from the next carriage giggled."

FROM "THE BEGINNING OF THE UNKNOWN CENTURY" BY KONSTANTIN PAUSTOVSKY

APOCALYPTIC UPHEAVALS

The heroic period of the Russian revolutionary poster started, not so much during the apocalyptic upheavals of 1917, but in the grindingly long-drawn-out Civil War that followed. From 1918 to 1921 over two hundred poster artists and designers sympathetic to socialism created an avalanche of political posters, widely considered to be the greatest in history, in defence of the Bolshevik Revolution. It is estimated that across Russia over 3,200 different posters were printed during the hostilities, sometimes in huge quantities, when ink and paper supplies permitted.

Dmitrii Moor, Viktor Deni and other caricaturists lampooned the White Generals – Yudenich, Denikin, Kolchak, Wrangel – and the fourteen foreign interventionist forces that fought against Leon Trotsky's new Red Army. The Futurist poet and artist Vladimir Mayakovsky, working through the nights with teams of comrades, turned out thousands more hand-painted and stencilled ROSTA posters. They were displayed in the windows of the offices of the Russian Telegraph Agency throughout the country, beseeching and encouraging the proletariat, satirising and ridiculing its enemies. "Art must be everywhere – on the streets, in trams, in factories, in workshops, in workers' apartments," he wrote. But the vast majority of poster propagandists were "artists unknown" who left their posters unsigned, their authorship unrecognised.

UNDER THE FLOORBOARDS

My dear friend the artist and illustrator Roger Law often says: "We artists, illustrators, designers, we're only as good as our reference. Without knowing our subjects, without researching our background material, we are lost." Those artists who took part in the Revolution and Civil War certainly had enough reference – first-hand experience. Their artwork became visible out of the most difficult conditions – shortages of food, clothing, art materials; subzero temperatures or extreme heat, sometimes under fire. Posters, like human beings, are fragile; they get damaged, most don't last. Posters get pasted on the walls and quickly torn down, become sodden with rain, burnt by the sun, whitewashed over or defaced, especially in times of stress. "Civil war, that's the worst kind of war," my father used to tell me darkly when I was a child. It sent my imagination out of control: "The worst kind of war."

Posters are social documents, and when times change they can become critical evidence. The political situation certainly changed in the USSR in the "unknown century". "Proletarians of All Lands, Unite", Bolshevism, Trotsky's "Permanent Revolution"; ideas that all got crushed under Stalin's totalitarian boot. "Socialism in One Country" replaced internationalism, and every Soviet leader from Stalin onwards would fear one thing above all others – another Bolshevik Revolution. So from the early 1930s onwards every detail of Bolshevik history was scrutinised by the unfriendly eyes of Stalin's henchmen and rewritten, manipulated, destroyed or hidden in the closed archives – including many of the posters.

Even de-Stalinisation under Khrushchev continued to silence much of the truth, so did the "years of stagnation" under Brezhnev, in whose interest it was to forget almost everything about the Soviet past.

The plan therefore was to pull up some old Soviet floorboards, find out what had happened to all those missing posters and see how they evolved politically and stylistically, from workers' revolution through to the madness of Stalinist glorification. My search started by looking for a lost book.

SEARCHING FOR POLONSKY

It's a long time ago now, over forty years, but this is roughly how it went. I was visiting Hammersmith Books, the legendary socialist bookshop run by the late Ronald Gray and his wife, Anita, in a huge warehouse set back from the main road in the affluent suburb of Barnes in West London. Five miles of shelving groaning under the political weight of at least half a million left-wing books. Ron sadly told me of the existence of a large format Russian album published in the 1920s, full of colour reproductions of political posters and photographs of agitational propaganda trains. Sadly, because to his dismay and especially mine he had recently sold this incredibly rare volume of Bolshevik history "to Tokyo". He had never seen another copy in thirty years of collecting. He said to look out for it, that it had a black cover with red Cyrillic typography. He said try Carbondale.

In the 1970s, Herbert Marshall, a very tall, fast-moving man who had once worked with both Mayakovsky and Eisenstein, ran a fiefdom of Sovietology at the University of Southern Illinois at Carbondale, a town built on coalmining but later known (because of its campus) as "the Athens of Little Egypt". When he wasn't igniting his unsuspecting students with electric readings of "A Cloud in Trousers" or 16mm flickerings of "Strike", he also lived in Belsize Park, London. His Hampstead flat was large, high ceilings but dark, and filled with the busts of postwar world leaders such as Jawaharlal Nehru and Kwame Nkrumah who had sat for his wife, the sculptor Fredda Brilliant. She was the sort of artist who hurls the clay around yet the result always comes out looking like Epstein. Marshall was helpful, said I might find the book I was looking for in Chorleywood.

The Honorable Ivor Goldsmid Samuel Montagu, third son of the Second Baron Swaythling, was a remarkable man who devoted his life, as

Ivor Montagu, to left-wing politics and the cinema. He had been an energetic figure in the British film industry between the wars. He made documentaries (including "Defence of Madrid" and "Peace and Plenty"), produced early Hitchcock, was a screenwriter, film critic and friend of Eisenstein. They travelled to America together and he wrote a book about it, "With Eisenstein in Hollywood". His sometime membership of the British Communist Party and great interest in leftist politics in general led to unsubstantiated rumours that he had once "spied for Moscow". He was also a world class table tennis player. I spun off a quick letter to him and got a much faster return; yes, he had a copy of the book I was looking for.

Soon I was walking up the sloping drive of their film-star house, possibly Voysey, brick and oak with those diamond-shaped leaded window panes. Chorleywood is a sort of Mulholland Drive, situated north of London. His wife, Eileen Hellstern, affectionately known as "Hell", let me in. Together, tall and attractive, they made an impressive couple. "Here is the book you asked for," said Ivor Montagu and, without a blink: "You can borrow it, make use of it but, please, do give it back, you know what people are like with books!"

"Russkii Revolyutsionnii Plakat" (The Russian Revolutionary Poster), written and edited by Vyacheslav Polonsky, State Publishing House, Moscow, 1925. The volume was more exciting than I could ever have imagined but I forced myself to take it back to him within a week.

THE BOLSHEVIKS' CREATIVE DIRECTOR

Vyacheslav Polonsky: "The poster is a weapon of mass persuasion, a device for constructing a collective psychology".

"Russkii Revolyutsionnii Plakat" documents in images and text Polonsky's years as boss of the Literature and Publishing Department of the Red Army Political Administration (Litizdat), under the direction of the Revolutionary Military Council (Revvoensovet) whose chairman was Leon Trotsky. Polonsky remained in charge of Litizdat throughout the Civil War, energetically organising propaganda, commissioning the artists (including Dmitrii Moor and Viktor Deni), guiding them politically, criticising them when necessary, overseeing printing and production. Put simply, he was the Bolsheviks' creative director, a powerful figure on the visual front in the Revolution's very difficult formative years. "Limited supplies of materials and a permanent shortage of time demanded the need for terse language in the posters of the Revolution," he wrote.

Nearly two hundred posters from the Civil War are reproduced in "Russkii Revolyutsionnii Plakat", many in colour and, along with some rather poor photographs showing the painted carriages of agitprop trains, a valiant attempt has been made to catalogue no less than 854 of the best posters. Polonsky's book was the first authoritative visual work to have been published on this subject and is still an invaluable record. It also contributed to getting him into trouble. Throughout the entire 200-plus pages of the book there is no mention, let alone image, of Stalin, his importance being almost negligable – "a grey blur" – until the later 1920s.

★ ★ ★ ★ ★

Vyacheslav Polonsky was born in St Petersburg in 1886, the son of a watchmaker. He became politically active during the 1905 Revolution, joining the Mensheviks. His wish was to have a life of literature and at the time of the October Revolution he was working on Maxim Gorky's paper, "Novaya Zhizn" (New Life). In 1919 he joined the Bolsheviks.

After the Civil War, Polonsky turned to literary criticism and writing. In 1921 he became editor-in-chief of the authoritative journal, "Pechat i Revolyutsiya" (Press and Revolution), producing in the following year a special issue on Bolshevik posters, a forerunner of his great book.

In 1923 he visited Yuri Annenkov in Petrograd to commission the cubo-futurist artist to make a large oil painting from life of Trotsky as leader of the Red Army. Later that year the painting was shown to great acclaim in a major exhibition in Moscow celebrating five years of the Workers' and Peasants' Red Army and it also became the centrepiece of the Russian exhibit at the Venice Biennale in 1924. The ownership of the painting had been credited to the Red Army Museum in Moscow but after Venice the painting vanished, nevermore to be seen in public.

Polonsky had also asked Annenkov to make a series of drawings of high-ranking Bolsheviks, eventually published as an album, "Semnadtsat Portretov" (Seventeen Portraits), published by Petropolis in 1926. Stalin was not thought worthy enough to be included. But the future tyrant had a long memory and a decade later he would execute almost all those who had been portrayed in the album which, apart from two or three known copies, also disappeared forever.

Polonsky held many other influential posts in the 1920s including editor-in-chief of the distinguished literary magazine, "Novy Mir" (New World) and Director of the Museum of Fine Art in Moscow (now the Pushkin Art Museum). As a moderate Marxist he could not help but become embroiled in the turbulent struggle for the future between Trotsky and Stalin following Lenin's death. He praised Trotsky's book, "Literature and Revolution" as "truly remarkable". He went on to reject, from a Marxist position, the narrow principle of "social command" (the ordering of artists and writers to carry out definitive ideological tasks on the cultural front) which he thought "failed to recognise an organic link between workers and artists". And in 1929 he also praised Isaak Babel: "In 'Red Cavalry' the rugged iron of Lenin's skull exists side by side with the faded silken portraits of Maimonides. But they cannot go on living in peace... Maimonides is not compatible with Lenin".

That was enough for Stalin. Polonsky's voice was soon silenced. After Trotsky was arrested, exiled and finally banished forever from Soviet soil, Polonsky was accused of "ideological and political mistakes", "counter-revolutionary activities", denounced as a Trotskyist and a "right-wing opportunist". While on a lecture tour of Magnitogorsk in February 1932 he contracted typhus and died on the train travelling back to Moscow. He was aged 45.

Polonsky was one of those remarkable members of the Bolshevik intelligentsia who were almost certainly saved by an early death from a much worse fate later in the decade. Stalin would surely have proposed arrest, imprisonment, interrogation, torture, followed by the Gulag or a bullet in the back of the neck.

And as frequently happened in the era of "the disappeared", Polonsky's works, including "Russkii Revolyutsionnii Plakat", soon faded from the "collective psychology" of the Soviet Union.

Page 1: Vladimir Kozlinsky's poster "RSFSR", published by the Political Department of the Revolutionary Military Soviet of the Baltic Fleet, circa 1920.
The initials of the new state and its full name "The Russian Socialist Federative Soviet Republic" were adopted in Lenin's Constitution, July 19, 1918.
Page 2: "From NEP Russia will come Socialist Russia (Lenin)." A photomontage poster by Gustav Klutsis, 1930.

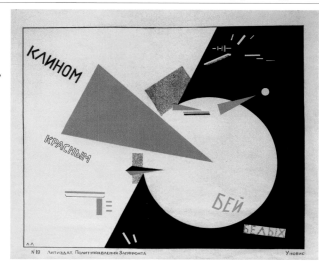

Pages 4/5: The original copy of El Lissitzky's poster "Beat the Whites with the Red Wedge", Vitebsk, 1920, which was mistakenly printed out of register. From the collection of the Russian State Library, Moscow.
Left: Another version of Lissitzky's poster, somewhat different in detail, but this time printed in register.
For a fuller explanation see page 9.

EXILED FROM BREZHNEV

Long ago, when everything was sent by post, a scruffy envelope floated through the letterbox containing some pink sheets of tiny and blurred Cyrillic text. It turned out to be a Russian catalogue sent from an emigré "bukhinist", a Leningrad bookseller who had wound up somewhere in Scandinavia and apparently knew my address. Struggling through it with the help of a magnifying glass, one line stood out: "Russkii Revolyut-sionnii Plakat. Polonsky. Mos.1925. -185. Original copy." Polonsky's poster book! For sale! Costing 185! I telephoned. Yes, he would send it immediately to "his people in Angliya". Six weeks later I get a phone call, gruff voice: "Ello! Got book. Bring cash". A woman's voice then took over and carefully gave me the address.

The arterial road leading out of London to Kent was grim; a dual carriageway lined by mile after mile of semi-detached housing, thrown up by unscrupulous builders in the 1920s and '30s and known as ribbon development. I think the address was near Sidcup, but I've forgotten. The house was in bad shape, dying a slow death from speed: the speed of the traffic – seventy miles an hour and not four metres away from the front step.

An elderly man answered the door and invited me in, his mind seemingly on other things. In the background, others are hovering. Plastic icons decorate the walls. The place smells of cat. The wallpaper needs serious attention. I have arrived at a house of exiles, a Christian sect, possibly a breakaway from Russian Orthodoxy.

Would I like some lemon tea? Yes, please. They take me into their dismal front room. Not a good idea. They are on the main road to Dover. Few houses had double-glazing in those days. Here they have only nets. A circle of small chairs and stools surrounds an old brown rug on which an injured coffee table tries to stand up. On the table lies at an angle a large brown package tied up with string. The elderly man points at the package. "Cash?" I pay for what I hope is the book. Then, "Open, please... book". The others quietly file in and sit down, as if to begin a seance. I struggle with the string and place the book on the table. The huge trucks thunder past outside. "Russkii Revolyutsionni Plakat". Black cover, red typography, 1925. Good condition. I turn some of the pages with care.

The others are now staring at the book with some embarrassment; Lenin's Bolsheviks, the Godless, the "Anti-Religiozniks" personified in colourful posters – stretched out on their broken coffee table. The others are polite but seemingly hurt. What suffering has led them to this? Years of exile, church-mouse poor, little understanding of the country that has taken them in, and Polonsky's volume threatening them in the middle of their front room. Scratching a living as a dumping ground for books they must have found abhorrent beyond belief.

TWO REVOLUTIONARY POSTER ARTISTS

Dmitrii Moor: "I wanted to give visual expression to words. I wanted the artist to wield the expressive power of the public speaker. It happened – through the medium of the political poster".

Dmitrii Stakhyevich Orlov, later known as Dmitrii Moor, was born in 1883 in Novcherkassk, Southern Russia, where the Don Cossacks come from. He was in Moscow during the 1905 Revolution and took an active part on the barricades, for which he was thrown out of law school. His real love was opera – he had originally wanted to become an opera singer – but 1905 decided his fate and he turned to political art instead. He made his first drawings in 1907 and found work at "Budilnik" (Alarm Clock), a pre-revolutionary satirical journal for which he made caricature drawings. He was almost entirely self taught.

In 1919, Vyacheslav Polonsky hired Moor to work for Litizdat and he began by helping to paint some of the legendary agitational propaganda trains that railed across Russia during the Civil War. Throughout 1919 and 1920 he produced over fifty revolutionary posters, some of them the greatest the world has ever seen.

Polonsky on Moor: "He is a talented draughtsman and one of the best caricaturists in Russia. He was the first person to openly sign his name on his posters, something none of the other revolutionary poster artists that I knew would have dared to contemplate. When Denikin's White army was approaching Tula, we were unsure whether he could be defeated and that dramatically reduced the number of poster artists working there for me. In fact Moor, exhausted and hungry, wearing his shabby clothes, was the only one left. He continued to paint in a state of rage, caring nothing for the finesse of the artwork, working through the night in his unheated studio, hurtling off one poster after another... Like many others among us, he was convinced that if Denikin's band took Moscow, he wouldn't be flung into gaol, he'd be hanged."

Fortunately for Moor and everyone else, Denikin was defeated, Moscow saved and Moor went on to perform his finest act, painting the poster "Death to World Imperialism" *(see page 22)*, staged as if it were the grand finale of some fabulous opera, with a cast of thousands (only ten in the poster) putting paid to the giant green dragon of capitalist slavery with a clatter of bayonets.

Moor had a great singing voice, listened to broadcasts on Moscow Radio from La Scala in Milan, knowing many of the scores by heart. A large and heavy man, noisy and sociable with piercing blue eyes, he was much loved and a great help to many of the younger artists who visited him, his wife, his raven Vanka and his dog Fifka, in their modest Moscow apartment. Later he co-founded the satirical magazine, "Krokodil" and art directed and illustrated for "Bezbozhnik" (The Godless), a journal famous for its virulently anti-religious, "clergy-eating" caricatures.

Dmitrii Moor: "Now there is art outside the class system, but there is no art outside the class struggle".

☆ ☆ ☆ ☆ ☆

Viktor Nikolaevich Denisov, later known as Deni, was born in 1893 into an upper-middle class family living in Moscow that had fallen on hard times. He was a successful caricaturist for a number of journals before the Revolution, but unfortunately for him when October came he found himself caricaturing on a right-wing satirical magazine called "Bich" (The Whip), run by an editor who hated the Bolsheviks and Lenin and Trotsky in particular. After the Revolution all politically subversive publications were forcibly closed down, and "Bich" was no exception. Deni fell upon hard times again.

He went to see Anatolii Lunacharsky, the Bolsheviks' first Commissar of Education and Enlightenment, and pleaded with him that he was real-

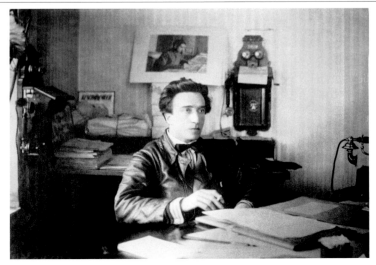

Right: Vyacheslav Polonsky in his office at Litizdat, 1920:
"The poster is a weapon of mass persuasion, a device for constructing a collective psychology."

ly a Bolshevik and could he have a job. Lunacharsky found him very young, very ill and "not without melancholy". He got him work at Litizdat. Many were struck by Deni's persona. At various times in his life he was called "puny, ailing, misanthropic, suffering from hypochondria, isolated, thin, mournful, fearful of dirt and infection, disapproving and unsociable". He disliked open windows and worked in a darkened room full of cats. Like Moor, he produced around fifty revolutionary posters during the Civil War. Some of them, once seen, are never to be forgotten, like "Capital" and "A Pig Trained in Paris" *(see pages 25 and 30)*.

In the later 1920s, Deni's work declined. Nina Vatolina, a major Soviet poster artist during the Great Patriotic War and beyond, was married to his son, Nikolai Denisov. From 1935 until 1939, the couple assisted Deni in his studio, doing his work for him.

Nina Vatolina: "Deni was smart and talented but a real drunk. I think his work as a political cartoonist humiliated his artistic soul. On the other hand he used to swank around, proud of his position at Pravda, his connections with the high-ups and the adulation he received. His studio was a real mess, totally cluttered up; the only clear space was his work table with its samovar always boiling, a glass and a bottle of Red. He would get some photos of "Our Leader" out of a folder – the unpublished, unretouched ones showing his incredibly pockmarked face. That's where I learned how to 'correct' life."

BEAT THE WHITES WITH THE RED WEDGE

The original copy of the first edition of El Lissitzky's poster, "Beat the Whites with the Red Wedge" *(see pages 4/5)* is held in the Visual Art Publications Collection of the Russian State Library, Moscow. We are extremely grateful to the library's VAP Department for providing us with this unique image of the poster, very rarely seen in its original form. It is signed "LL" in Cyrillic in the lower left corner and published by Litizdat for the Political Administration of the Western Front. It is also credited to "Unovis" (lower right).

El Lissitzky's famous Civil War poster must have caused something of a sensation in 1920 when it was flyposted in the streets of Vitebsk, a town situated on the border between Russia and Belorussia. He designed it whilst teaching students at Unovis, a wing of Vitebsk Art School, where he had come under the influence of its professor, the suprematist artist Kasimir Malevich. The poster was one of Lissitzky's earliest non-figurative works, made during his "Proun" period (Project for the Affirmation of the New). It was to become an almost mythical symbol, a combination of Bolshevism's new politics and Suprematism's new vision, in the struggle to overthrow the last vestiges of old regimes worldwide.

El Lissitzky worked on the original poster between April and May 1920, at the time of the threat of Polish invasion. Its dynamic composition represents the Reds, surrounded by light, stabbing the heart out of the Old World surrounded by darkness. The message is hardly unintelligible. In terms of twentieth-century design, the poster was a revolution.

The Russian State Library's copy is unique, not least because the red and black, two-colour lithographed poster was printed out of register. This can be seen fairly easily by looking at the two narrow "wedges", black on red, printed below the large red wedge. Their longest sides should butt up together so that the wedges do not overlap. Likewise, the two small red wedges that bisect the top of the circle should fit properly into the counter spaces left for them. In other words, the red printing plate should have been moved down slightly to correct these imperfections. It is possible that this survivor from the first edition was a trial proof, maybe the printer's or designer's own copy. The fault might then have been corrected, we cannot be sure, but we know the rest of the print run of 2,000 copies was plastered all over Vitebsk and beyond.

There is another version of the poster in existence *(see page 7)* that looks like the original but on closer inspection has definite dissimilarities. Several copies still exist of this separate edition; the paper sizes vary (51x61.5cm as opposed to the original's 53x71cm) although the printed area is the same, and the red/black printing is in register. Some of the small details in the design are in slightly different positions, the Cyrillic word "Belykh" (Whites) in the lower right hand corner is in smaller and lighter lettering, the larger outline box is missing, and the positions of Lissitsky's signature

"LL" and the credit line running along the bottom has been marginally shifted. The exact date of this edition is open to question. Did Lissitzky, or his Unovis students, make two close but not identical artworks? If so, were they printed at the same or different times, maybe for different distribution? We are unlikely ever to find out.

Lissitzky complicated things further in 1925. It is said that he had kept only one old copy of his poster and, because it was so damaged, made a tracing of it in black and white. He modified the artwork, including changing the grey areas of the original poster from a mottled pattern to a sort of Zippertone tint of fine parallel lines. This unfortunate metamorphosis became the template for almost all subsequent reproductions of the poster in books and journals, its harsh lines and ultra-white background giving a very poor impression of the original.

El Lissitzky, without doubt the greatest Soviet designer/artist of the twentieth century, died in 1941 after a twenty-year battle against tuberculosis. How on earth anyone could have produced so much inventive work as he did in the 1920s and '30s to such a high a standard, all the while fighting a debilitating disease, is beyond reason. His last work, "Build More Tanks", a photomontage poster designed with Nikolai Troshin, was delivered to the printer in November 1941 as the Nazis were snowbound outside Moscow, freezing to death in their thousands.

At the end of December, Sophie, his wife and comrade designer wrote, "Our son, Hans, who was called up into the army on the morning of December 30th, wanted to say goodbye to his father, but Lissitzky was no longer able to recognise him. He was dying. Painlessly and peacefully his restless, creative spirit slipped away into eternity".

NATAN

Natan Federovsky left Leningrad in the mid-1980s and moved to Berlin where he started the remarkable AvantGarde Gallery of Russian Art. It became an extraordinary clearing-house for paintings, posters, photographs and photographic albums, magazines and everything else that was starting to flow through the newly-opened borders of what was soon to become the former Soviet Union. Natan worked with great enthusiasm – full of cubo-futurist expression, he looked like an Annenkov drawing come to life – and put on many innovative displays exhibiting, for example, such great Klutsis posters as "Under the Banner of Marx, Engels, Lenin and Stalin". I had previously seen this powerful photomontage only in reproduction, unaware that any copies still existed. Not only that, Natan also showed its original maquette, never printed, in which Klutsis had used friendlier images of two of the four heads in question.

At the time of the collapse of the Berlin Wall, a time of great festivities in the city, Natan told me that a small number of copies of El Lissitzky's "Beat the Whites with the Red Wedge" had come to light in Moscow. He said he was thinking about buying them but the problem was, apart from the cost, the posters had been quite damaged over the years and there had been some loss of colour in the red triangles. Worse than that, he said, they had been given to someone in Russia who had tried to do some retouching on them with a red felt-tip pen. He was worried about the cost of restoration, wondered if it was even worth it. Interestingly, he had also been told that the posters in question were not from 1920 but possibly reprinted by El Lissitzky for a later exhibition. It's a further "Red Wedge" mystery; was there yet another printing?

Sadly we may never know. Like so many fine Russians before him, Natan, usually so cheerful, also suffered from depression. He died at his own hand, leaving his wife, their dear son and many, many friends to miss him and remember him with the greatest affection.

PRIMITIVE EXCHANGE

One day I had a phone call from Masha. She needed some cash, wanted to sell some of her mother's Russian revolutionary posters, was I interested? I asked her if her mother knew and she said yes, she didn't want them. Masha was a Russian intellectual leading an emigré's life in Highgate, the daughter of a famous Soviet writer from the days of Stalin. When she opened the door I could see that the house was a real mess, damp everywhere. What's gone wrong? I asked. The roof, she replied.

The posters were good, some were by Apsit as I recall. I asked her what she and her mother wanted for them. She didn't know. I said what's the

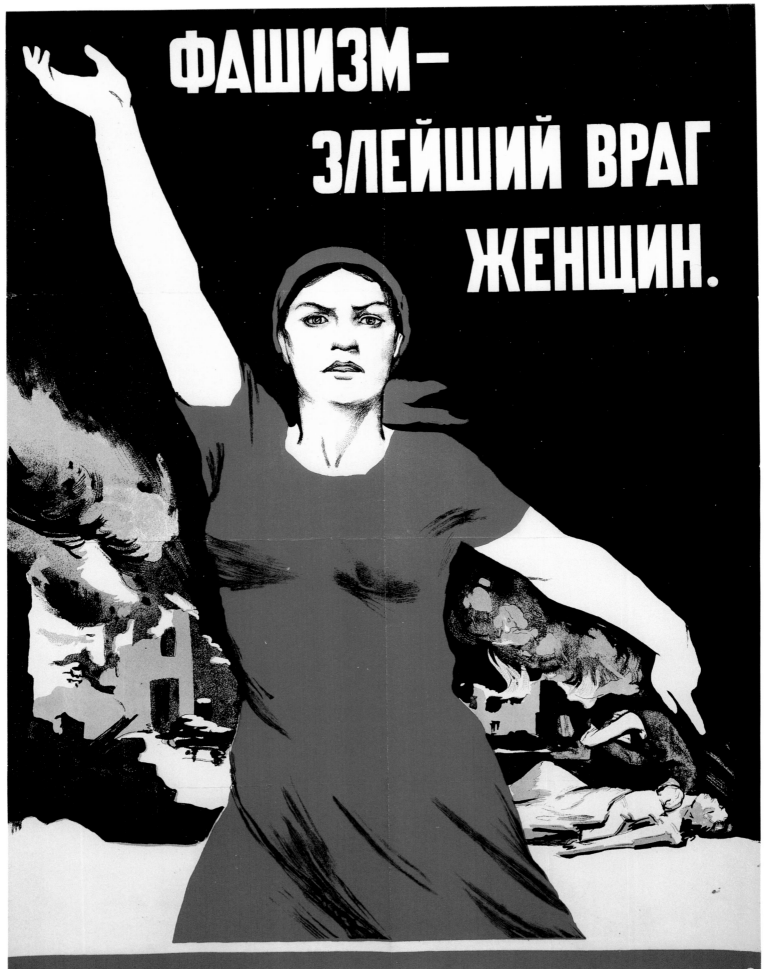

matter with the roof? It collapsed. She needed a new one but she couldn't afford it. So how much is a new roof? She told me. I said fine; give me the posters and I'll pay for the roof – primitive exchange. She was thrilled, couldn't believe it. She phoned me again a few weeks later; the builders had finished and the house was perfect. Some of the posters, three or four, are reproduced in this book.

FABULOUS HAVEN OF CULTURE

In the 1970s there were still many fine second-hand bookstores in New York run mainly by Jewish emigrés who had fled either from the "Old Country" or Nazi Germany. One of these establishments was a gigantic outfit called University Place Books that specialised in a wide range of leftist politics and was located on the 9th floor of 810 W11th Street in Manhattan. It prided itself on being a complete wreckage, couldn't have been cleaned in 30 years. Books cascaded from busted shelving, books were strewn across the floor, books rose high in pyramids of the great unsorted. This fabulous haven of culture was run by Walter Goldwater, an elderly socialist who had "been there" in the 1930s, I believe mainly to Moscow. I asked him about "USSR in Construction" magazine, did he have any. He was amazed. He said in the fifties he used to "put all that stuff out on trestle tables on the sidewalk, ten cents a go. You couldn't give it away, not even for a nickel, and now a limey comes along over twenty years later wanting it!" But somewhere in his apartment at home, he said, he had some early Bolshevik posters, typographical fliers. They were of no use to him anymore and he wanted them to go to a good home: "It's good to help a young guy like you who's still interested in this stuff, so take 'em before I change my mind!"

FROM BOLSHEVISM TO STALINISM

After the defeat of the White armies and following the harsh years of War Communism, the Soviet government decided in 1921 to move in a new direction. Lenin's New Economic Policy allowed for an improvement in social and economic conditions by encouraging private enterprise in trade and manufacturing. A new wave of graphic design on the constructivist model prospered during this period, especially with the dramatic development of the Soviet film industry. Spectacularly designed film posters using photomontages of film stars made their first appearances on the billboards, their dynamic compositions, often on the diagonal, incorporating strong colours and closeup/longshot photography.

Parallel with this, major social issues had to be confronted following the Civil War. Poster campaigns were launched to encourage the reconstruction of the devastated towns and countryside, organise relief from widespread famine and poverty, and promote Lunacharsky's great scheme for universal education and the eradication of illiteracy by the end of the decade. The expansion of the Soviet Union to include the Central Asian Republics also meant new poster campaigns had to be fought on highly contentious issues such as the role of women in these former Muslim societies, where even the poster itself was a new cultural form.

★ ★ ★ ★ ★

Lenin had always been against the glorification of the individual, but following his death in 1924, a great barrage of Lenin worship was unleashed with posters leading the campaign. The Lenin Cult (as it became known), engineered by Stalin, was followed in the 1930s by the much more fearsome Stalin Cult, also engineered by Stalin. Heavyweight Stalinist photomontage using massive differentiations of scale, created the illusion of the Leader standing hundreds of metres tall. Posters began to hammer home the consolidation of Stalin's power and the entrenchment of the one-party state, the five-year plans, collectivisation and the shift to industrialisation. And montage, like Socialist Realist painting, could put Stalin where he had never been or was too scared to visit – the factory workplace, for example.

The greatest exponent of the Stalin Cult was undoubtedly Gustav Klutsis, an artist turned poster designer who did so much to visually mythologise Stalin. The dictator later had him shot.

An eerie change in style descended over Soviet posters and propaganda in general at the end of the 1930s with production dwindling to only fifty or so new works being published each year, mainly due to the imposition of rigorous censorship. Stalin's Great Purges, followed by the Stalin-Hitler Pact, brought about a stillness, quietude, deathliness. The dictator was often portrayed in stone – remote, distant, far, far away. If large sections of the Soviet people were still walking around in fear or unease – the arrests, the trials and the Gulag were still day-to-day, night-to-night – they didn't have very long to wait for things to become far, far worse.

WAR EFFORT

The Nazis launched their sudden attack on the Soviet Union on June 22, 1941. The heroism of the Soviet people in defence of their homeland during the Great Patriotic War is reflected in the work of their poster artists in much the same way as it had been during the Civil War. Socialist Realism had long since forcibly replaced all other "isms" in the arts, but works like Nina Vatolina's "Fascism – The Most Evil Enemy of Women" *(see opposite page)*, Viktor Koretsky's haunting "Soldier, Liberate Your Belorussia!" and his "Red Army Warriors, Save Us!" *(see pages 121 and 123)* are without doubt some of the greatest Soviet posters ever produced. Gigantic print runs of anti-Nazi, anti-Hitler and anti-Fascist caricature posters cascaded from Soviet war artists' drawing boards, and hand-painted satirical TASS (Telegraphic Agency of the Soviet Union) window posters covered the land in the same way ROSTA posters had, back in 1919 and 1920.

NINA VATOLINA

Nina Vatolina was there: "That summer (1941) I was working on my thesis, about to graduate from the Moscow Institute of Fine Arts, dreaming of a bright future. Then everything turned upside down. One day Elena Povolotskaya, my editor at Izogiz Publishing House, asked me to make a poster. She put her finger to her lips and told me: 'It should be like this; we want people to chatter less'". Millions were printed in many different forms; posters, postcards, fliers *(see detail page 118)*.

"In 1941 I painted 'Citizens, Donate Warm Clothes!', 'Muscovites, Don't Let the Enemy Burn Moscow Down!' and 'Fascism – The Most Evil Enemy of Women!' I hoped that my efforts would be of some help. Only during the war years was there a hope, a hope that my work was needed! Later on came prizes and rewards, but nothing compared to that sensation of being needed."

Vatolina continued to make posters until the mid-1960s when she could finally return to oil painting. She was hugely famous as a poster artist, and deservedly so, but she regretted that the poster had taken up so much of her time: "The work of the political poster artist turned out to be extremely corrupting. It was such a temptation for a young artist like me to see my work on the walls all over the city. I was the 'faces specialist'. I had to portray the kids being hugged by 'Our Greatest and Most Beloved Leader of Nations'. How could I do it when he was taking away my relatives and friends?"

MOSCOW TODAY

Entering it is difficult, especially in the pack ice and snow drifts of deep midwinter when the temperatures dive through the pain barrier. But there is a heavy steel door in Barrikadnaya – the sort of door signalling that its owners are expecting trouble – which will lead you into what looks like a dream world of unreconstructed socialism but in reality is a marshalling yard of free market capitalism. Press four numbers and the door reluctantly opens into darkness.

A metal cage elevator grinds you up to another steel door, slightly ajar and half concealing the beautiful Russian lamplight inside that so quietly greets your arrival. From the hallway, doors open into several dusty rooms piled high with even dustier printed matter. In one, original Soviet posters, floor to ceiling. History confused, Cyrillics everywhere.

And there in the centre of it all, decades after his death, were the remnants of Vyacheslav Polonsky's personal collection; posters by Deni and Moor – "Capital" and "Death to World Imperialism".

David King, London, 2011

Opposite page: Nina Vatolina's poster "Fascism – The Most Evil Enemy of Women. Everyone to the Struggle Against Fascism".
Published in August 1941, five weeks after the Nazi invasion of the Soviet Union, with an initial print run of 75,000 copies. Vatolina asked her neighbour, who had already seen two of her sons leave for the battlefield, to model for this heroic poster.

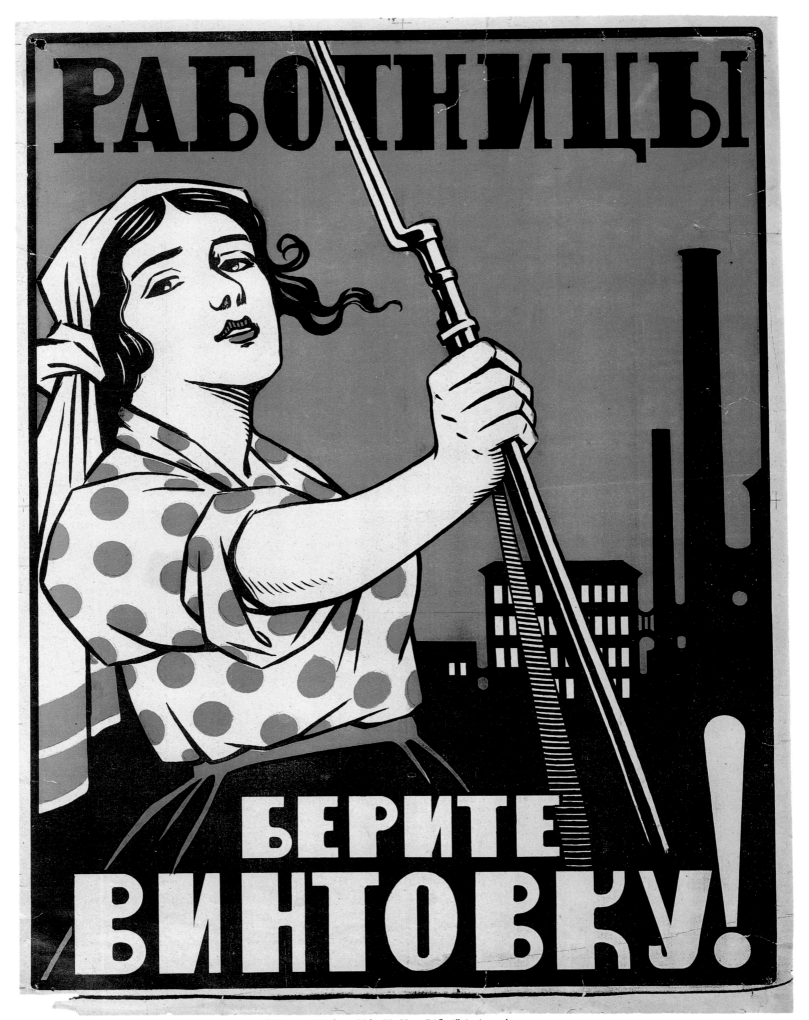

"Women Workers, Take Up Your Rifles!" Artist unknown.
A poster from the early days of the Civil War, circa 1918, calling for working-class women to join in armed resistance against the White Guard enemies of Bolshevism.
The stylistic depiction of the woman's face and hair, headscarf, polka dot blouse and gun,
backed by a humming factory landscape worth defending,
is reminiscent of highly decorative Russian poster art from pre-revolutionary times.

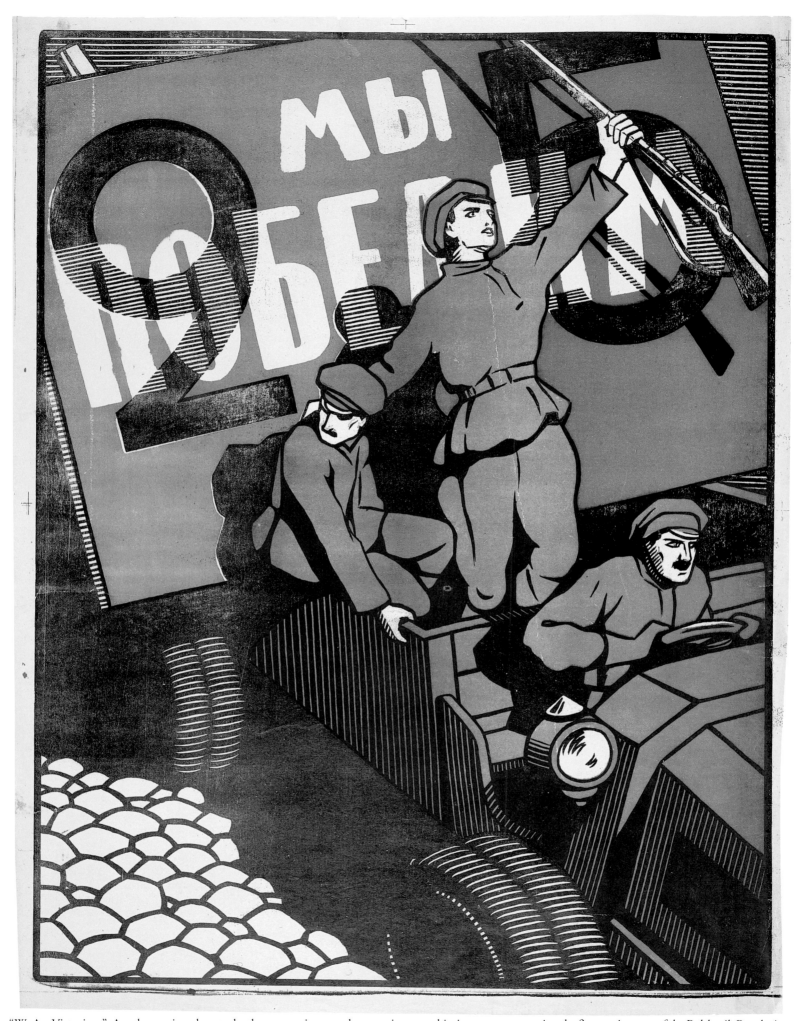

"We Are Victorious". Another unsigned poster by the same artist as on the opposite page, this time commemorating the first anniversary of the Bolshevik Revolution.
A Red Guard patrol hurtles through the cobbled streets of Petrograd on the night of October 25th, 1917.
The Red Guards were armed groups of factory workers who initially formed in Petrograd in 1917 to protest against their appalling living conditions and the war.
They supported the Bolsheviks during the October Revolution and defended it against the inevitable counter-revolution that followed.
In January 1918 many of them joined Trotsky's new Workers' and Peasants' Red Army.

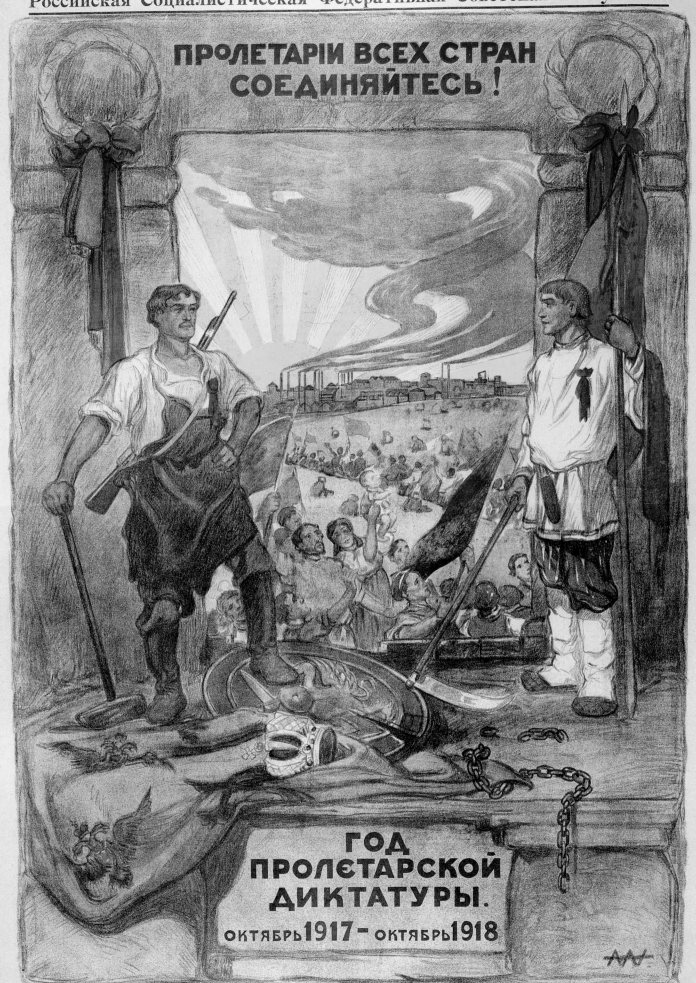

Российская Социалистическая Федеративная Советская Республика.

„Пролетарии всѣхъ странъ, соединяйтесь!"

МЩЕНЬЕ ЦАРЯМЪ
(ВАРШАВЯНКА).

Вихри враждебные вѣютъ надъ нами,
Темныя силы насъ злобно гнетутъ,
Въ бой роковой мы вступили съ врагами,
Насъ еще судьбы безвѣстныя ждутъ,
Но мы подниемъ гордо и смѣло
Знамя борьбы за рабочее дѣло,
Знамя великой борьбы всѣхъ народовъ
За лучшій міръ, за святую свободу.

На бой кровавый,
Святой и правый,
Маршъ, маршъ впередъ,
Рабочій народъ!

Мретъ въ наши дни съ голодухи рабочій,
Станемъ-ли, братья, мы дольше молчать.
Нашихъ сподвижниковъ юныя очи
Можетъ-ли видъ эшафота пугать?
Въ битвѣ великой не сгинутъ безслѣдно
Павшіе съ честью во имя идей,
Ихъ имена съ нашей пѣсней побѣдной
Станутъ священны милліонамъ людей...

На бой кровавый,
Святой и правый,
Маршъ, маршъ впередъ,
Рабочій народъ!

Намъ ненавистны тирановъ короны,
Цѣпи народа-страдальца мы чтимъ,
Кровью народной залитые троны
Кровью мы нашихъ враговъ обагримъ,
Месть безпощадная всѣмъ супостатамъ,
Всѣмъ паразитамъ трудящихся массъ,
Мщенье и смерть всѣмъ царямъ-плутократамъ,
Близокъ побѣды торжественный часъ!

На бой кровавый,
Святой и правый,
Маршъ, маршъ впередъ,
Рабочій народъ!

Издательство Всероссийского Центрального Исполнит. Комитета
Советов Рабочих, Крестьянск., Красноарм. и Казачьих Депутатов.

Opposite page: "Year One of the Proletarian Dictatorship" by Alexander Apsit, Petrograd, 1918.
Above: "Revenge on the Tsars", also by Alexander Apsit, 1918. The text reproduces the words to the "Varshavyanka", originally a Polish working-class song
that became an anthem of the Russian Revolution of 1905. Apsit was born in Riga, Latvia, in 1880. As a teenager he used his artistic skills to fake famous Russian paintings
and spent time at Mount Athos monastery illustrating for the monks. He was also well known for being a heavyweight and riotous drunk.
He produced many early Bolshevik posters and used several pseudonyms such as "Skif" (Scythe), after an ancient South Russian nomadic tribe.
He left Petrograd in late 1919, heading back to Latvia in 1921 and died in unexplained circumstances in Germany in 1944.

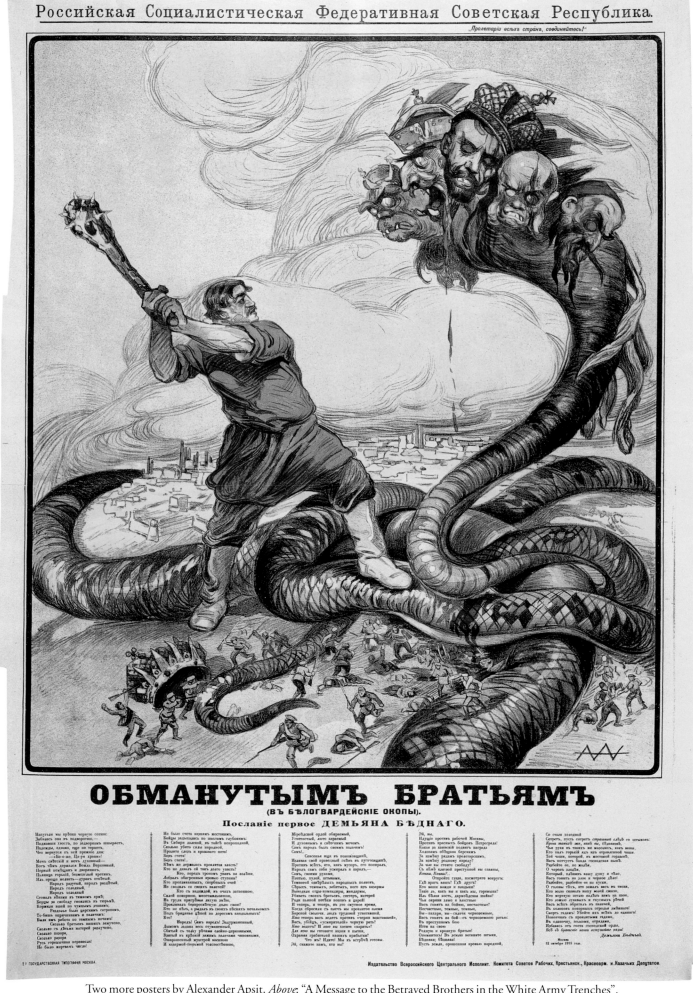

Two more posters by Alexander Apsit. *Above*: "A Message to the Betrayed Brothers in the White Army Trenches".
The text, dated October 12th, 1918, is by Demyan Bedny, a popular poet of the period. He beseeches the White soldiers to join the Workers' and Peasants' Red Army
as Apsit's heroic peasant takes the cudgel to the last remnants of Tsardom.
Opposite page: "The Internationale", 1918/19. Apsit's fantastic vision of the final end, on the golden edifice, of the mythological monster, "Capital".
The translated text uses verse from "The Internationale", written in 1871 by Eugene Pottier, a Paris transport worker. The music was composed later by Pierre De Geyter
and became the official anthem of the Soviet state from 1918 until the end of 1943.

"Пролетарии всех стран соединяйтесь!"

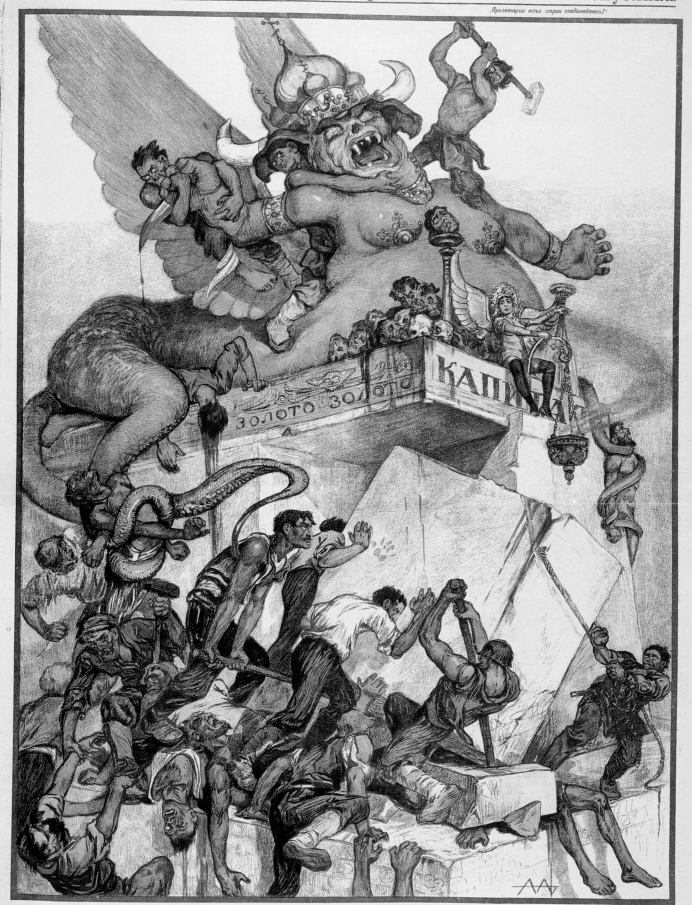

ИНТЕРНАЦИОНАЛ.

Вставай, проклятьем заклейменный,
Весь мир голодных и рабов!
Кипит наш разум возмущенный
И в смертный бой вести готов.
Весь мир насилья мы разрушим
До основанья,— а затем

Мы наш, мы новый мир построим:
Кто был ничем, тот станет всем.

Это будет последний
И решительный бой.
С Интернационалом
Воспрянет род людской!

Никто не даст нам избавленья
Ни бог, ни царь и ни герой,
Добьемся мы освобожденья
Своею собственной рукой.
Чтоб свергнуть гнет рукой умелой,
Отвоевать свое добро,—

Вздувайте горн и куйте смело,
Пока железо горячо!

Это будет последний
И решительный бой.
С Интернационалом
Воспрянет род людской!

Лишь мы, работники всемирной
Великой армии труда,
Владеть землей имеем право,
Но паразиты — никогда!
И если гром великий грянет
Над сворой псов и палачей,—

Для нас все также солнце станет
Сиять огнем своих лучей.

Это будет последний
И решительный бой.
С Интернационалом
Воспрянет род людской!

ВТОРАЯ ГОСУДАРСТВЕННАЯ ТИПОГРАФИЯ.
Москва, Трехпрудный пер., 9.

Издательство Всероссийского Центрального Исполнит. Комитета Советов Рабочих, Крестьянск., Красноарм. и Казачьих Депутатов.

17

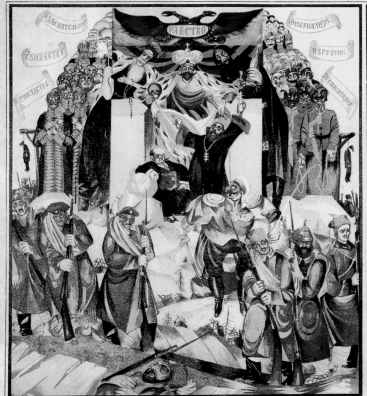

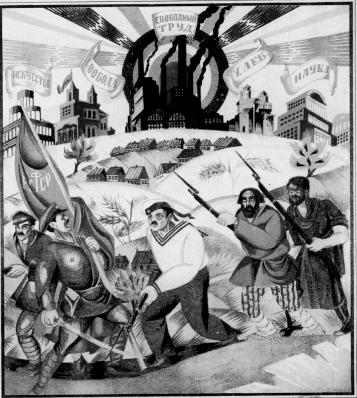

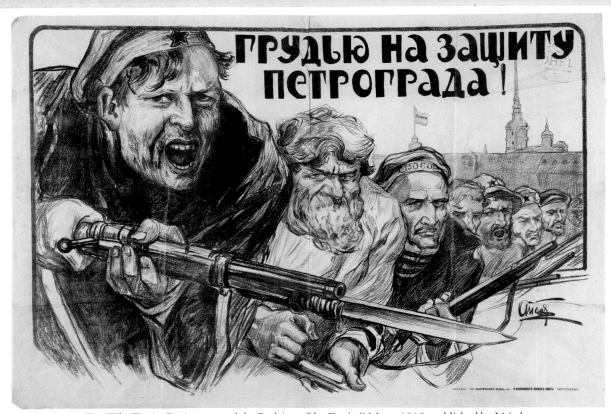

Top: "The Tsarist Regiments and the Red Army" by Dmitrii Moor, 1919, published by Litizdat.
The subtitles to the contrasting illustrations read: "What we used to be fighting for" and "What we are fighting for now".
Above: "Stand up For the Defence of Petrograd" by Alexander Apsit, 1919. Apsit's call to arms was conceived, drawn and printed in a single day as General Yudenich's White Army prepared to attack the city. Trotsky's response was to mobilise the Red Army and Yudenich's forces were routed.
Apsit's work was often criticised, not least by Dmitrii Moor, who later accused him of "cinema poster pseudodramatics, cheap vulgar symbolism and old-fashioned romanticism", but the artist has forsaken everything here for the intense representational immediacy of a charcoal drawing.
Opposite page: "February 23, 1919. The Red Army is the Defender of the Proletarian Revolution". Artist unknown.
Published in Petrograd to celebrate Red Army Day, the poster commemorates the tens of thousands of volunteers who joined the Red Army in 1918 in response to Trotsky's call, "The Socialist Fatherland is in Danger".
The red star, hammer and plough were the symbols of the Workers' and Peasants' Red Army until 1922 when the plough was replaced by the sickle. Here the red star resembles a red flower.

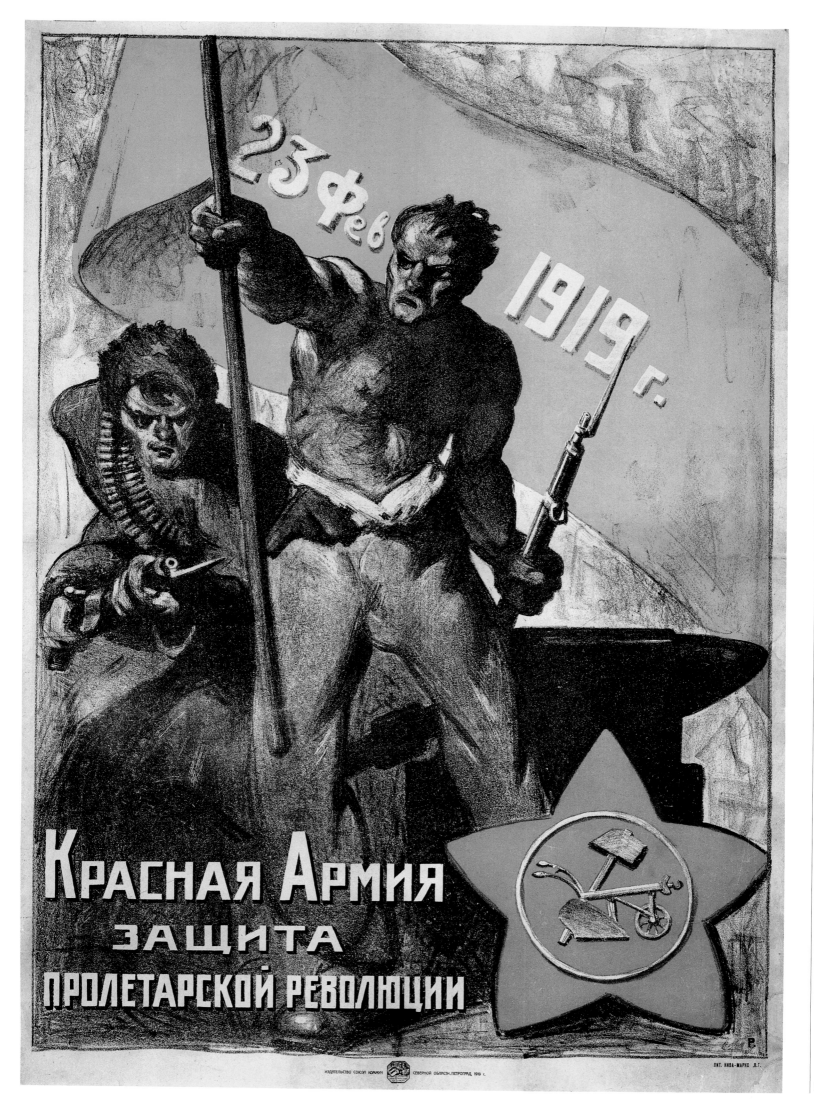

КРАСНАЯ АРМИЯ
ЗАЩИТА
ПРОЛЕТАРСКОЙ РЕВОЛЮЦИИ

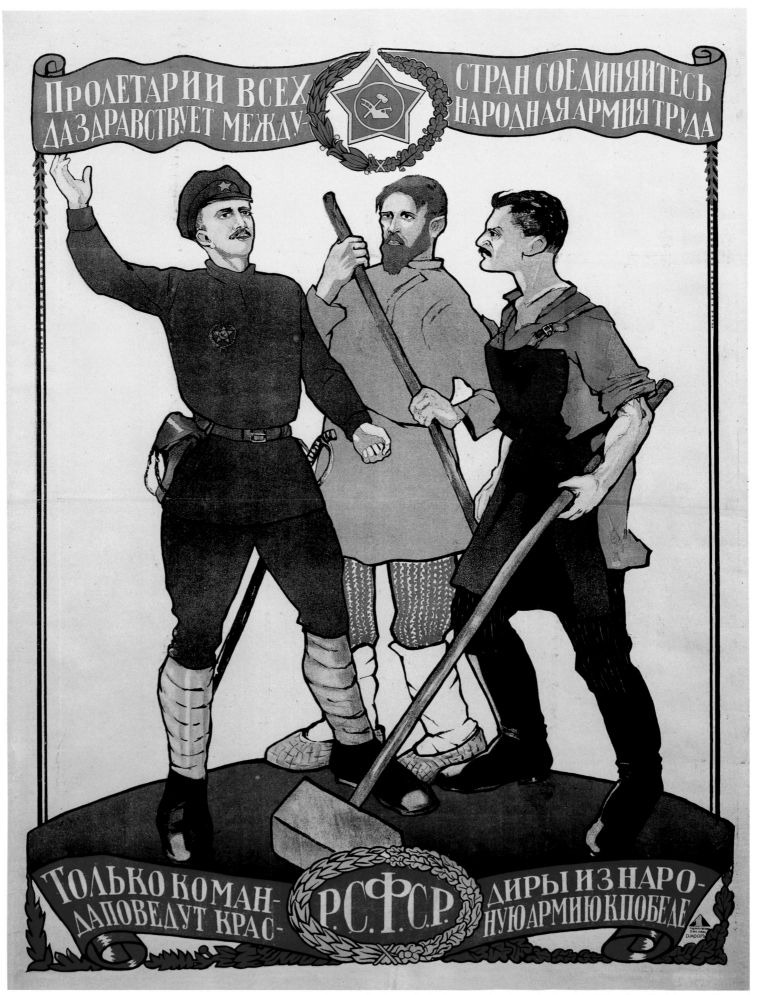

Above: "Proletarians of all Lands, Unite. Long Live the International Army of Labour. Only Commanders from the People will Lead the Red Army to Victory".
A poster by Dmitrii Moor for the Worker's and Peasants' Red Army, 1918.
Opposite page: "The Red Army's Anniversary Celebration. February 23, 1919. Red Present Day". Artist unknown.
Red Present Day was a Soviet government initiative that aimed to raise voluntary donations for the troops through meetings, demonstrations and posters
published for the occasion. Unfortunately for the public, due to chronic shortages throughout the country because of the Civil War,
the "voluntary" part soon turned into mass confiscations.

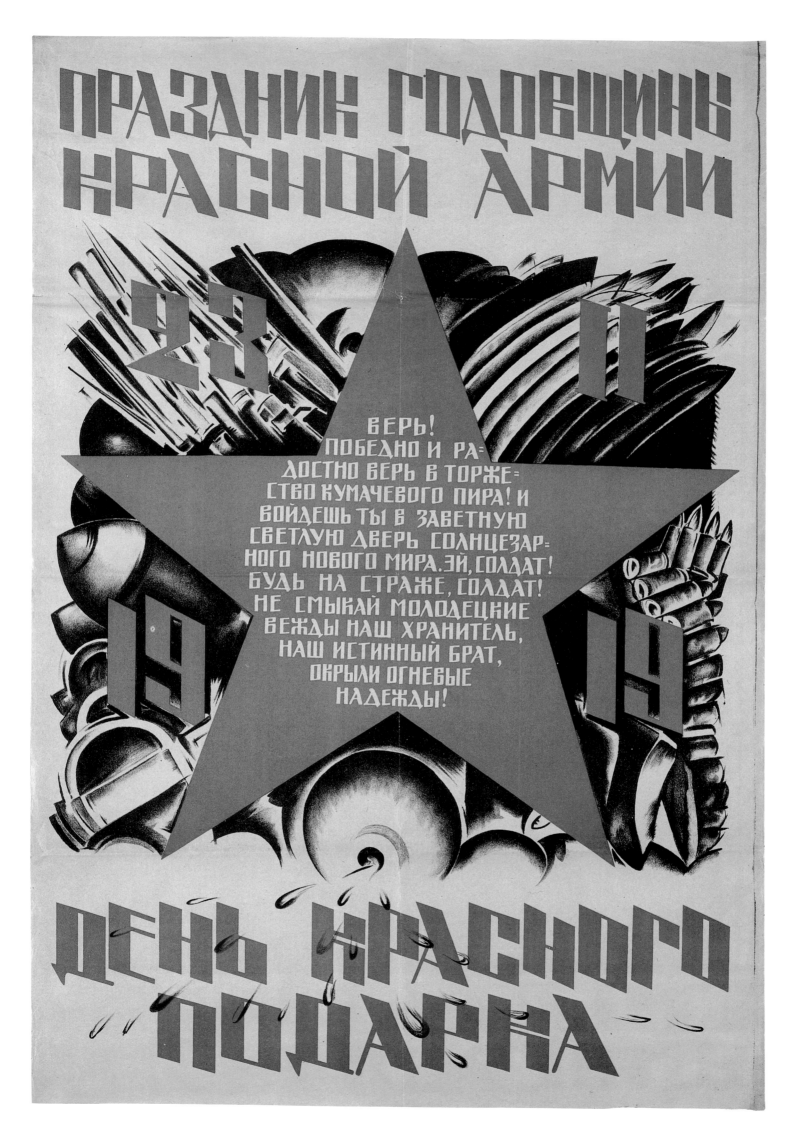

ПРАЗДНИК ГОДОВЩИНЫ
КРАСНОЙ АРМИИ

23
II
19
19

ВЕРЬ!
ПОБЕДНО И РА=
ДОСТНО ВЕРЬ В ТОРЖЕ=
СТВО КУМАЧЕВОГО ПИРА! И
ВОЙДЕШЬ ТЫ В ЗАВЕТНУЮ
СВЕТЛУЮ ДВЕРЬ СОЛНЦЕЗАР=
НОГО НОВОГО МИРА. ЭЙ, СОЛДАТ!
БУДЬ НА СТРАЖЕ, СОЛДАТ!
НЕ СМЫКАЙ МОЛОДЕЦКИЕ
ВЕЖДЫ НАШ ХРАНИТЕЛЬ,
НАШ ИСТИННЫЙ БРАТ,
ОКРЫЛИ ОГНЕВЫЕ
НАДЕЖДЫ!

ДЕНЬ КРАСНОГО
ПОДАРКА

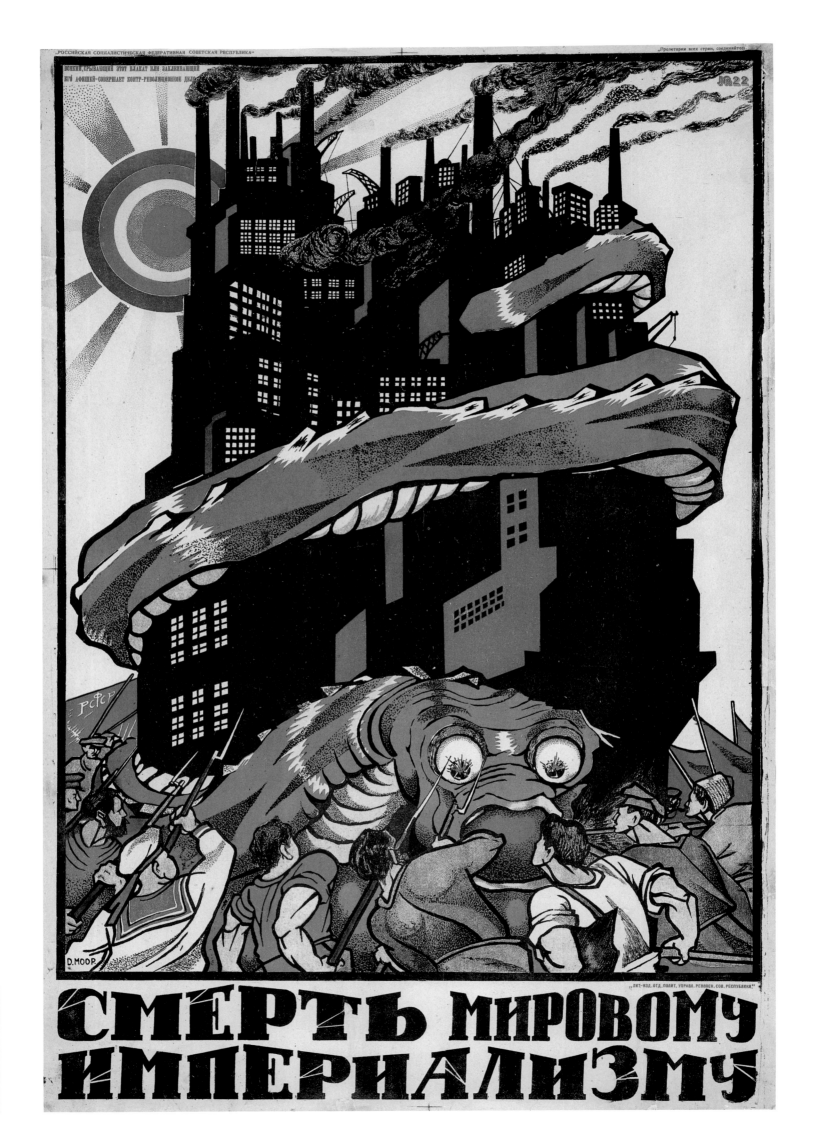

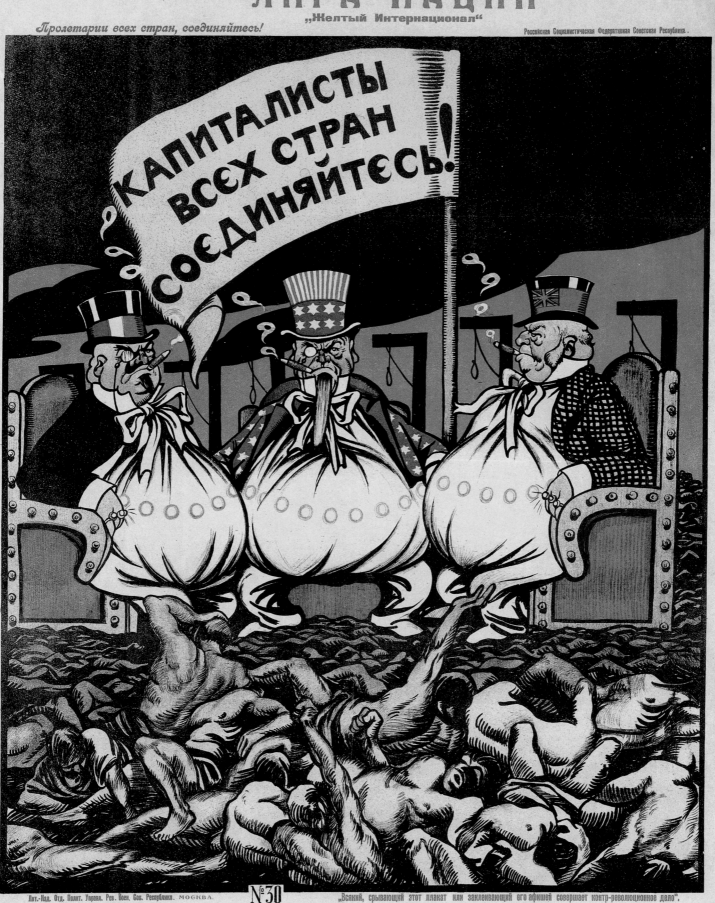

Above: "Capitalists of the World, Unite!" by Victor Deni, 1920, and subtitled "The Yellow International".
Deni viciously attacks the newly-formed League of Nations. Fourteen years later the Soviets changed their minds about the League and joined it in a bid to strengthen the anti-Axis alliance after the departure of Germany, Italy and Japan.
Opposite page: "Death to World Imperialism", Dmitri Moor's operatic masterpiece from 1919. The Bolsheviks' foremost poster artist of the Civil War period, Moor was not above attacking his fellow artists – including Deni – whom he regarded, rather unfairly, as pre-Revolutionary old hat suffering from "stylistic inertia".
Both these posters carry a sinister warning in small print: "Anyone who tears down this poster or covers it up is performing a counter-revolutionary act."

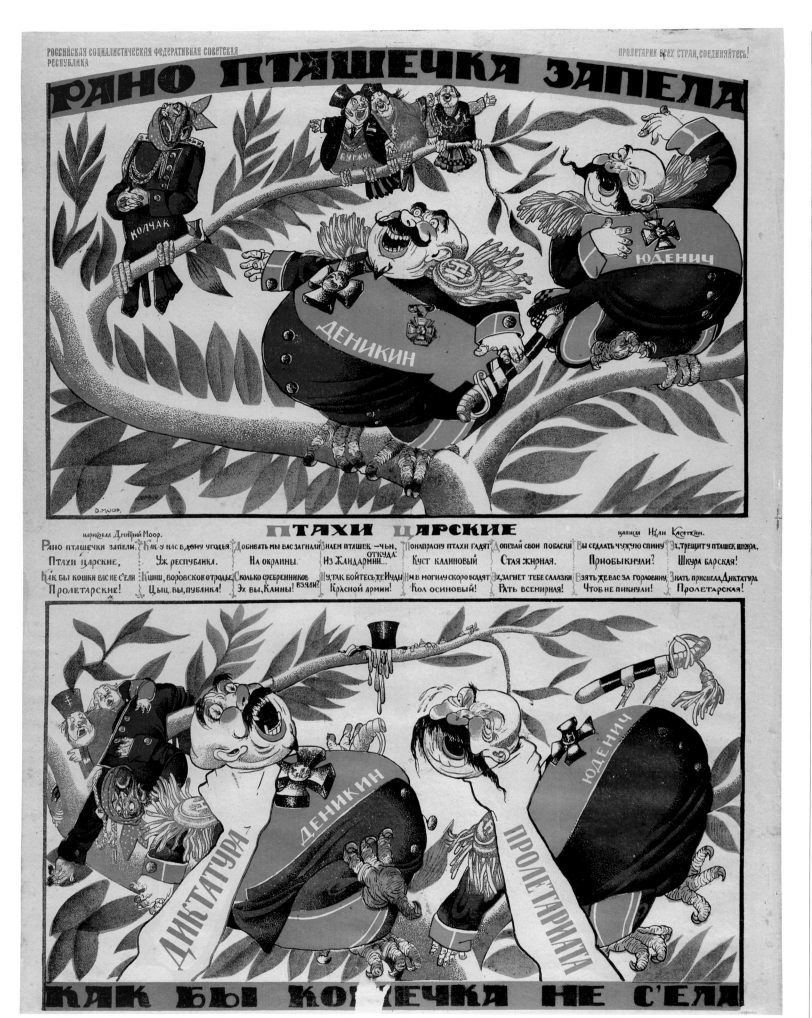

Above: "The Birds of the Tsar" by Dmitrii Moor, 1919. The black on red headline reads: "It is too early for the bird to sing – The cat might get it".
The two fat White generals, Denikin and Yudenich, have certainly got it in the neck from the strong arms of the "Dictatorship of the Proletariat", while their assorted
friends look on in horror as a capitalist suffers meltdown under a top hat.
Ivan Kasatkin's dark verses describe Kolchak and Yudenich as "Cain" and "Judas", promising to "stab those evil spirits with an aspen stake".
Opposite page: Viktor Deni's "Capital", his most famous artistic contribution to the class struggle, was published in 100,000 copies in Moscow, 1919.
Pravda praised the artist: "Making the enemy look hilarious is fifty per cent of the way to victory".

Российская Социалистическая Федеративная Советская Республика.

„Пролетарии всех стран, соединяйтесь!"

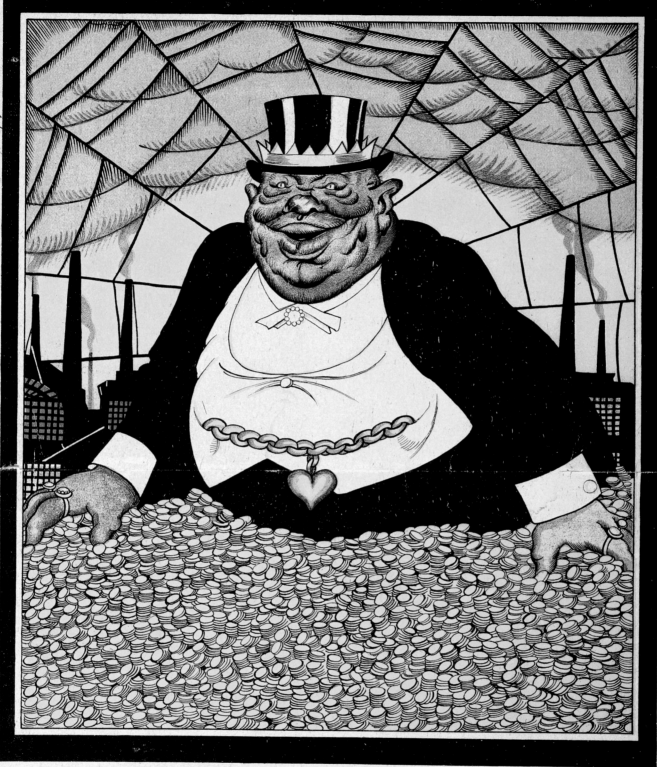

17-я Государств. типо-лит. (бывш. Кушнерева). Москва.

КАПИТАЛ.

Да не будут тебе бози инии разве мене.

Любуясь дивною картиной,
Рабы, склонитесь предо мной!
Своей стальною паутиной
Опутал я весь шар земной.
Я—воплощенье КАПИТАЛА.
Я—повелитель мировой.
Волшебный блеск и звон металла,
Мой взгляд и голос властный мой.

Тускнеют царские короны,
Когда надену я свою.
Одной рукой ломая троны,
Другой—я троны создаю.
Моя рука чертит законы

И отменяет их она.
Мне все „отечества"—загоны,
Где скот—людские племена.

Хочу—пасу стада в долинах,
Хочу—на бойню их гоню.
Мой взмах—и области в руинах,
И храмы преданы огню.
Средь всех твердынь—моя твердыня
Стоит незыблемой скалой.
Храм биржевой—моя святыня,
Конторский стол—мой аналой.

Мое евангелье—балансы,
Богослужение—„игра",
Дары священные—финансы,

Жрецы—мои бухгалтера.
Я в этом храме—жрец верховный,
Первосвященник ваш и вождь.
Свершая подвиг мой духовный,
Я золотой сбираю дождь.

Мои сокровища несметны.
Их не отдам я без борьбы.
Да будут вечно ж безответны
Мной усмиренные рабы!
Да будут святы им ступени,
Где жду я жертвы их трудов!
Да склонят все они колени,
Целуя прах моих следов!

Демьян Бедный.

№ 47.

Товарищи Мусульмане! Под зеленым знаменем Пророка шли вы завоевывать ваши степи, ваши аулы. Враги народа отняли у вас родные поля. Ныне под красным знаменем Рабоче-Крестьянской революции под звездой армии всех угнетенных и трудящихся собирайтесь с востока и запада, с севера и юга. В седла товарищи! Все в полки Всевобуч!

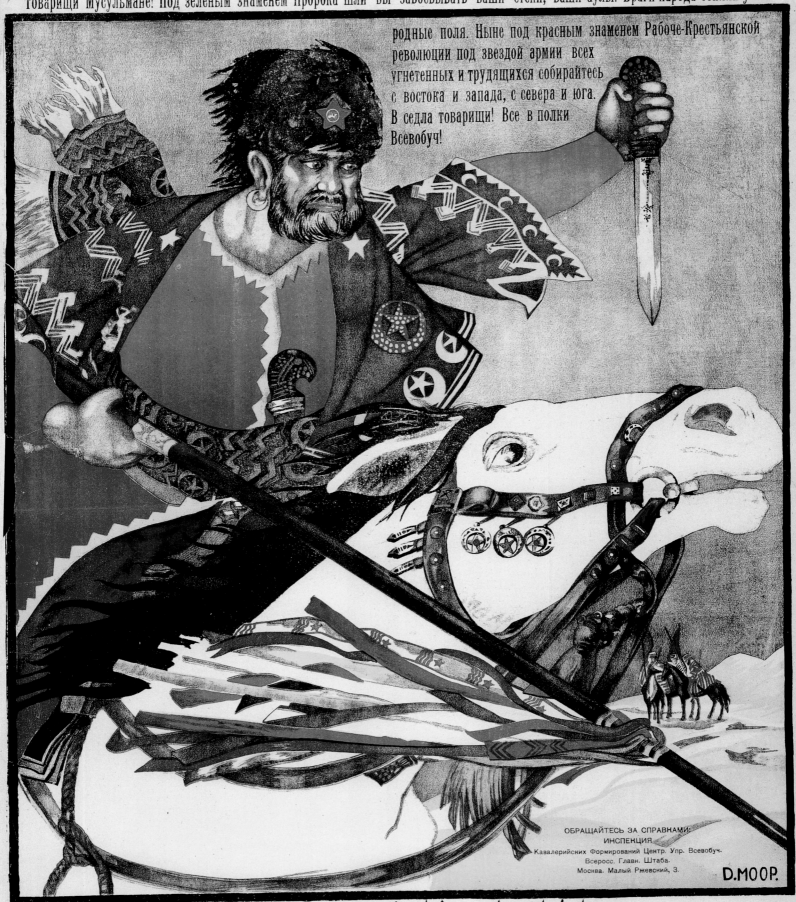

Изданіе Центр. Управл. Всевобуч.

ОБРАЩАЙТЕСЬ ЗА СПРАВКАМИ:
ИНСПЕКЦИЯ
Кавалерийсних Формирований Центр. Упр. Всевобуч.
Всеросс. Главн. Штаба.
Москва. Малый Ржевский, 3.

D.MOOP.

مسلمانلار ایبداشلر !
عسکرلک که اوویره تو اداره سی توزوگدن آتلی مسلمان عسکر
لری پولتینه یازلکز !
اوزکزنک اویوکزنی ، یبرلرکزنی اوزکزگند صافلی آلورسز !

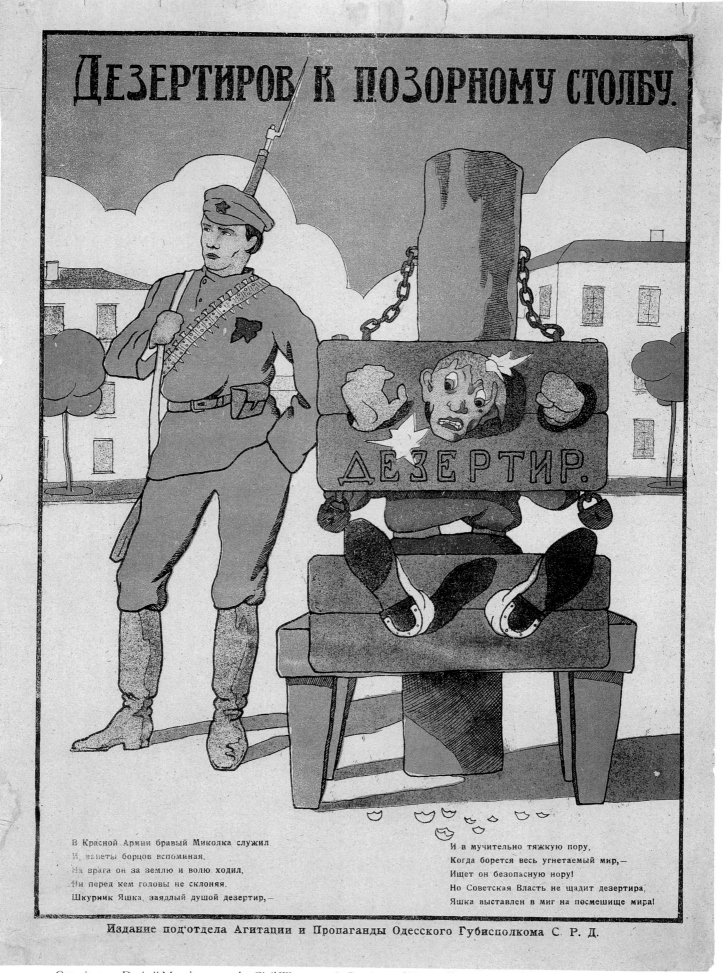

ДЕЗЕРТИРОВ К ПОЗОРНОМУ СТОЛБУ.

ДЕЗЕРТИР.

В Красной Армии бравый Миколка служил
И, заветы борцов вспоминая,
На врага он за землю и волю ходил,
Ни перед кем головы не склоняя.
Шкурник Яшка, заядлый душой дезертир,—

И в мучительно тяжкую пору,
Когда борется весь угнетаемый мир,—
Ищет он безопасную нору!
Но Советская Власть не щадит дезертира,
Яшка выставлен в миг на посмешище мира!

Издание под'отдела Агитации и Пропаганды Одесского Губисполкома С. Р. Д.

Opposite page: Dmitrii Moor's spectacular Civil War poster, in Russian and Tatar, calling upon Muslims to join the Red Cavalry.
The hammer and sickle is replaced by a crescent and star.
The full slogan: "Comrade Mussulman! Under the green banner of the Prophet you fought for your land and villages.
But then the enemies of the people took your land. Now, under the banner of the workers' and peasants' revolution, under the star of the army of all oppressed and working people, join up from the east and west, north and south. Saddle up, comrades! Everyone to the Enlightenment!"
Above: "The Deserter is Put to Shame", artist unknown.
Published by the Agitprop Department of the Central Executive Committee of Soviet Workers' Deputies, Odessa during the Civil War. The theme is medieval.

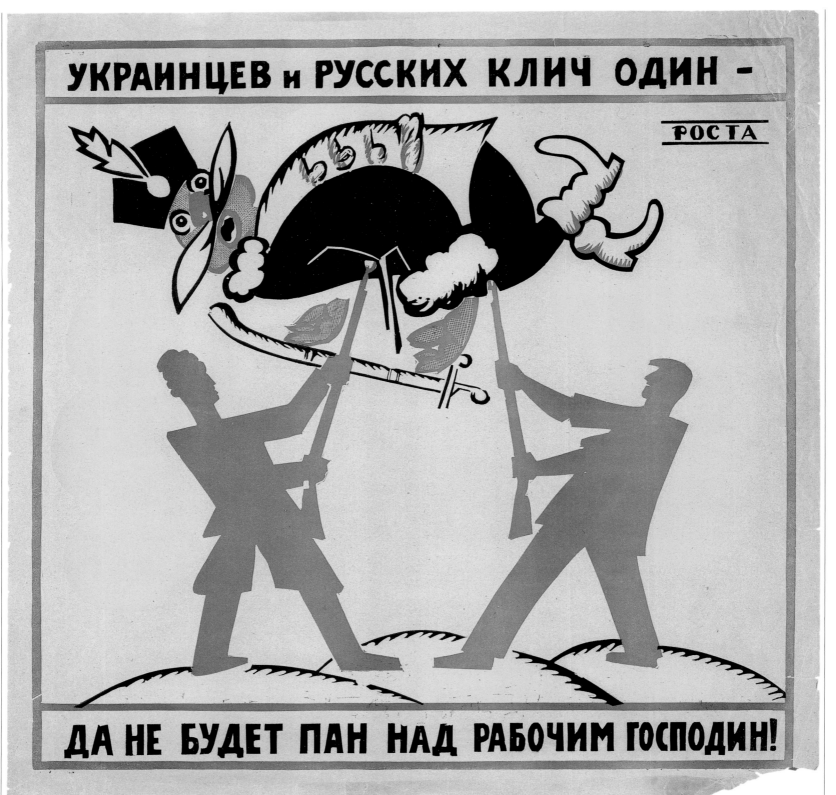

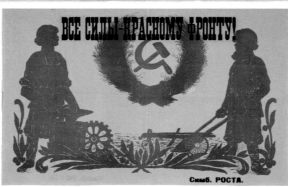

Top: "Ukrainians and Russians have a Common War Cry – Pan will not be the Master of the Worker!" Vladimir Mayakovsky's ROSTA poster of 1920 satirising the landowners of Poland at the time of the Russo-Polish War.

Above: "Make Every Effort for the Red Battlefront!" An early Civil War poster published by Simbirsk ROSTA. Artist unknown.

Opposite page: "Be on Guard!" by Dmitrii Moor with text by Trotsky, published during the Russo-Polish War. A soldier of the Red Cavalry stamps on the Polish landlords while capitalists from Finland, Estonia, Latvia and Romania hover around hoping to become a potential threat.

After Marshal Pilsudski's Polish army staged an ill-fated assault on Kiev in April 1920, Trotsky advised Lenin that the Red Army's counter-attack should stop at the Polish border. Lenin disagreed, believing a Soviet Poland was in his sights. It wasn't to be.

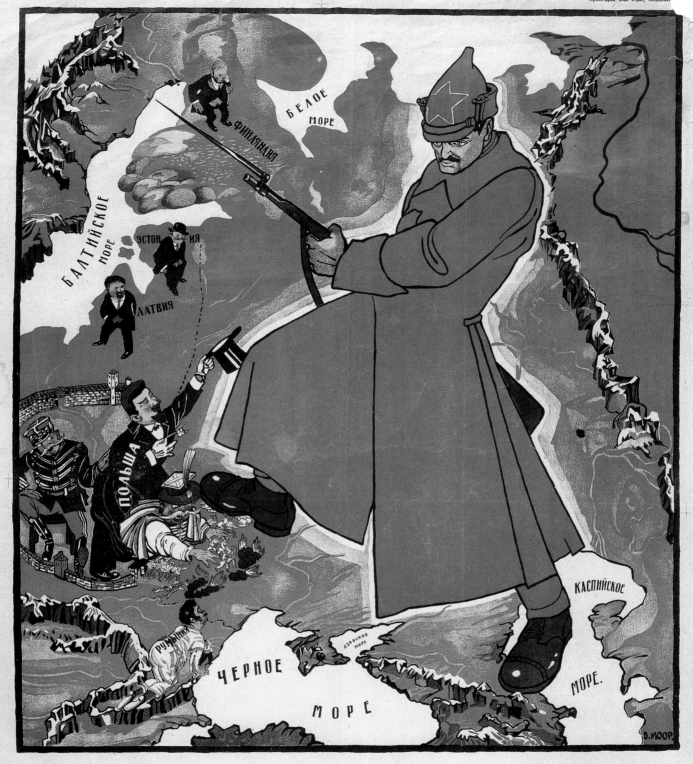

БУДЬ НА СТРАЖЕ!

Польша выбросила на нашу территорию несколько новых значительных банд под руководством того самого петлюровского бандита Тютюника, который подлежал высылке из пределов Польши. Неслыханно провокационный характер этого нового нападения заставил всю армию встрепенуться и спросить себя: „доколе же?"...

Каждый красноармеец должен уяснить себе действительное положение дел. В Польше не одно правительство, а два. Одно—официальное, гласное, выступающее в парламенте, ведущее переговоры, подписывающее договоры. Другое—негласное, опирающееся на значительную часть офицерства, с так-называемым начальником государства Пилсудским во главе. За спиной тайного правительства стоят крайние империалисты Франции. В то время как официальное польское правительство под давлением не только трудящихся, но и широких буржуазных кругов, вынуждено стремиться к миру с советской Россией, провокаторы Польского штаба изо всех сил стремятся вызвать войну.

Мы не знаем, победят ли в Польше этой зимой или ближайшей весной сторонники мира или преступные поджигатели. Мы должны быть готовы к худшему.

Красная армия снова раздавит Петлюровские банды, выброшенные к нам польскими авантюристами. Красная армия удвоит свою работу по боевой подготовке. Никакой поворот событий не застигнет красную армию врасплох.

Л. Троцкий.

Высший Военный Редакционный Совет. Государственное Издательство.

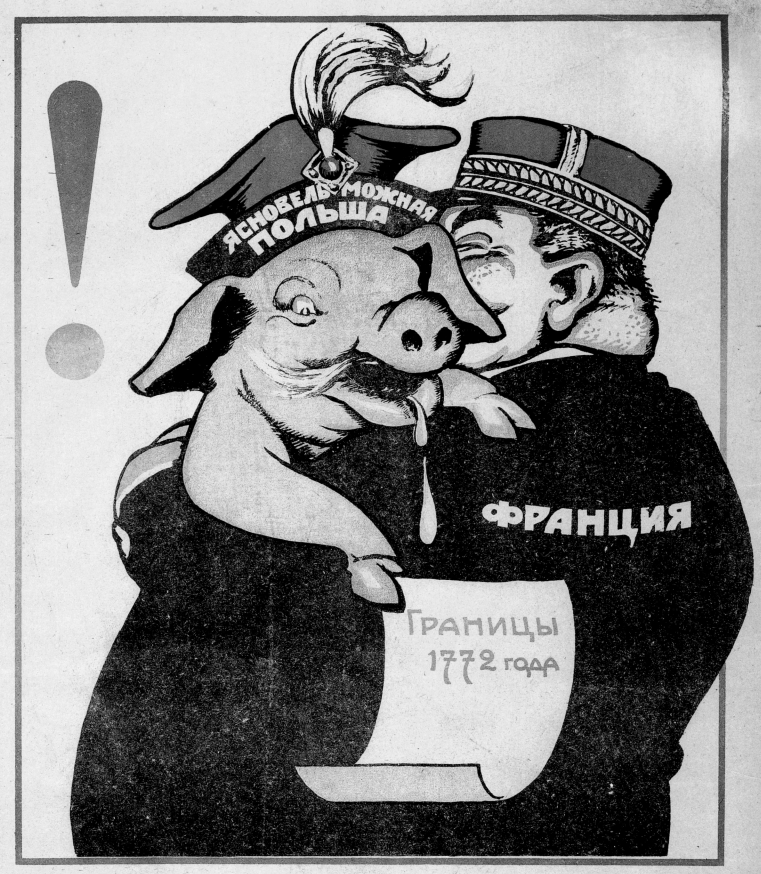

Свинья, дрессированная в Париже.

Государственное Издательство.
1920 г.

30

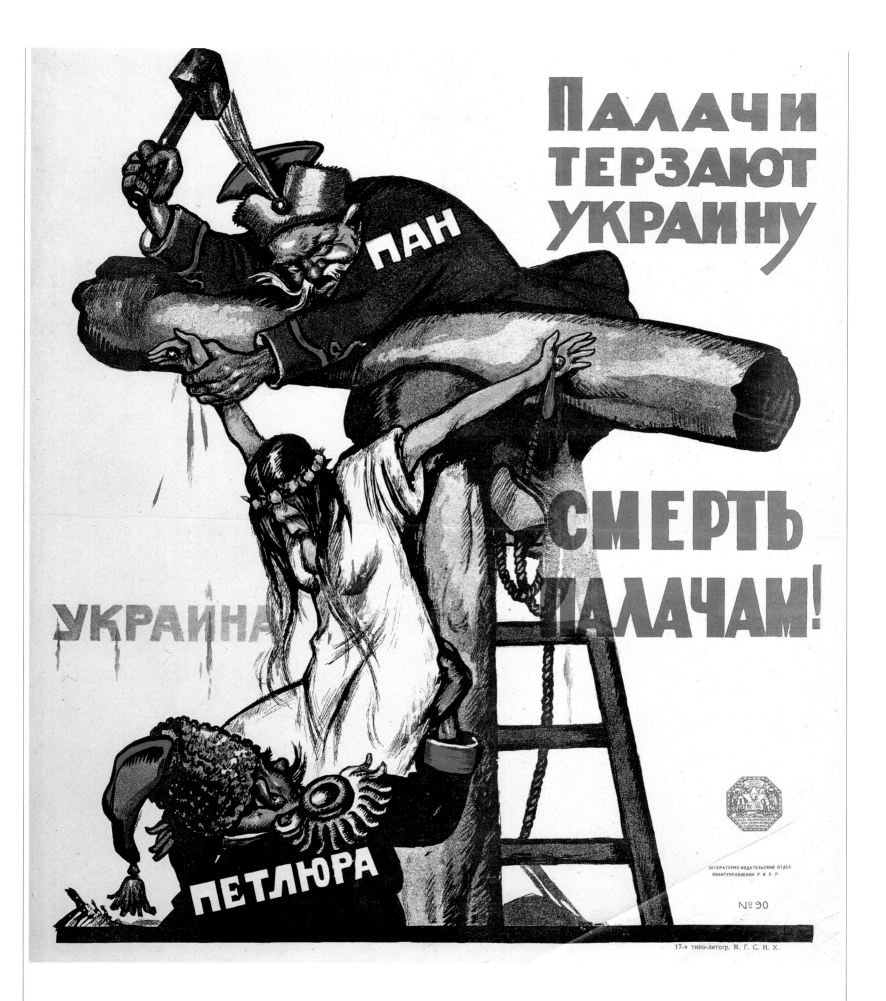

ПАЛАЧИ
ТЕРЗАЮТ
УКРАИНУ

СМЕРТЬ
ПАЛАЧАМ!

УКРАИНА

ПАН

ПЕТЛЮРА

№ 90

17-я типо-литогр. М. Г. С. Н. Х.

Opposite page: "A Pig Trained in Paris" by Viktor Deni, published in 1920 during the Russo-Polish War.
The pig, whose hatband reads "The Poland of the Landlords", is slumped in the arms of its ally "France" and happily salivates over a proclamation, "Frontiers of 1772",
referring to Poland's desire for the restoration of its historical borders.
Above: "The Butchers are Torturing Ukraine – Death to the Butchers!" Viktor Deni's gruesome poster, circa 1919, shows a Polish
landlord, "Pan", nailing "Ukraine" to the stake aided by Petlyura, commander-in-chief of the Ukrainian army and counter-revolutionary in the Civil War.
After his defeat by the Red Army, Petlyura fled to Paris where he was assassinated by a Chekist agent in 1926.
Deni suffered from hypochondria, was a mysanthropic loner, a thin and mournful alcoholic. He died in 1946, aged 53.

ВСТУПАЙТЕ ДО ЧЕРВОНОЇ КІННОТИ!

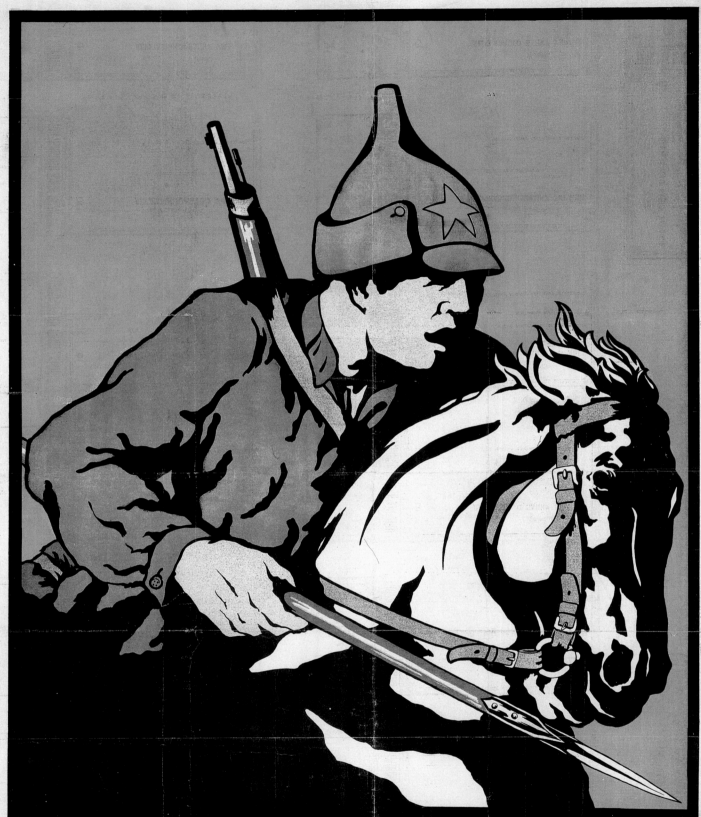

Червона кіннота знищила Мамонтова, Шкуро, Деникина.
Вона била панів і Петлюру,
зараз потрібно знищити недобитка Врангеля.

Робітники й селяне—вступайте до лав Червоної Кінноти.

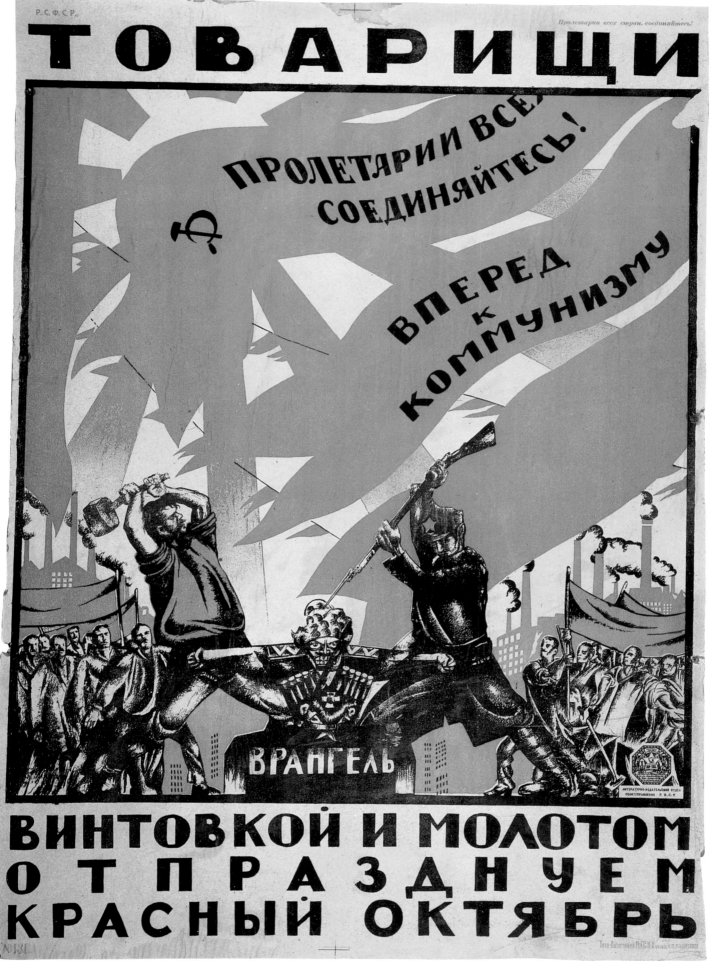

Opposite page: "Join the Red Cavalry!" by V. Silkin. A recruitment poster published in Ukrainian from Kiev, 1920.
The text reads: "The Red Cavalry fought against Mamontov, Shkuro, Denikin. They fought against Pans and Petlyura. Now it's Wrangel's turn.
Workers and Peasants – Join the Red Cavalry."
The distinctive helmet of the Red Cavalry, known as the "budenovka", is named after Semyon Budenny, the Red First Cavalry commander.
Designed in 1918, the helmet was originally called the "bogatyrka", its inspiration coming from Viktor Vasnetsov's famous painting of 1898, "The Bogatyrs";
three legendary warriors are depicted on horseback, defending ancient Russian soil and wearing metal armoured head-dress of a similar design.
Above: "Comrades! With Rifles and Hammers, Let's Celebrate Red October" by Dmitrii Moor, 1920. The flags read, "Proletarians of the World, Unite!"
and "Forward to Communism". Baron Wrangel's last seconds look clearly numbered.

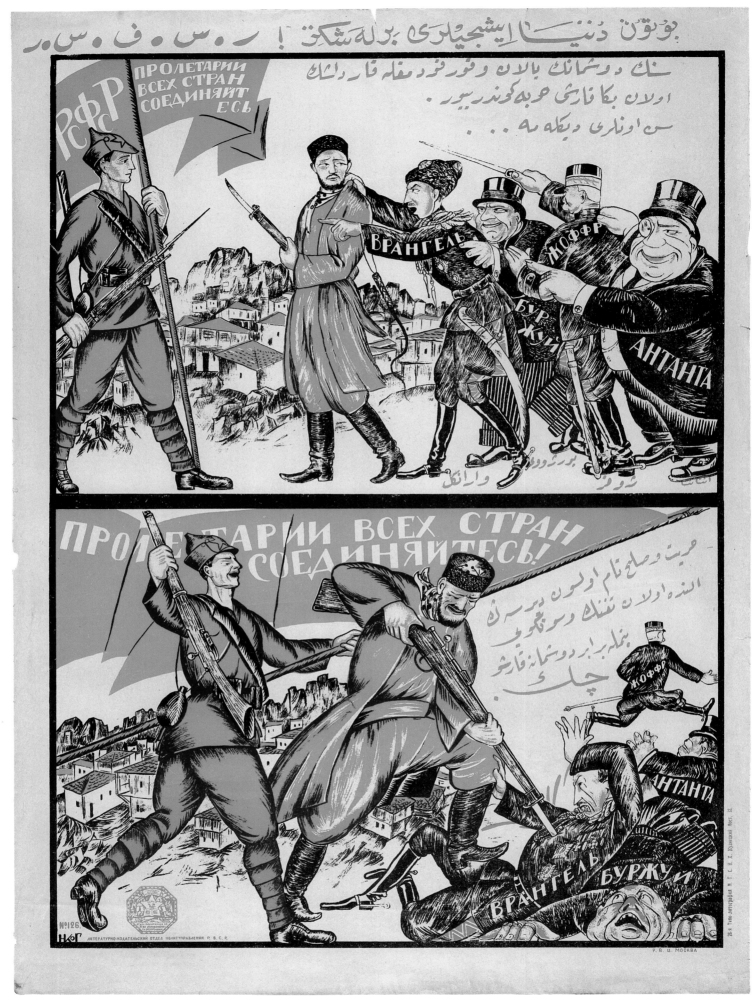

Above: "Proletarians of All Lands, Unite!" by Nikolai Kogout, 1920. Text in Russian and Tatar. The upper panel shows a Red Cavalryman facing a Crimean Tatar soldier, behind whom lurks Baron Wrangel with his acolytes – the bourgeoisie, the French General Joffre and the Entente.

The script in Arabic reads: "Your enemies are lying to you and frightening you because they want you to fight against your brothers. Don't listen to them! If you want to fight for peace and freedom, take up your rifle and let us fight the enemy together". The lower panel describes the outcome.

Opposite page: "Women, Throw Out the Deserter!" Artist unknown, Odessa, 1920.

Trotsky's Red Army took battlefield discipline very seriously. Blocking units behind the front lines were sanctioned to shoot anyone retreating without orders.

ЖЕНЩИНЫ
ГОНИТЕ
ДЕЗЕРТИРОВ!

Издание Одесского Губернского Отделения Всеукриздата 1920 г.

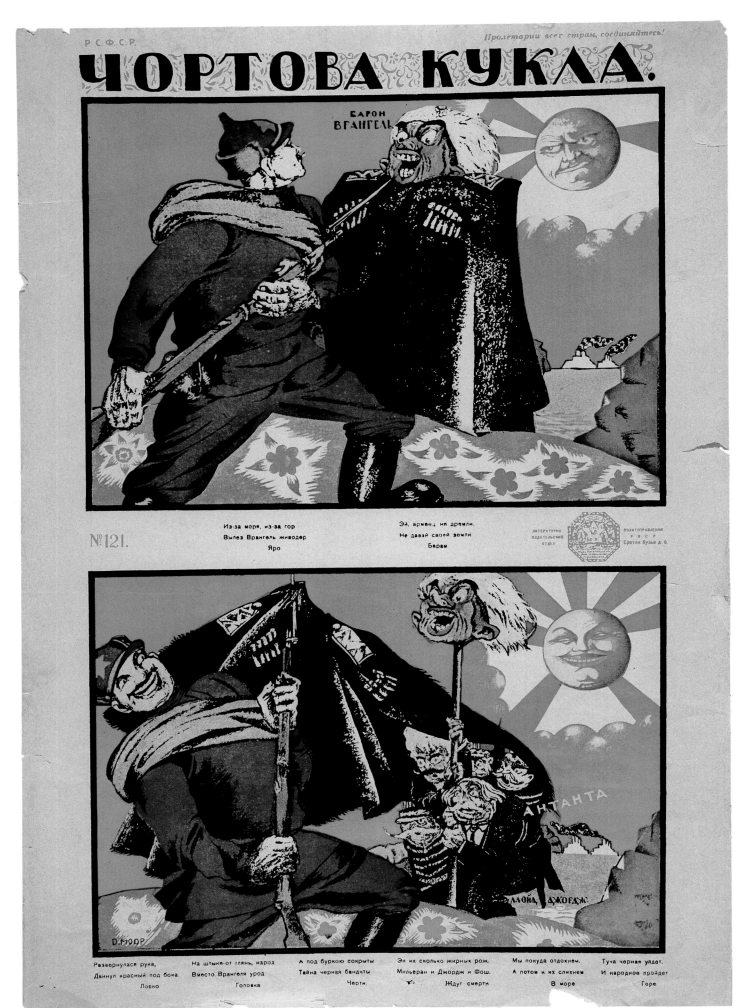

Above: "Damned Doll" by Dmitrii Moor, 1920. Moor's Red Cavalryman uncloaks Baron Wrangel to expose his clandestine support from foreign powers – British Prime Minister Lloyd-George, French military commander Foch and others. Note the sun's reaction and the pretty flowers.
Opposite page: "The Last Battle". Artist unknown, Kiev, 1920. The sunlit shores of the Crimean coastline bask in the expectancy of a long-awaited peace. The distant ships in both posters symbolise the final escape of Wrangel and his White Army from the Crimea.
The Black Baron, as he was called, found exile in Brussels, Belgium, where he died suddenly in 1928, possibly poisoned by his brother's butler who was thought to have been a Chekhist agent.

Последний бой!

Задушив
последнюю гадину
контр-революции—
—барона Врангеля,
рабочие и крестьяне
вернутся к мирному
труду.

Редакционно-Издательский Отдел
Политуправления Киевского Военного Экруга.

2-я Советская фото-лито-типография
Киев, Пушкинская 4. № 2000—3000

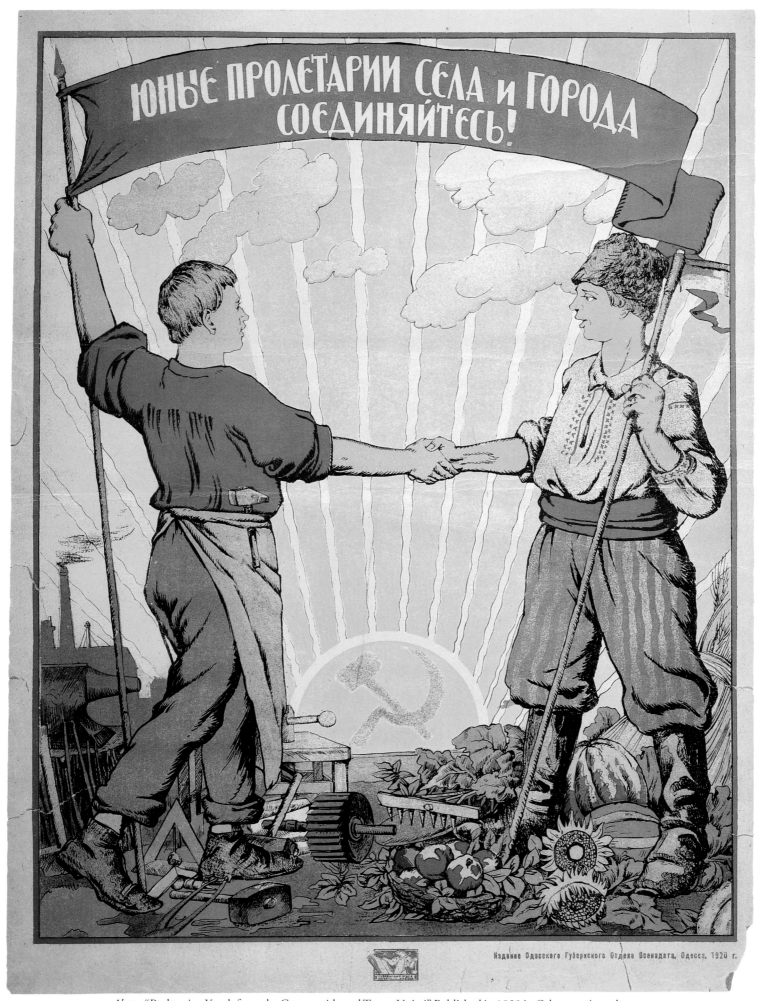

Above: "Proletarian Youth from the Countryside and Town, Unite!" Published in 1920 in Odessa, artist unknown.
At the start of the twentieth century Odessa had been the fastest-growing and most ethnically diverse city in the Tsarist empire.
But with the new Soviet regime's increasing isolation from the West after the Civil War, the boomtown free port slid into economic decline. Much worse was to follow.
In 1941 its famously large and vibrant Jewish population was viciously massacred, not by the Nazis, but by their Romanian fascist allies.
Opposite page: "Down with Capital, Long Live the Dictatorship of the Proletariat!"
A poster by Dmitrii Melnikov published in Moscow in 1920, celebrating the third anniversary of the October Revolution.

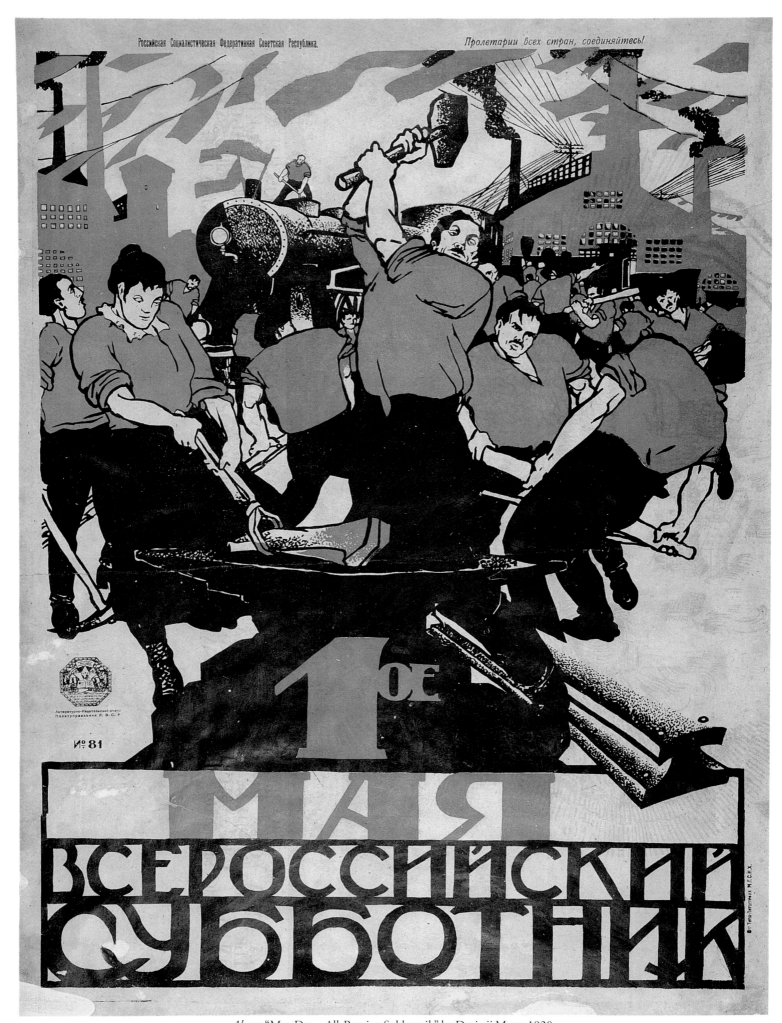

Above: "May Day – All-Russian Subbotnik" by Dmitrii Moor, 1920.
The "subbotnik" movement (voluntary unpaid work carried out on holidays, especially Saturdays) was promoted by the Soviet government
to overcome labour shortages and speed the rebuilding of the country after three years of civil war.
Opposite page: "We Defeated the Enemy with Weapons – With Hard Work We Will Get Our Bread. Everyone to Work, Comrades".
Nikolai Kogout's inspiring poster for post-Civil War reconstruction, 1920.

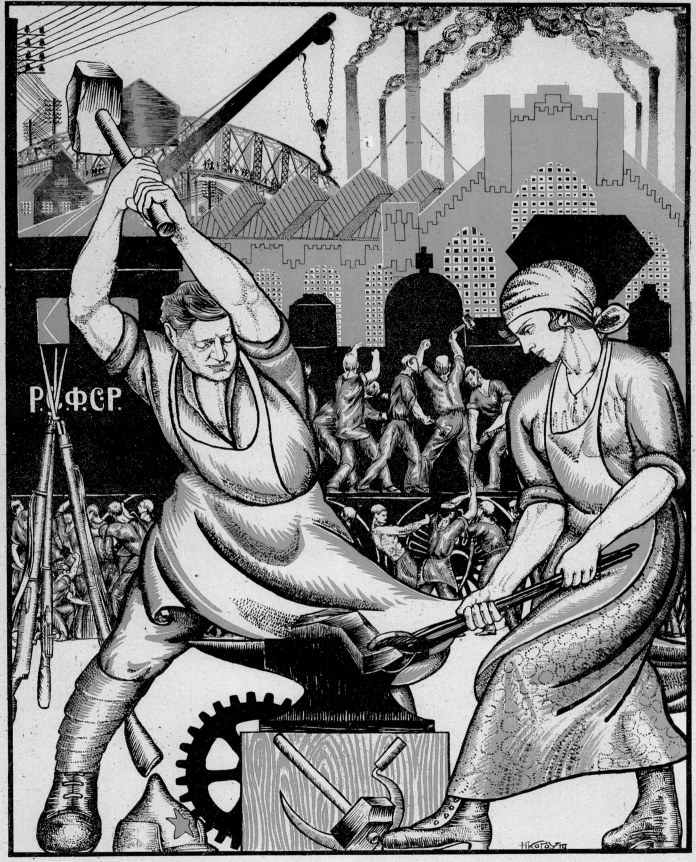

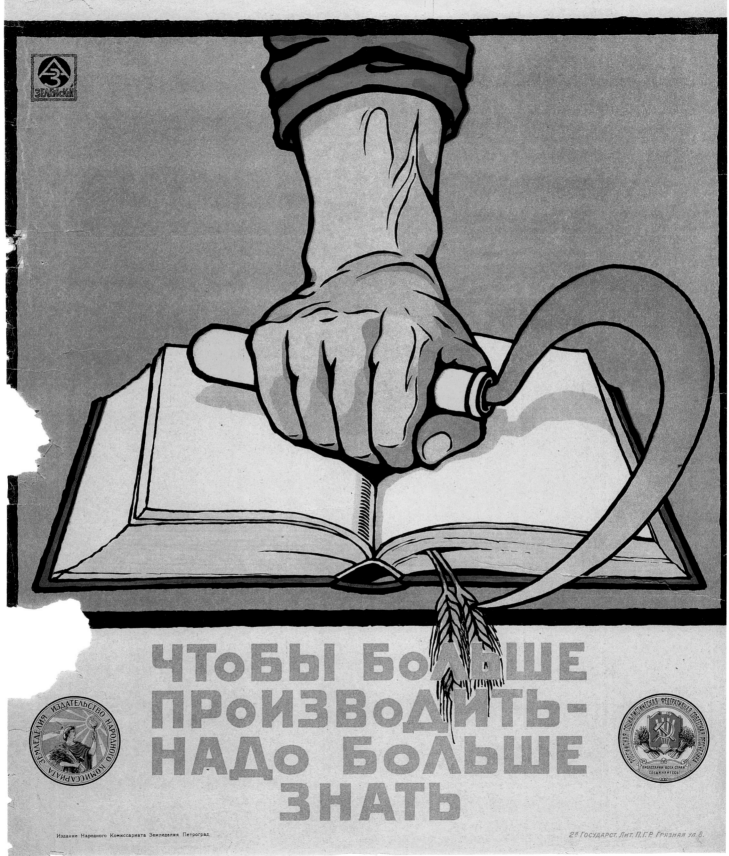

Above: "To Have More, You Must Produce More – To Produce More, You Must Know More" by Alexander Zelensky.
Peoples' Publishing House Commissariat of Agriculture, Petrograd, 1920.
Opposite page: "Red Moscow – The Heart of the World Revolution".
A bilingual poster published in June 1921 by Vkhutemas, the Higher State Artistic and Technical Studios in Moscow. The art school remained a hotbed of constructivist art and design throughout the 1920s until it was shut down in 1930 and replaced by the conservative Moscow Art Institute.

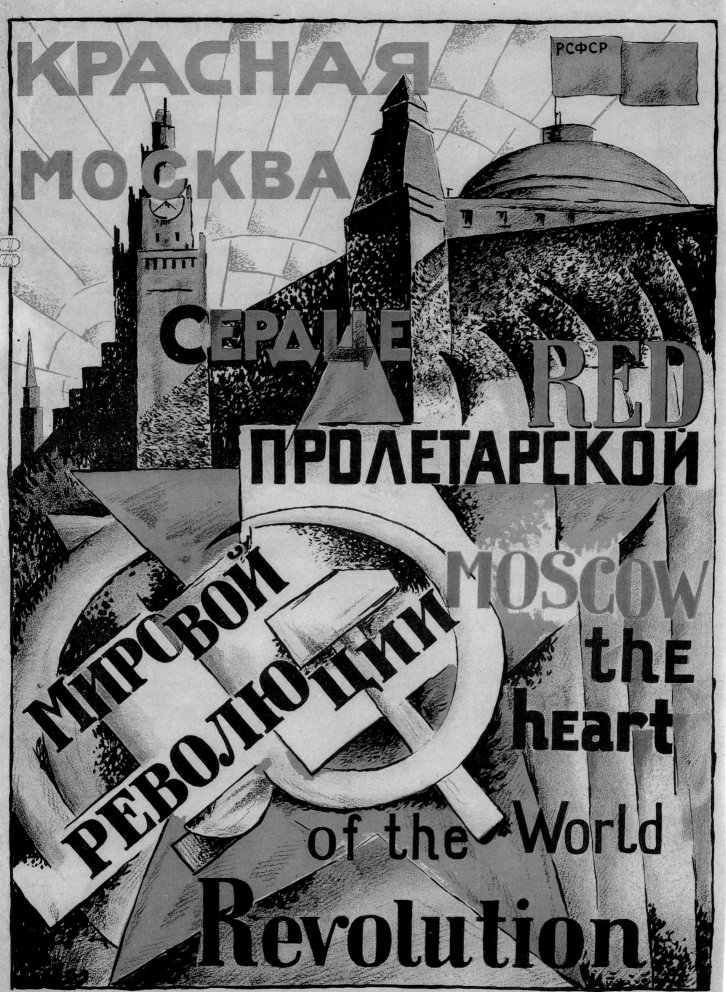

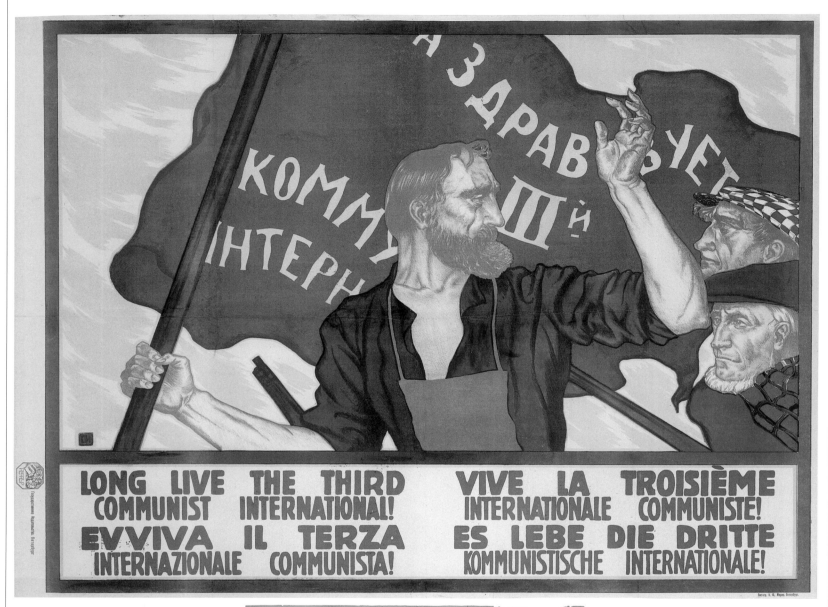

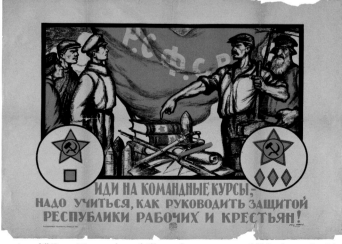

Top: "Long Live the Third Communist International!" Sergei Ivanov's multilingual poster was published to coincide with the Second Congress of the Comintern, held in Moscow and Petrograd during the summer of 1920.

Above: "Join the Commanders' Courses – Learn How to Lead the Defence of the Workers' and Peasants' Republic".

A 1921 poster from Petrograd calls for Red Army soldiers to improve their education.

Opposite page: "Literacy is the Path to Communism". Published in 1920, artist unknown, with text in Yiddish with Hebrew script.

The Cyrillic lettering on the book reads, "Proletarians of All Lands, Unite". In the poster, the classical hero Bellerophon, astride the winged Pegasus, leads the struggle to combat illiteracy and distribute knowledge. The print run was 50,000 copies, also printed in the Russian, Polish and Tatar languages.

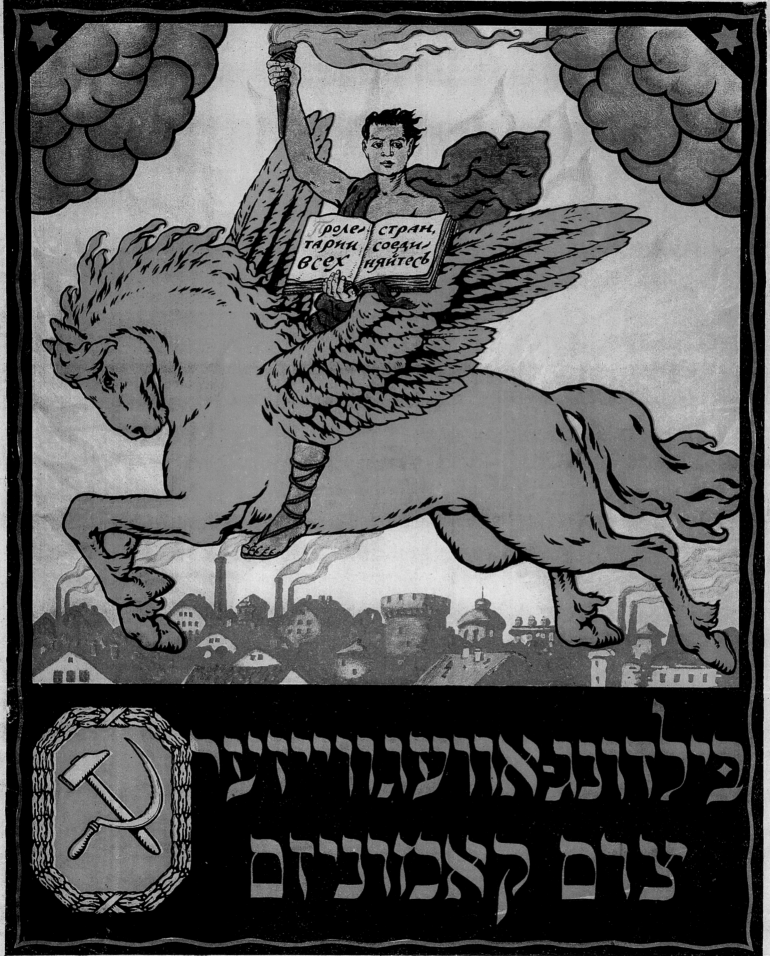

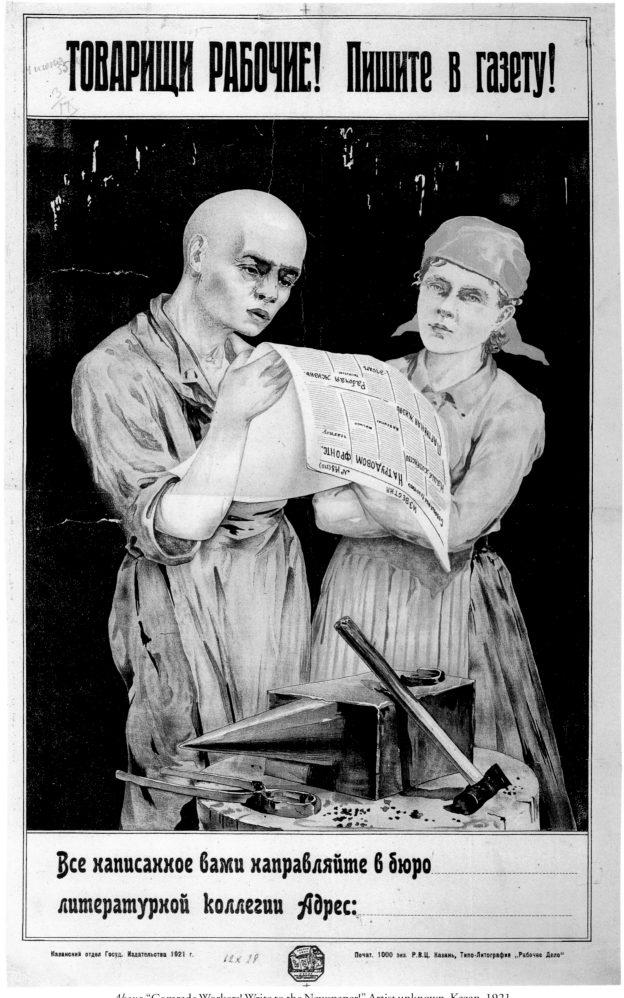

Above: "Comrade Workers! Write to the Newspaper!" Artist unknown, Kazan, 1921.
The Commissariat of Enlightenment's war on illiteracy meant reforming the old Tsarist educational system and modernising teaching methods.
Here we see beneficiaries from the campaign; two comrade workers make a determined effort to get through a copy of Izvestia during a break from the anvil.
Inscribed on the stamp of the State Publishing House: "Knowledge itself is power".
Opposite page: "Understand that the Sabotage Attempts of the World Bourgeoisie are Useless".
A provincial poster from Voronezh, printed in black and hand coloured, on the fourth anniversary of the October Revolution, 1921.

В ЭТИ ДНИ ВСЕ ДОЛЖНЫ ПОНЯТЬ, КАК БЕСПЛОДНЫ ВСЕ ЗАГОВОРЫ ВСЕМИРНОЙ БУРЖУАЗИИ.

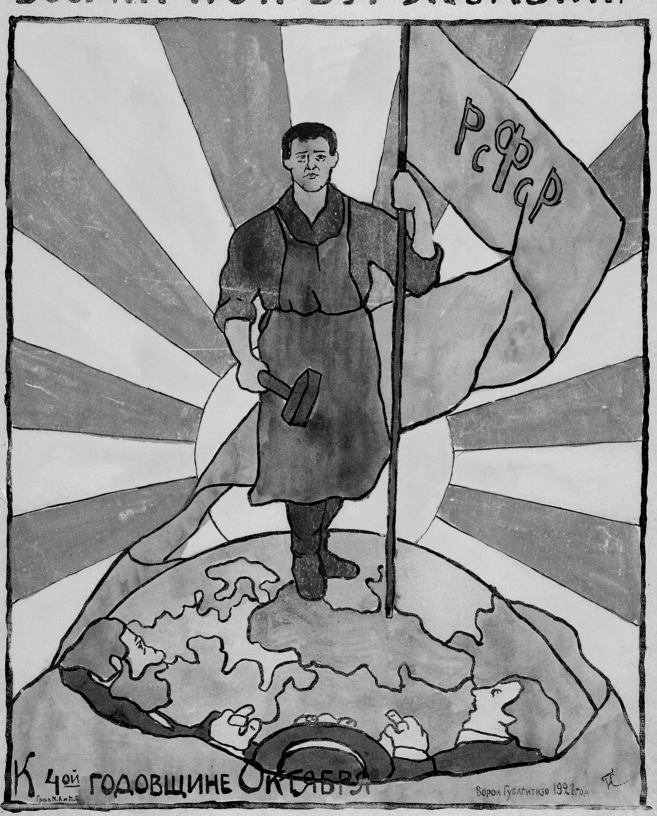

К 4ой ГОДОВЩИНЕ ОКТЯБРЯ

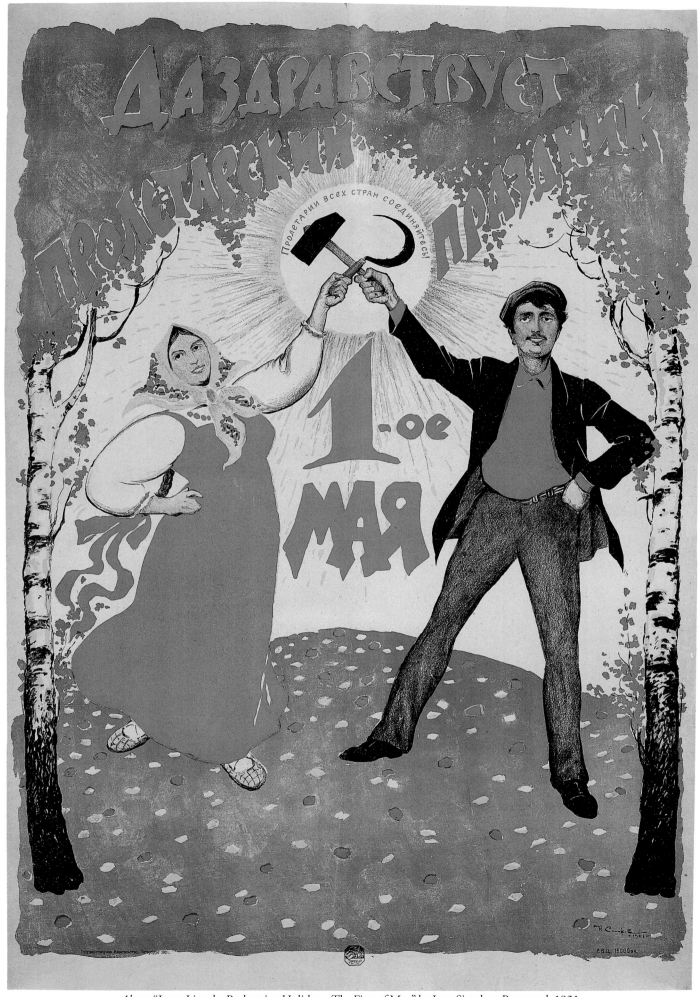

Above: "Long Live the Proletarian Holiday – The First of May" by Ivan Simakov, Petrograd, 1921.
Opposite page: "Citizens! Get Vaccinated Against Cholera. It is the Only Protection Against the Deadly Disease"
by Sergei Ivanov. State Publishing House, Petrograd, 1920.
Due to the upheavals of millions of people in Russia at this time caused by years of war and revolution, diseases normally associated with warmer regions began to spread
even as far as Northern Siberia. The death rate from cholera reached 65% of those infected.
The contrast between Simakov's idealised confection of peasant life and the horrifying spectre of "Cholera" stalking Ivanov's poster could hardly be greater.

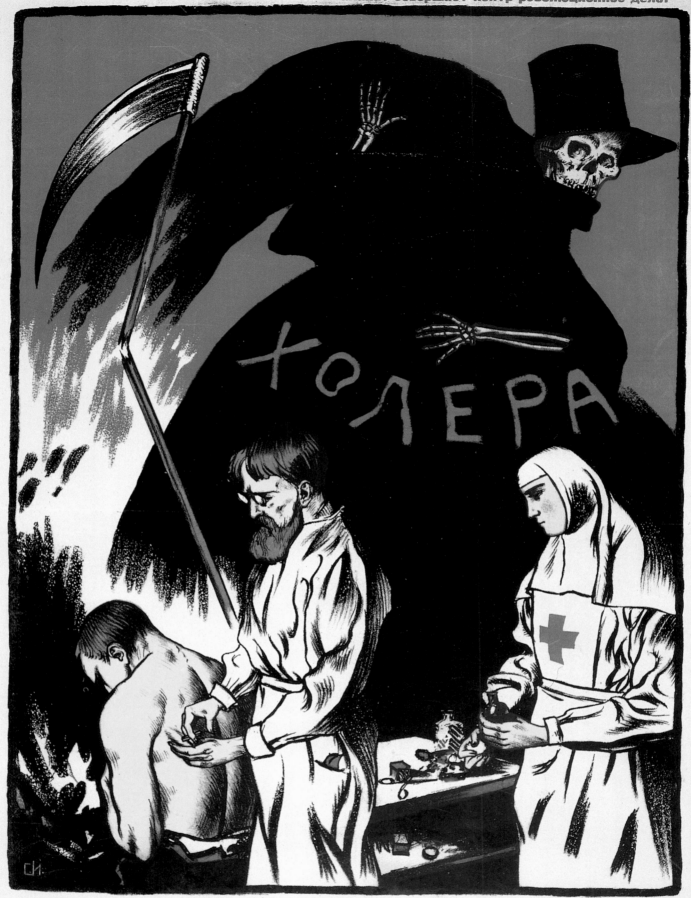

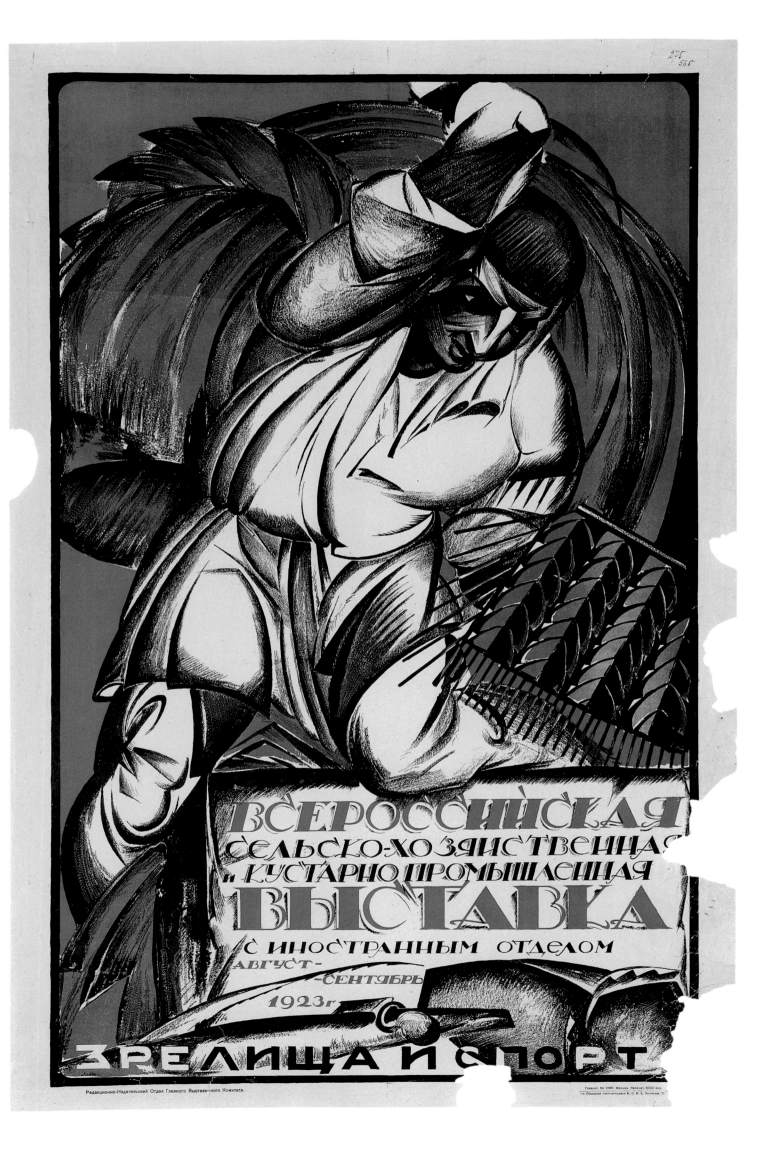

ВСЕРОССИЙСКАЯ
СЕЛЬСКО-ХОЗЯЙСТВЕННАЯ
и КУСТАРНО-ПРОМЫШЛЕННАЯ
ВЫСТАВКА
с иностранным отделом
АВГУСТ-
-СЕНТЯБРЬ
1923г.
ЗРЕЛИЩА И СПОРТ

Редакционно-Издательский Отдел Главного Выставочного Комитета.

Главлит. № 2586. Москва. Напечат. 5000 экз.
1-я Образцовая типо-литография М. С. Н. Х. Пятницкая, 71.

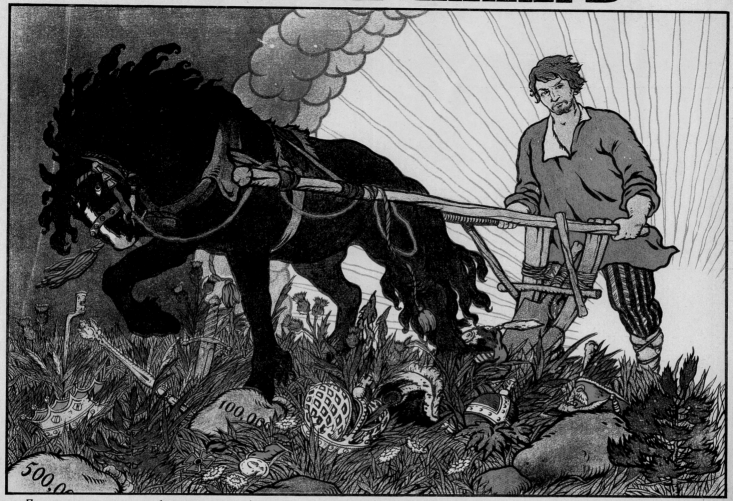

Opposite page: Alexander Lebedev's poster for the All-Russian Agricultural and Industrial Crafts Exhibition held in Moscow, August-September 1923.
The exhibition was a great success in showing how rapidly Soviet agriculture had progressed in two years since the famine.
Top: "Red Ploughman" by Boris Zvorykin based on a medieval Russian fairytale. Moscow, 1920.
The great sun rises and the dark clouds disperse as the beautiful horse treads warily through the fallen trappings of Tsardom.
Above: "The book will teach you how to run your farm. Ask for books in every cooperative store or register for postal delivery". Poster by O. Grun, 1922,
for the "New Village" publishing house started by the Ministry of Land (Narkomzem).

Right: "A Spectre is Haunting Europe, the Spectre of Communism" by Valentin Shcherbakov, Moscow, circa 1924.

The slogan is taken from the first line of the Manifesto of the Communist Party (Marx and Engels, 1848). Shcherbakov's poster, an early example of the Lenin Cult, is based on G.P. Goldshtein's photographs of Lenin addressing Red troops in Moscow, May 5, 1920.

Lenin disliked any form of adulation: "All our lives we have waged an ideological struggle against the glorification of personality… and suddenly here again is a glorification of the individual!" Stalin had no such scruples. After Lenin's death in January 1924, the General Secretary engineered a massive Lenin Cult propaganda campaign in preparation for the far greater Stalin Cult, which was to follow in the 1930s. Stalin would then become known as "The Lenin of Today".

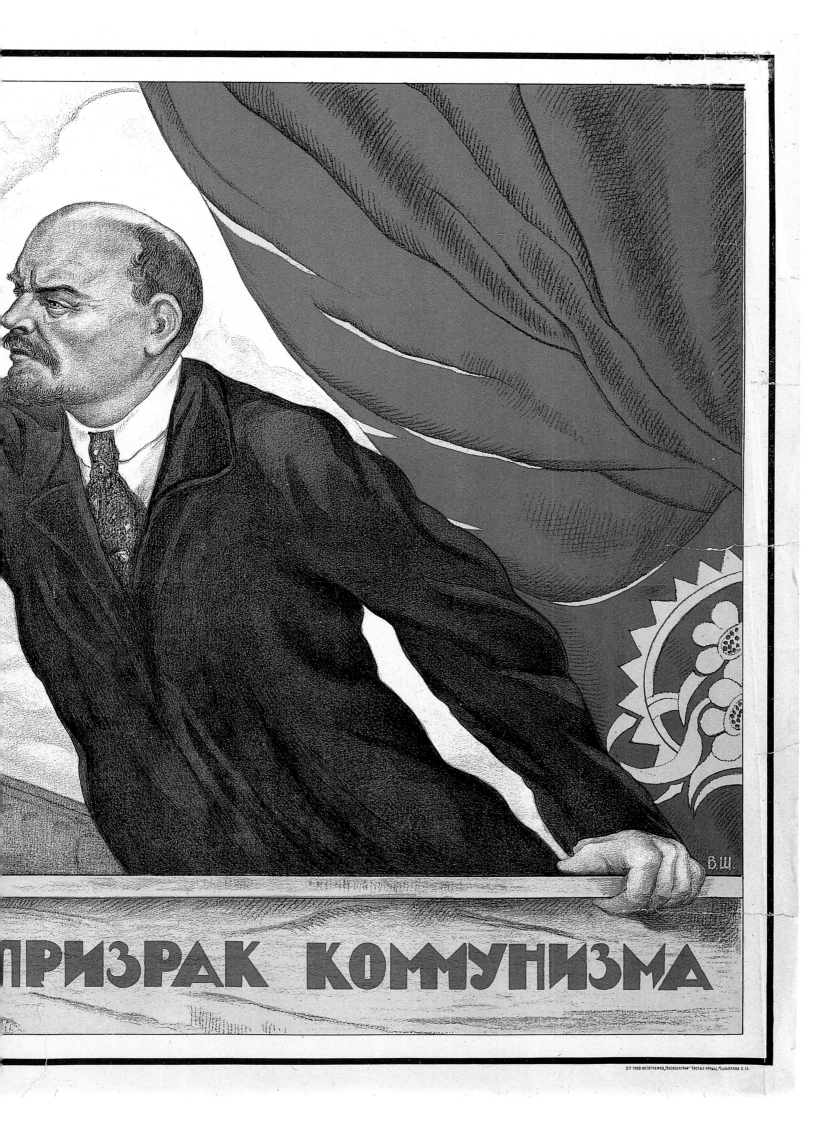

ПРИЗРАК КОММУНИЗМА

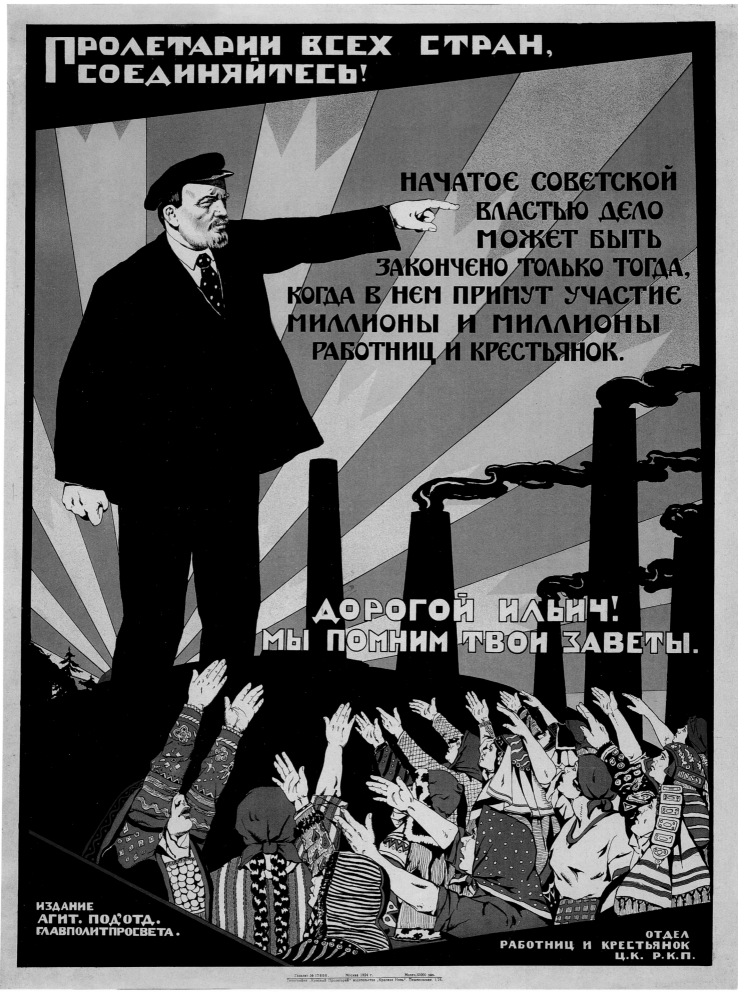

Above: "Dear Illyich! We Remember Your Command".
An unsigned poster from Moscow, 1924, showing Lenin mobbed by adoring women of the Soviet Union
dressed in their traditional costumes.
The sun rises dramatically over the smokestacks behind him.
The top line reads, "Proletarians of All Lands, Unite!", followed by a quote from Lenin: "The struggle started by Soviet power
will only be completed when we are joined by millions and millions of working class and peasant women".

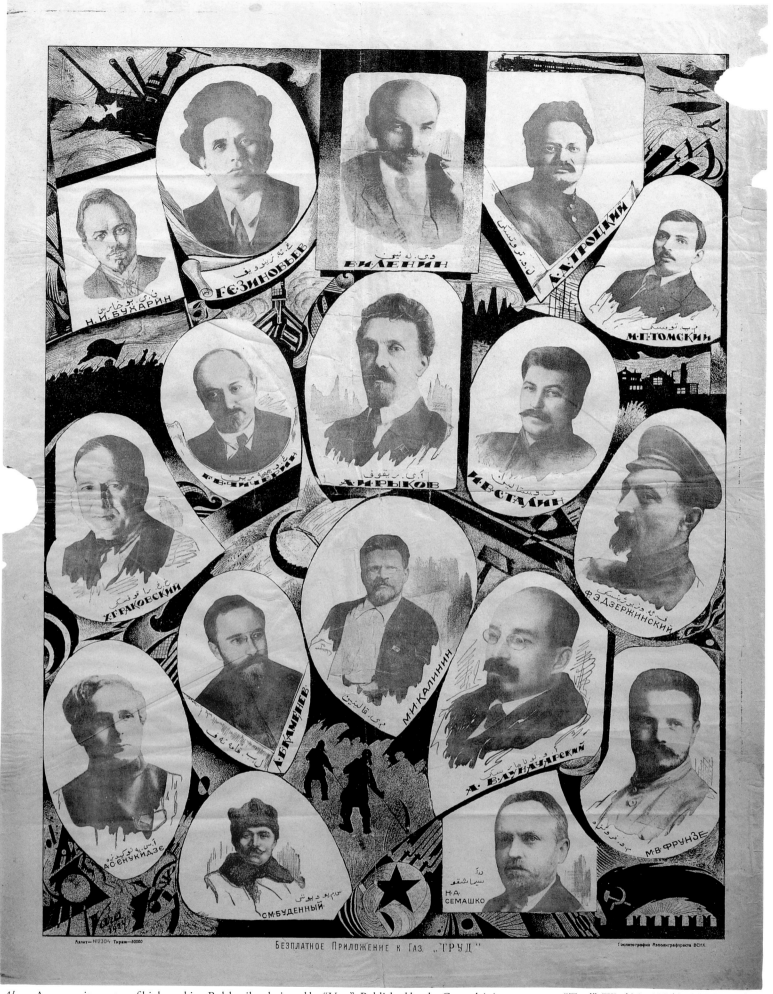

Above: A composite poster of high-ranking Bolsheviks, designed by "Vara". Published by the Central Asian newspaper "Trud" (Work) in 1924 in 80,000 copies. Seventeen officials are shown, including Stalin, who later had eight of the group murdered (not counting one suicide).
Top row, left to right: Bukharin (shot 1938), Zinoviev (shot 1936), Lenin (died 1924), Trotsky (assassinated 1940), Tomsky (suicide 1936).
Second row, left to right: Rakovsky (shot 1938), Chicherin (died 1936), Rykhov (shot 1938), Stalin (died 1953), Dzerzhinsky (died 1926).
Third row, left to right: Yenukidze (shot 1937), Kamenev (shot 1936), Kalinin (died 1946), Lunacharsky (died 1933), Frunze (medical murder 1925).
Front row, left: Budenny (died 1973). Front row, right: Semashko (died 1949).

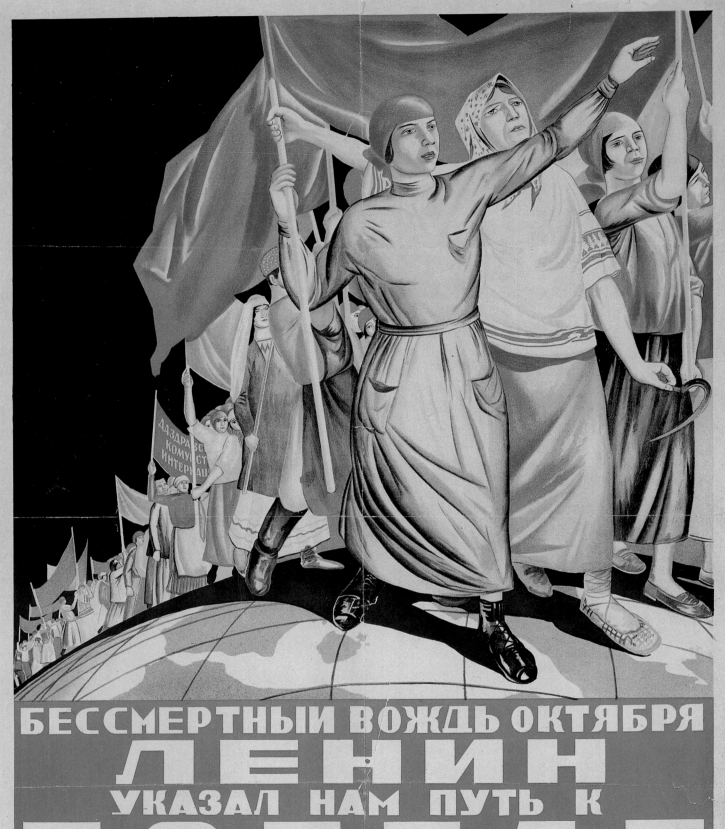

БЕССМЕРТНЫЙ ВОЖДЬ ОКТЯБРЯ
ЛЕНИН
УКАЗАЛ НАМ ПУТЬ К
ПОБЕДЕ
ДА ЗДРАВСТВУЕТ
ЛЕНИНИЗМ

К 7-ой ГОДОВЩИНЕ ОКТЯБРЬСКОЙ ПОБЕДЫ.

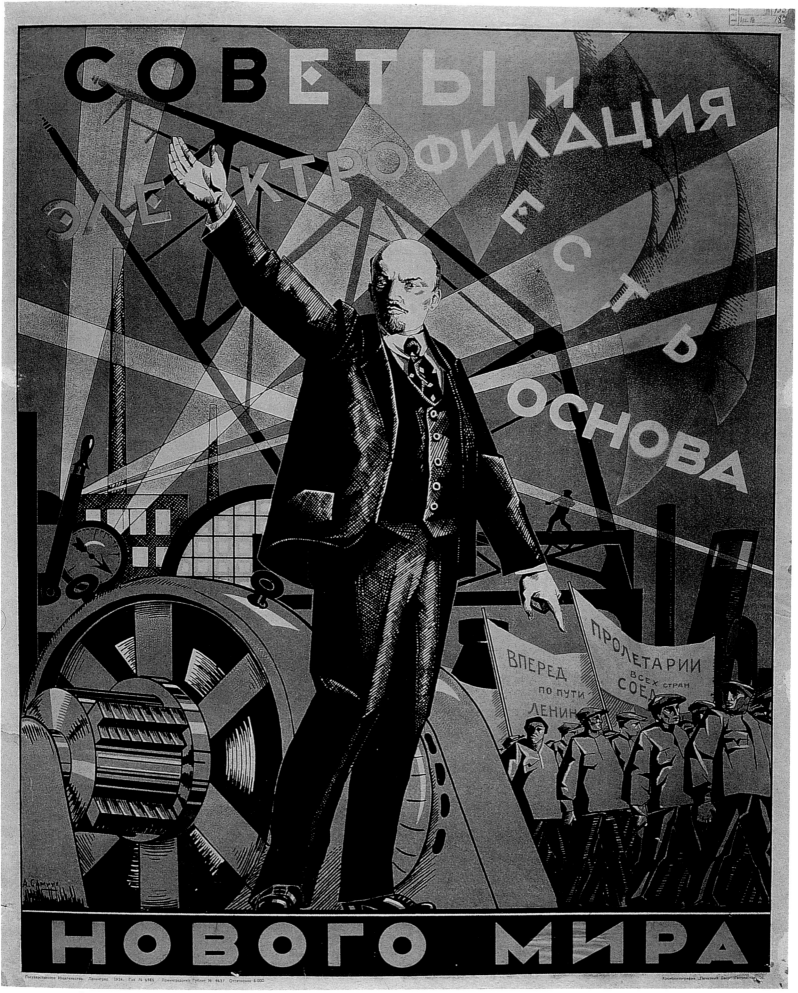

Above: "Soviets and Electrification – This is the Foundation of the New World". Alexander Samokhvalov's 1924 contribution to the new Lenin Cult portrays him as the master of ceremonies of hydroelectricity. Lenin's great plan for the electrification of Russia would be completed in about twelve years.
Opposite page: "The Eternal Leader of October – Lenin – Has Shown Us the Path to Victory. Long Live Leninism".
Published in Leningrad "On the Seventh Anniversary of the October Victory", 1924.
The new public image of socially-active Soviet women – from the working classes, of all ages and ethnicities – marching forward to the future.
The slogan on the banner: "Long Live the Communist International".

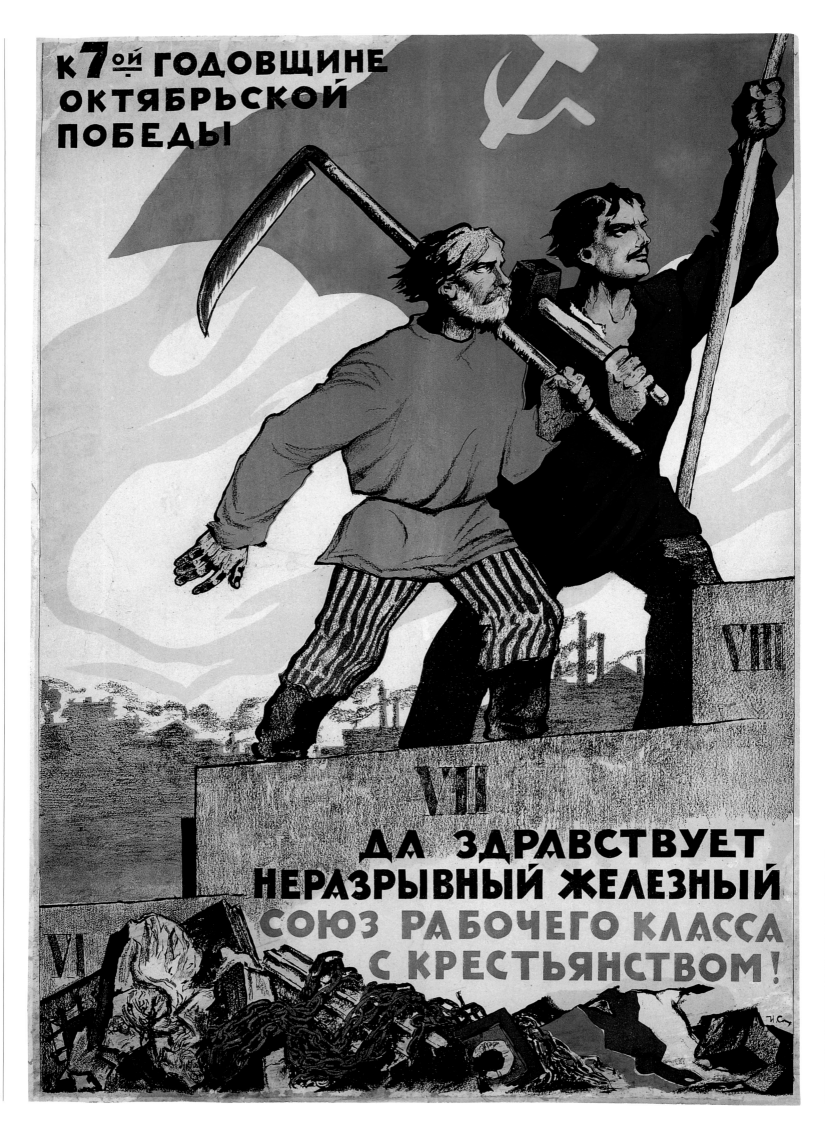

К 7ОЙ ГОДОВЩИНЕ ОКТЯБРЬСКОЙ ПОБЕДЫ

ДА ЗДРАВСТВУЕТ НЕРАЗРЫВНЫЙ ЖЕЛЕЗНЫЙ СОЮЗ РАБОЧЕГО КЛАССА С КРЕСТЬЯНСТВОМ!

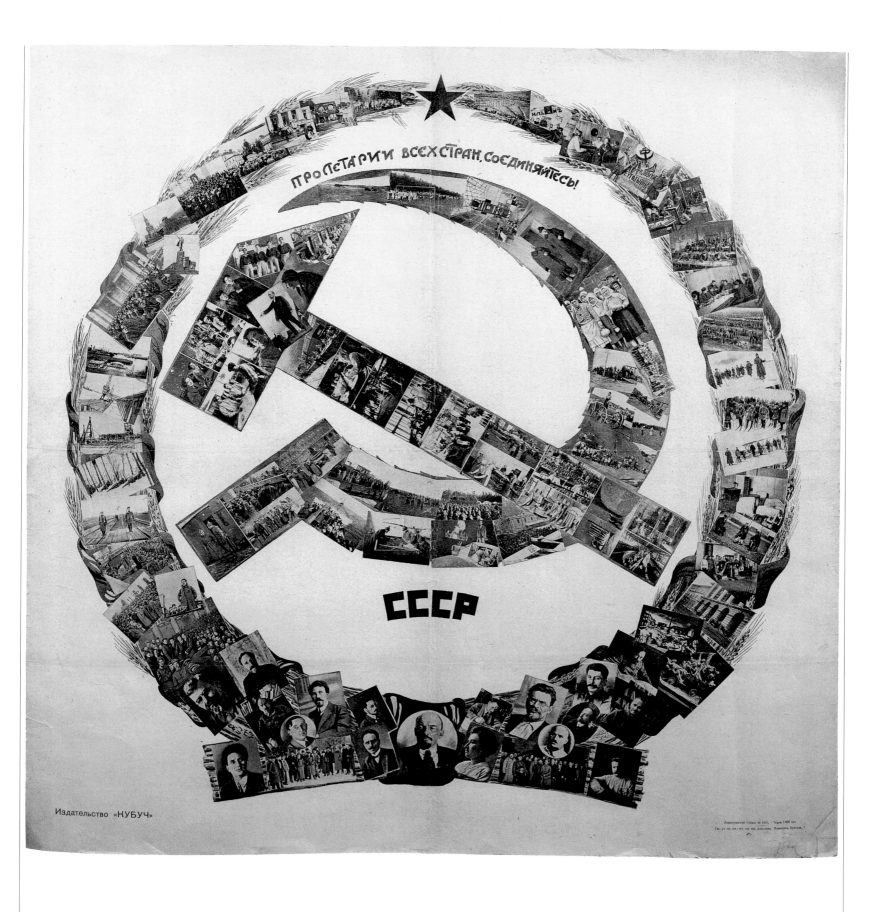

Opposite page: "Long Live the Unshakeable Iron Union of the Working Class and Peasantry!" by Ivan Simakov, published in 1924, "On the Seventh Anniversary of the October Victory".

Above: "SSSR" (USSR – Union of Soviet Socialist Republics). This unusually square format poster with a print run of 1,000 copies was published by Kubuch, a publishing house in Leningrad founded in 1925 by a commission for the improvement of student life.

The USSR was formed in 1922 when the RSFSR (Russian Soviet Federative Socialist Republic) amalgamated with the neighbouring soviet republics of Ukraine, Belorussia and Transcaucasia at the end of the Civil War.

At its height the Soviet Union became the world's largest country, with as many as fifteen constituent republics until dissolution in 1991.

The poster uses portraits of Bolshevik leaders and scenes from the birth of a new civilisation, montaging them into a hammer, sickle and wheatsheaves, an early example of the new state's emblem.

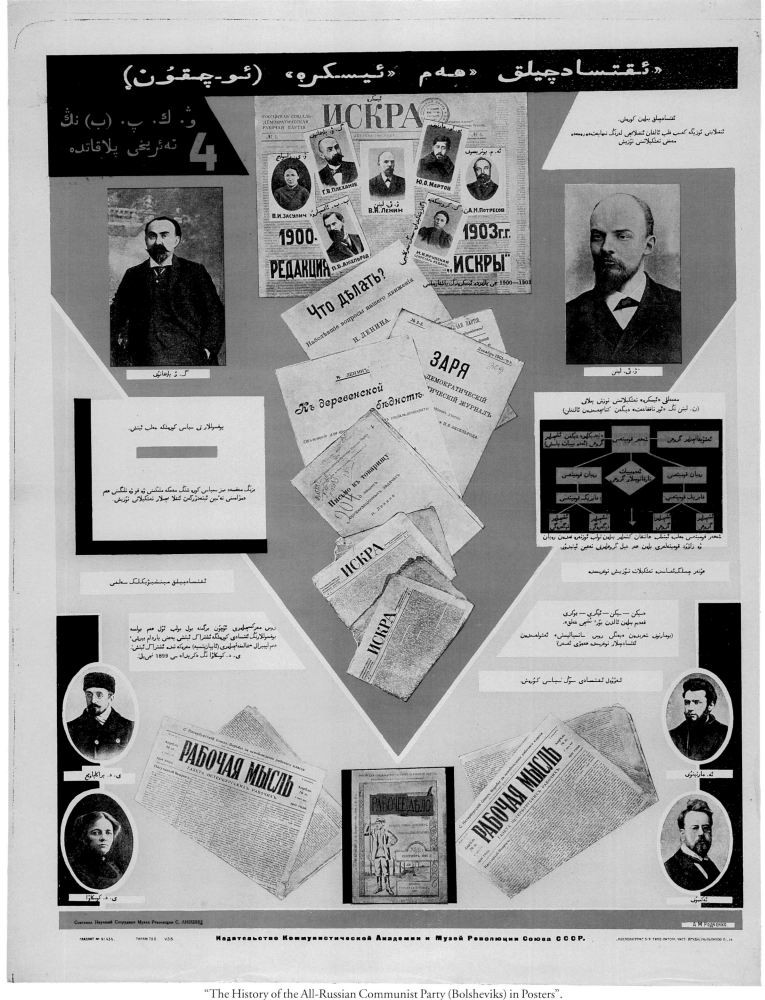

"The History of the All-Russian Communist Party (Bolsheviks) in Posters".
Published by the Communist Academy and the Museum of the Revolution, USSR, 1926 and 1927.
A series of 25 posters telling the story through photographs, graphics and documents. All designed by Alexander Rodchenko. Translated into many languages.
Poster No.4 (in Uzbek) focuses on Vladimir Ulyanov's life in 1901 when he first used his Party name, Lenin.
He wrote for the underground socialist newspaper Iskra and outlined his plans for building a revolutionary party of the working class,
later developed in the essay "What is to be Done?"

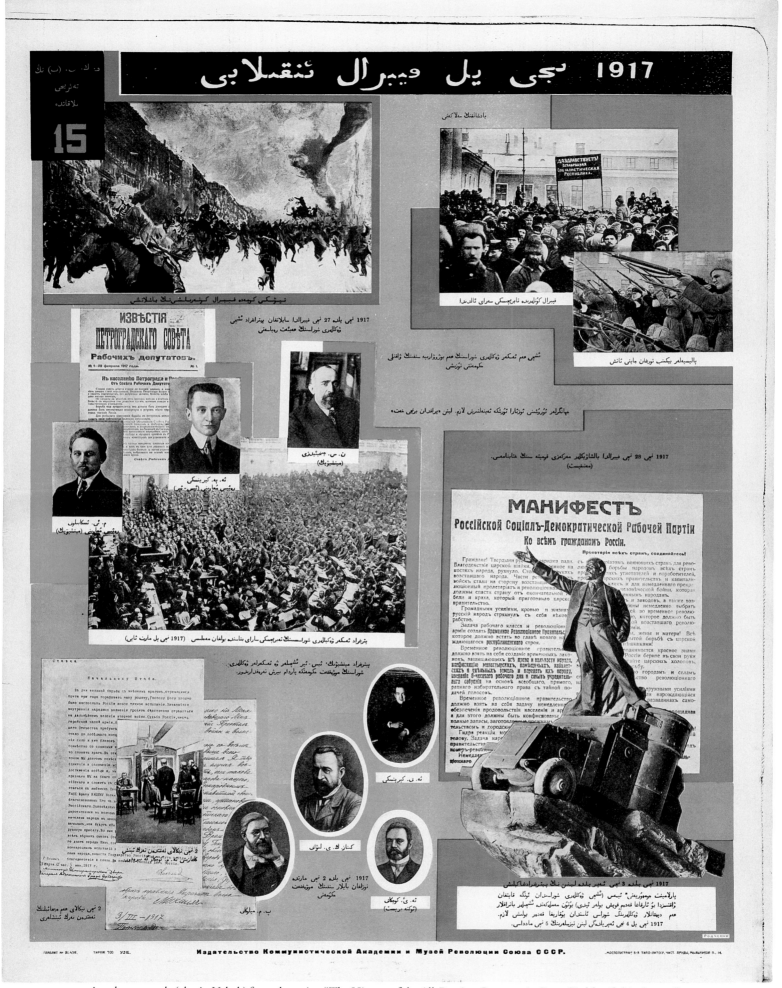

Another example (also in Uzbek) from the series, "The History of the All-Russian Communist Party (Bolsheviks) in Posters".
Poster No.15 documents the February Revolution of 1917 (demonstrations, meetings and portraits of members of the Provisional Government)
and the abdication of Tsar Nicholas II (the document is reproduced lower left).
Also, Lenin's return from exile to the Finland Station in Petrograd on the night of April 16th.
"The worldwide socialist revolution has already dawned!" he tells a rapturous crowd from the top of an armoured car
(a fanciful monument of which can also be seen, lower right in the poster).

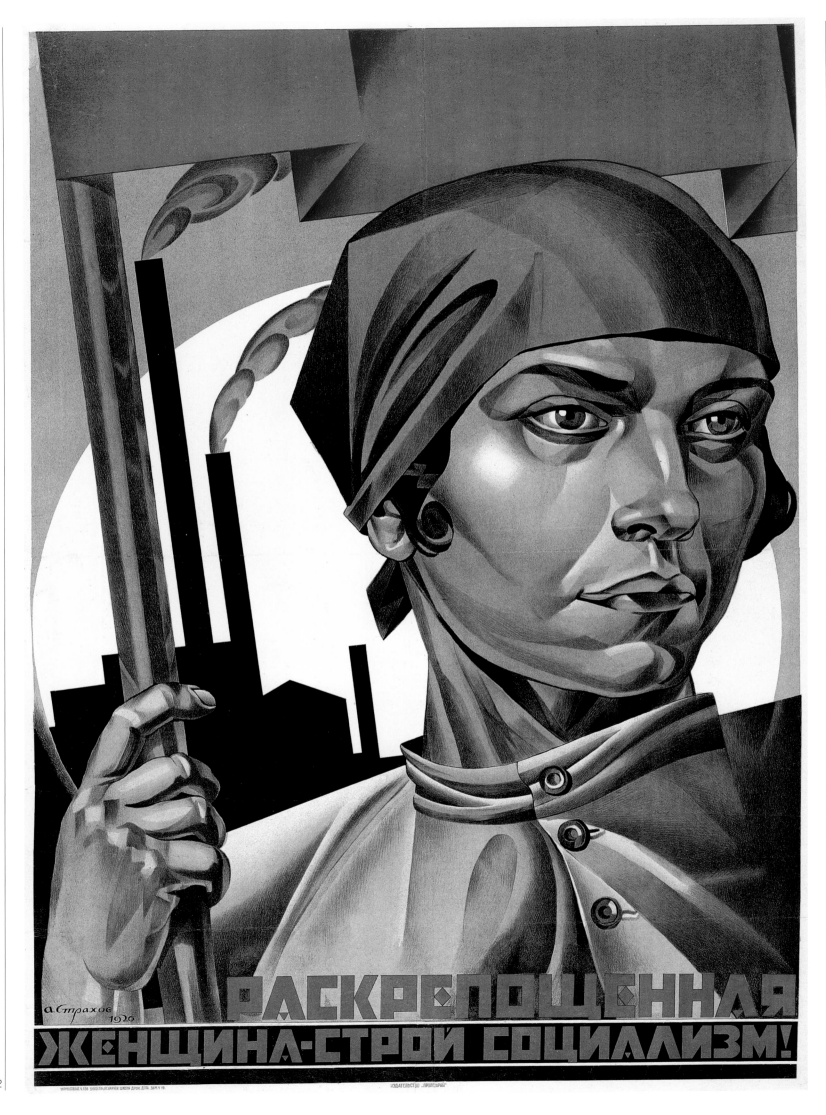

РАСКРЕПОЩЕННАЯ
ЖЕНЩИНА-СТРОЙ СОЦИАЛИЗМ!

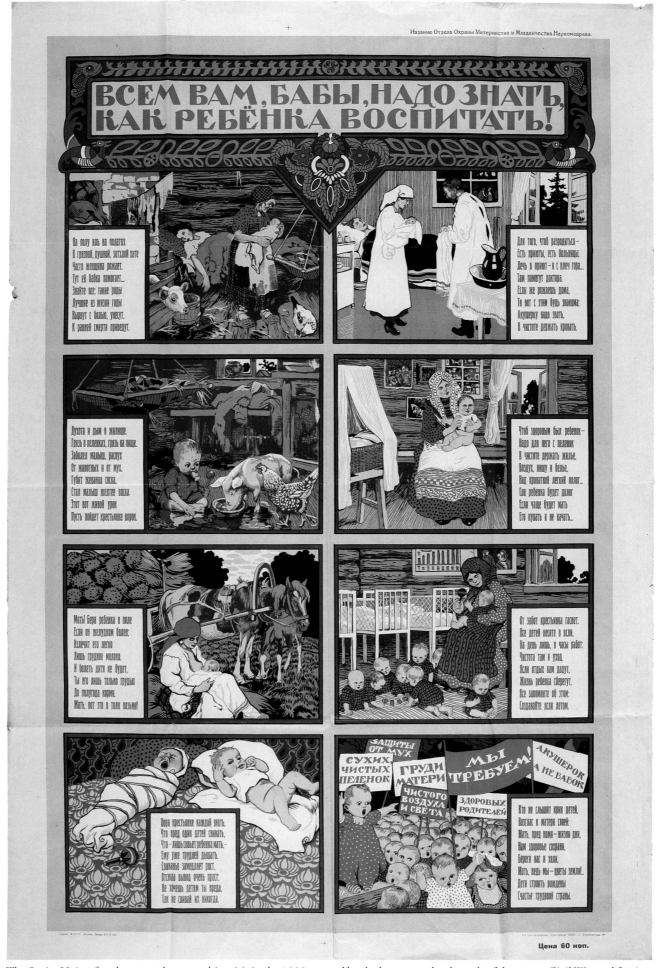

The Soviet Union faced a severe demographic crisis in the 1920s caused by the horrors and upheavals of the recent Civil War and famine. The posters shown here illustrate two of the issues that needed swift resolution.
Opposite page: "The Emancipated Woman is Building Socialism" by Adolf Strakhov-Braslavsky. Kharkov, 1926.
The heroic portrayal of a politicised woman worker, shouldering her equal rights and taking her place in the centre of a new society, firmly endorses the need to increase production in the factories.
Above: "Every Woman Should Know How to Bring up a Child Properly" by Alexei Komarov. Published by the Mother's and Children's Care Division of the People's Commissariat of Public Health, 1925. A poster demonstrating childcare techniques (left hand column bad, right hand column good) for the loving mother to care for her healthy babies and hurriedly increase the debilitated population.

آذپولغرافترېستث حکومت لیتوغرافیاسی

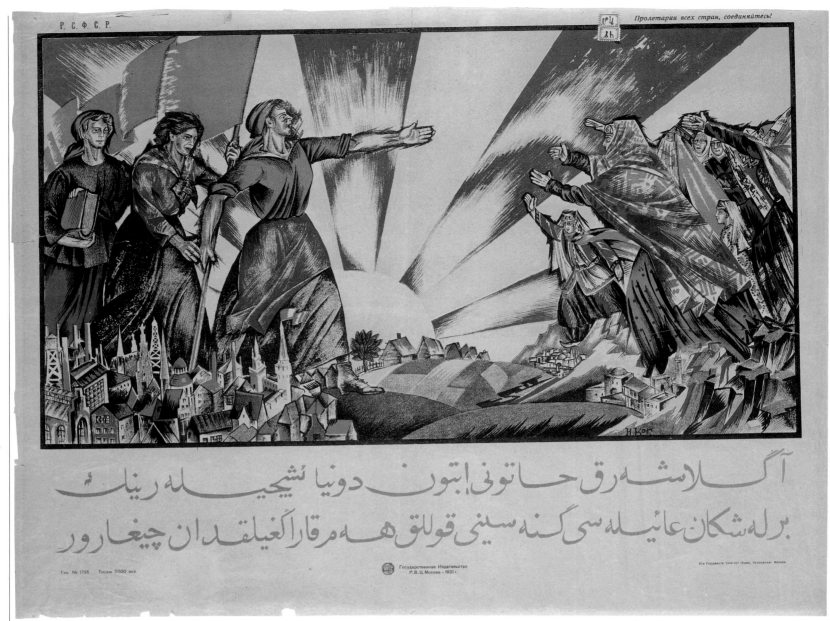

Р.С.Ф.С.Р.

Пролетарии всех стран, соединяйтесь!

آگلاشەرق حاتونی ایتون دونیا ئیچیله رینك
برله شکان عائیله سی کنه سینی قوللق هه مرقار اکغیلقدان چیغارور

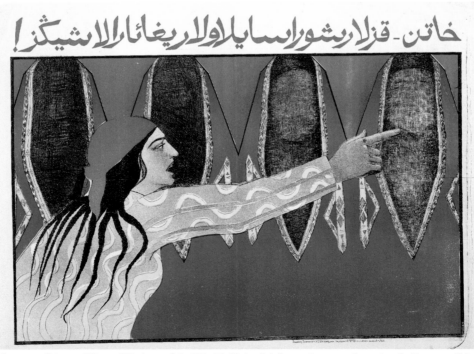

خاتین ۔ قزلار یشورا ساپلاولار یغائار الاشیکز!

Previous page: "The Nightmare of Future Wars – Workers of the World, Unite!" A fantastic poster from Azerbaijan, possibly for the cinema, 1920s.
The text is in Tatar. Artist unknown.
Top: A poster by Nikolai Kochergin published in Moscow, 1921, also in the Tatar language. Muslim women hail the arrival of their Russian sisters
who are offering them liberation through literacy, politics and rolled-up sleeves. The artist's sunrise warmly endorses Soviet power.
Above: "Women! Take Part in the Elections to the Soviets!" An Uzbek poster published in Tashkent in the 1920s.
Note the gradual appearance of a woman's face from behind the veil, a ghostly response to the efforts of the Uzbek agitator in the foreground.
Opposite page: "Tatar Women! Join the Ranks of the Women Workers of Russia. Arm-in-arm with the Proletarian Women of Russia, You will Finally
Break off the Last Shackles". Text in Tatar and Russian. Kazan, 1920s, artist unknown.

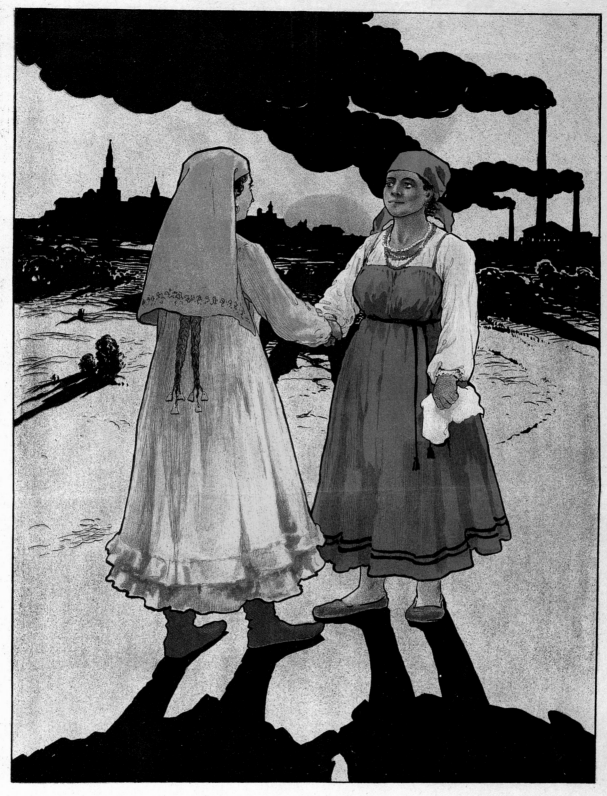

Женщина-татарка! Вступай в ряды всех тру-
жениц Советской России.

Об руку с русскими пролетарками ты разобьешь
последние оковы.

Р. В. Ц.—Казань. Каз. Отд. Госуд. Изд. Напечатано 1000 эк. Лит. 2-й Гос. типографии Казань.

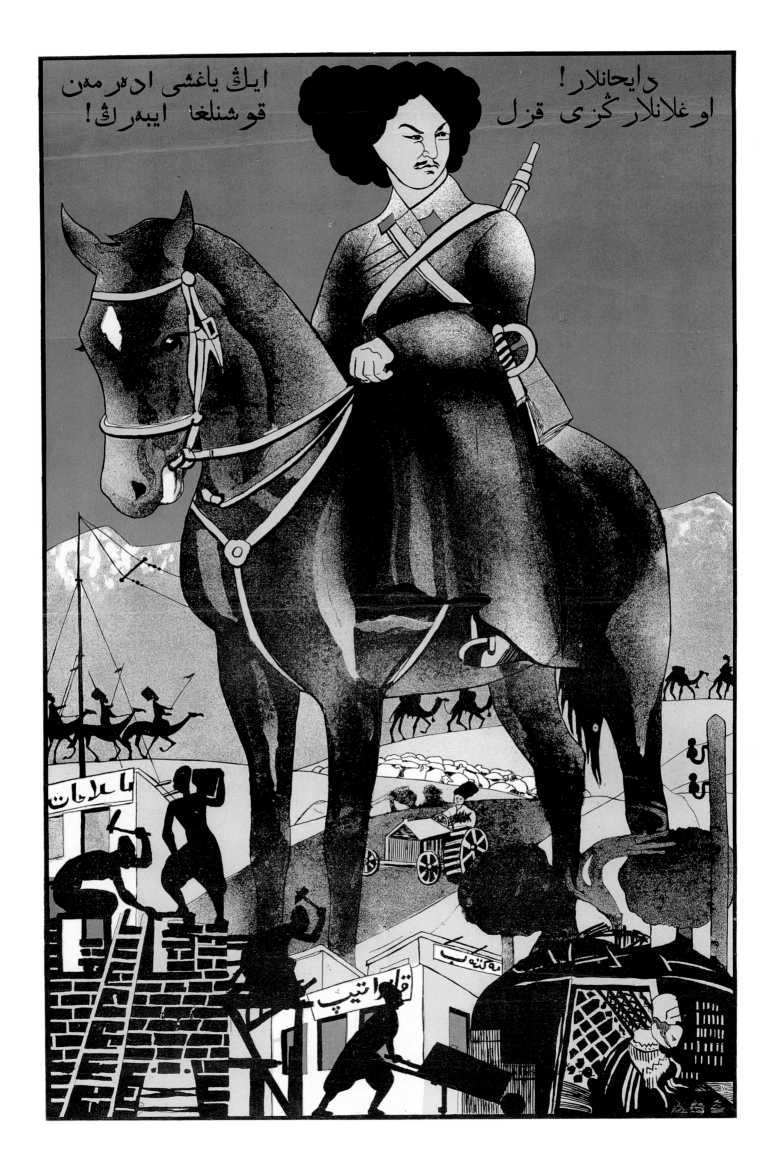

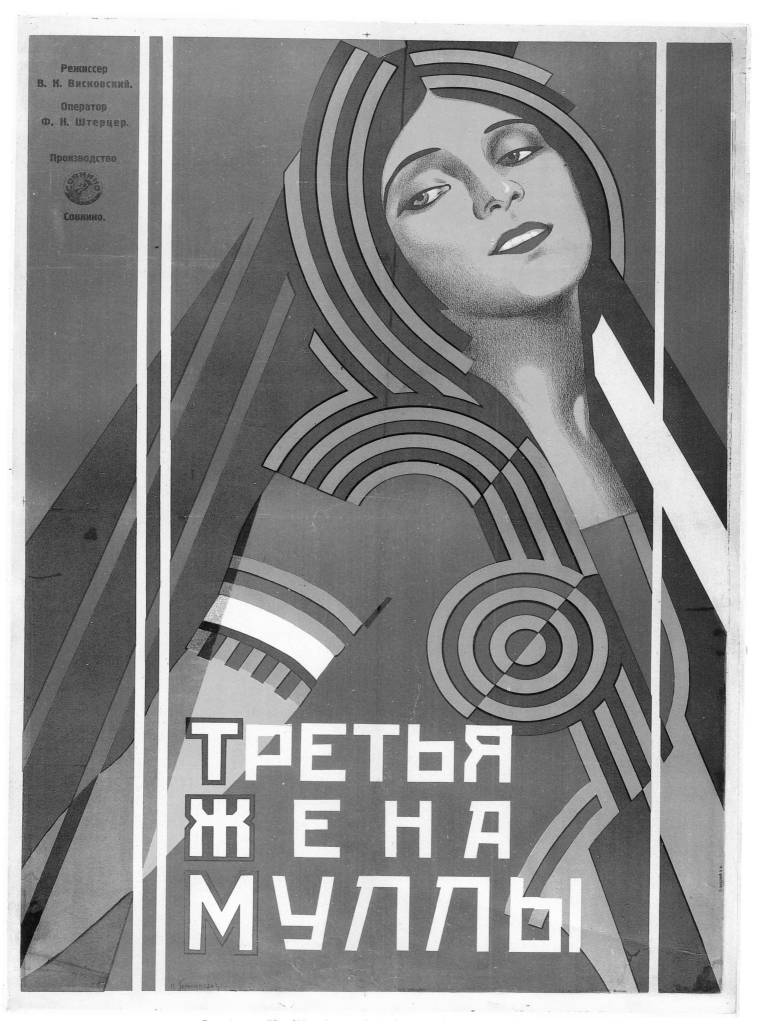

Opposite page: "Send Your Sons to the Red Army – the Best and Foremost".
A beautiful poster by an unknown artist, signed "V.Ch.K", 1920s. Text in Turkman.
Above: "The Mullah's Third Wife". A poster designed by Iosif Gerasimovich for a silent feature film directed by Vyacheslav Viskovsky
in Leningrad for Sovkino in 1928.
The film, long since lost, was a bitter criticism of the lack of freedom for Eastern women.

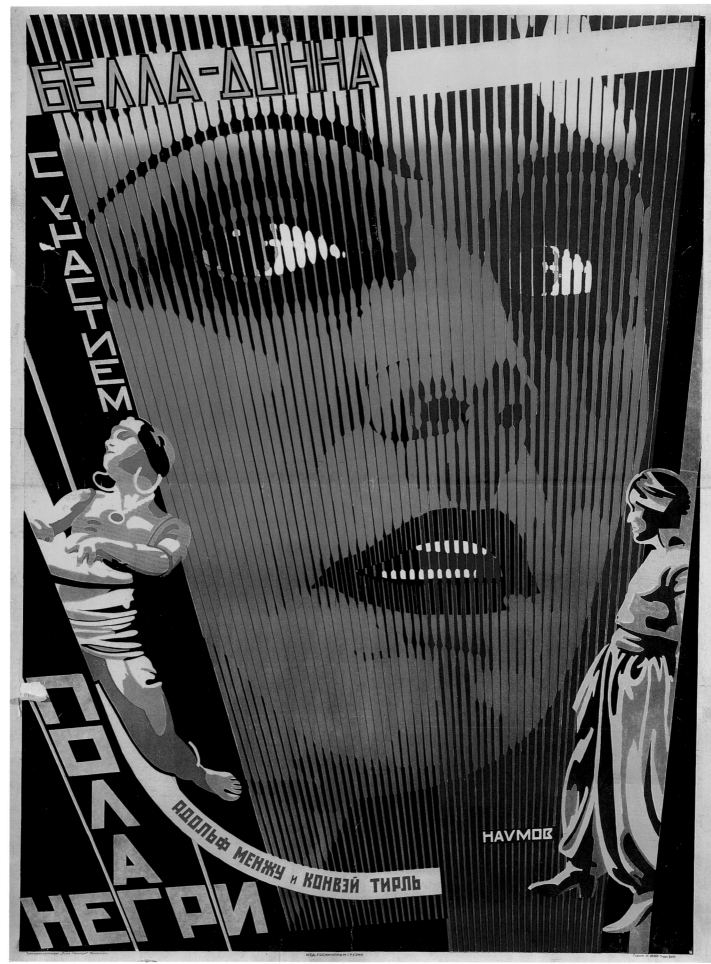

Above: "Bella Donna", Alexander Naumov's glamorous cinema poster, Moscow, 1927.
Foreign films, especially American, were hugely popular with Soviet audiences and their takings at the box office helped subsidise the rapidly expanding Soviet film industry. "Bella Donna" starred Pola Negri, Adolphe Menjou and Conway Tearle. It was directed in the USA by George Fitzmaurice.
Opposite page: "An Everyday Occurrence". Another cinema poster from 1927, this time designed by Georgii and Vladimir Stenberg. The film was directed by Fyodor Otsep at the Sovkino Studios in Moscow, starred Anna Sten, and told a tale of merciless exploitation.
The Stenberg brothers combined theatrically decorative as well as constructivist ideas in their posters along with elements of cinematic montage developed in film by Lev Kuleshov, Dziga Vertov and Sergei Eisenstein. They were praised for their work, even by Dmitrii Moor, who admitted:
"The political photomontage is largely indebted to the cinema poster and to the Stenberg brothers first and foremost".

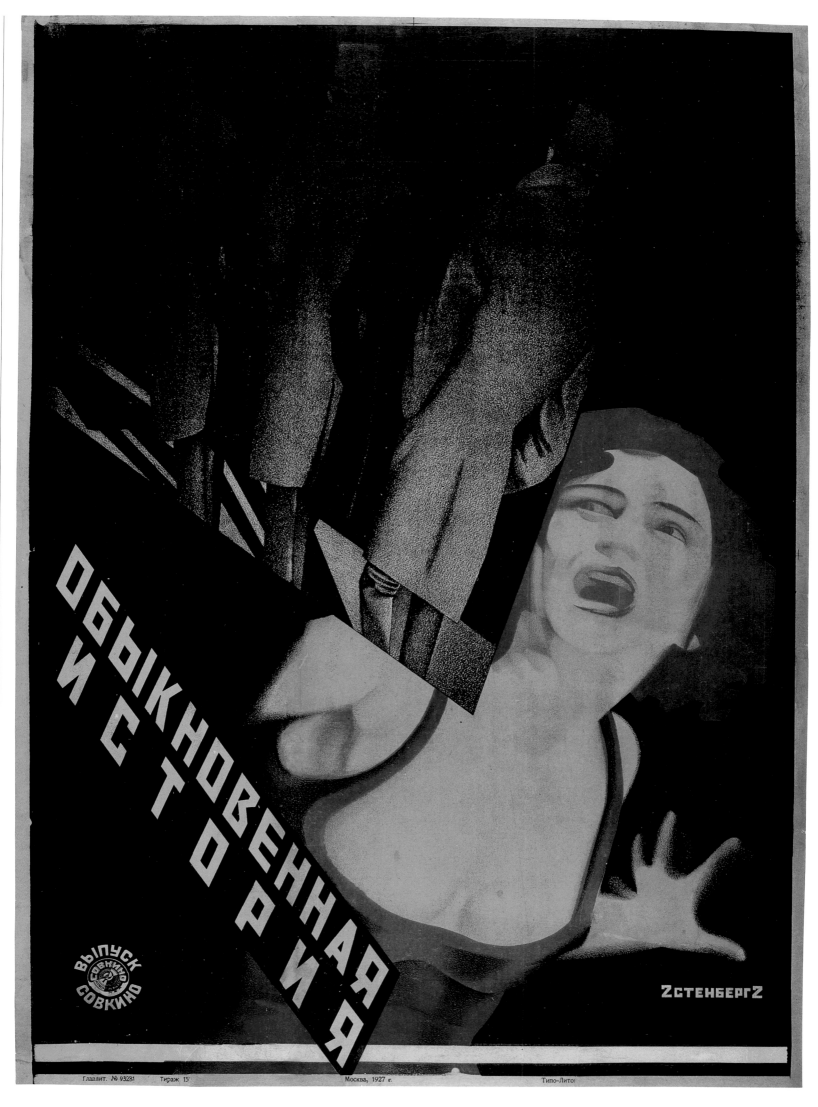

ОБЫКНОВЕННАЯ ИСТОРИЯ

Выпуск СОВКИНО

2СТЕНБЕРГ2

Главлит. № 93281 Тираж 15' Москва, 1927 г. Типо-Лито

71

VIVE LA COOPÉRATION OUVRIÈRE !

ES LEBE DIE ARBEITER-KONSUMGENOSSENSCHAFT-BEWEGUNG!

МЕЖДУНАРОДНЫЙ ДЕНЬ КООПЕРАЦИИ

КООПЕРАЦИЯ СССР

В МЕЖДУНАРОДНЫЙ ДЕНЬ КООПЕРАЦИИ УКРЕПИМ СВЯЗЬ СОВЕТСКОЙ КООПЕРАЦИИ С РАБОЧЕЙ КООПЕРАЦИЕЙ ВО ВСЕМ МИРЕ

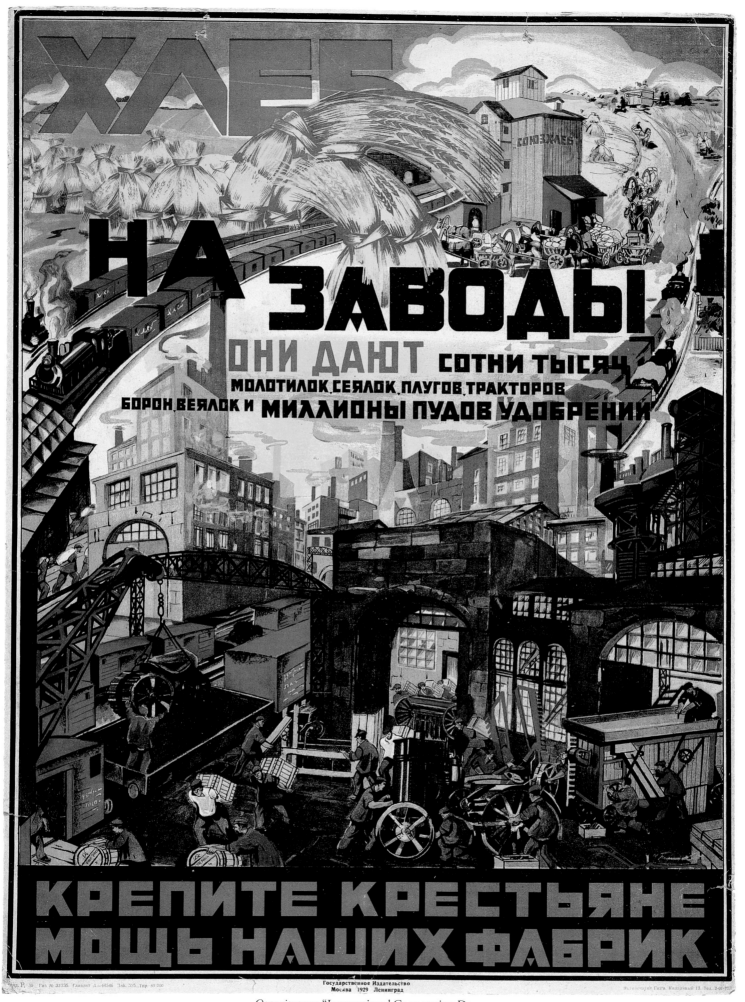

Opposite page: "International Cooperation Day:
Let us strengthen the link between Soviet cooperatives and workers' cooperatives all over the world".
Artist unknown, Moscow, 1929. The poster features a rough approximation of architect Ilya Golosov's constructivist Zuev Workers' Club,
unveiled the same year. International Cooperation Day came into being on July 5th, 1923 as part of an attempt by the Soviets to replace the peasants' Christian festivals.
Above: "Bread to the Factories – They produce hundreds of thousands of harvesters, seeders, ploughs, tractors, harrows and tonnes of fertilizer –
Peasants Strengthen the Power of our Factories". Poster by Nikolai Kogout, Moscow/Leningrad, 1929.

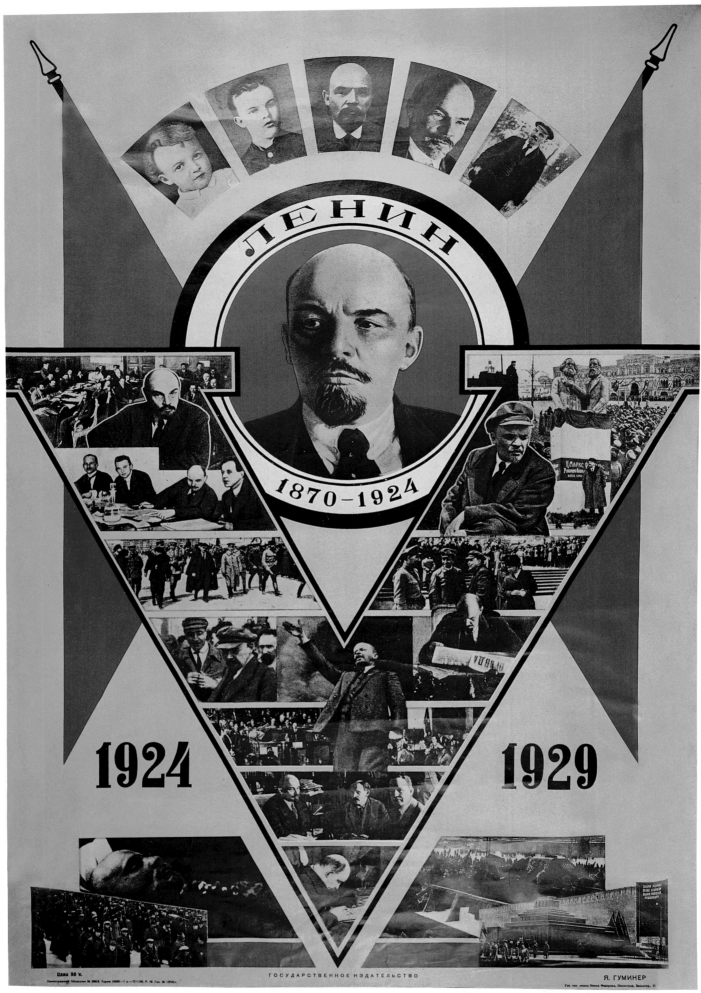

Above: A poster by Iakov Guminer published in 1929 commemorating the fifth anniversary of Lenin's death.
Opposite page: "The Path of Lenin is the Path of Revolution". Another Lenin Cult poster, signed "Mor". Published Moscow/Leningrad in 1931.
The design follows the pictorial organisation of the traditional Orthodox church icon,
telling the story of the Bolshevik leader's life through images presented from left to right from the top down.
Lenin wrote that the belief in any sort of god is "necrophilia" and he would have cursed Stalin's campaign to immortilise him
posthumously as the great god of Communism.

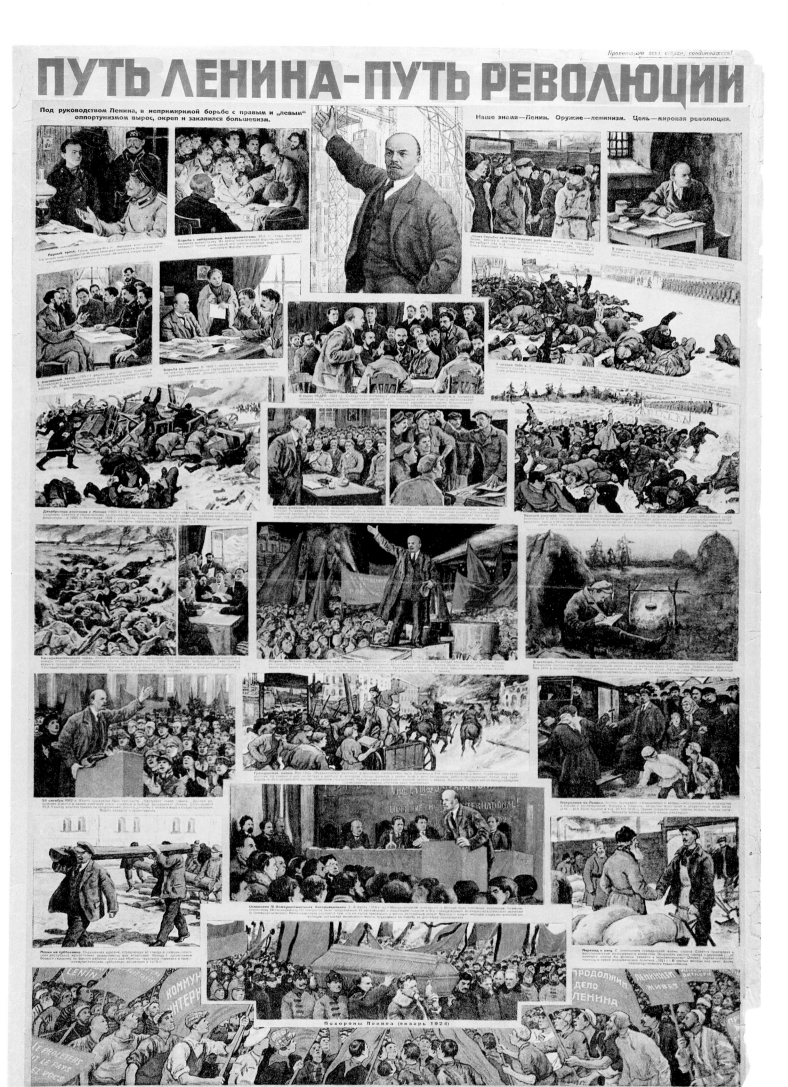

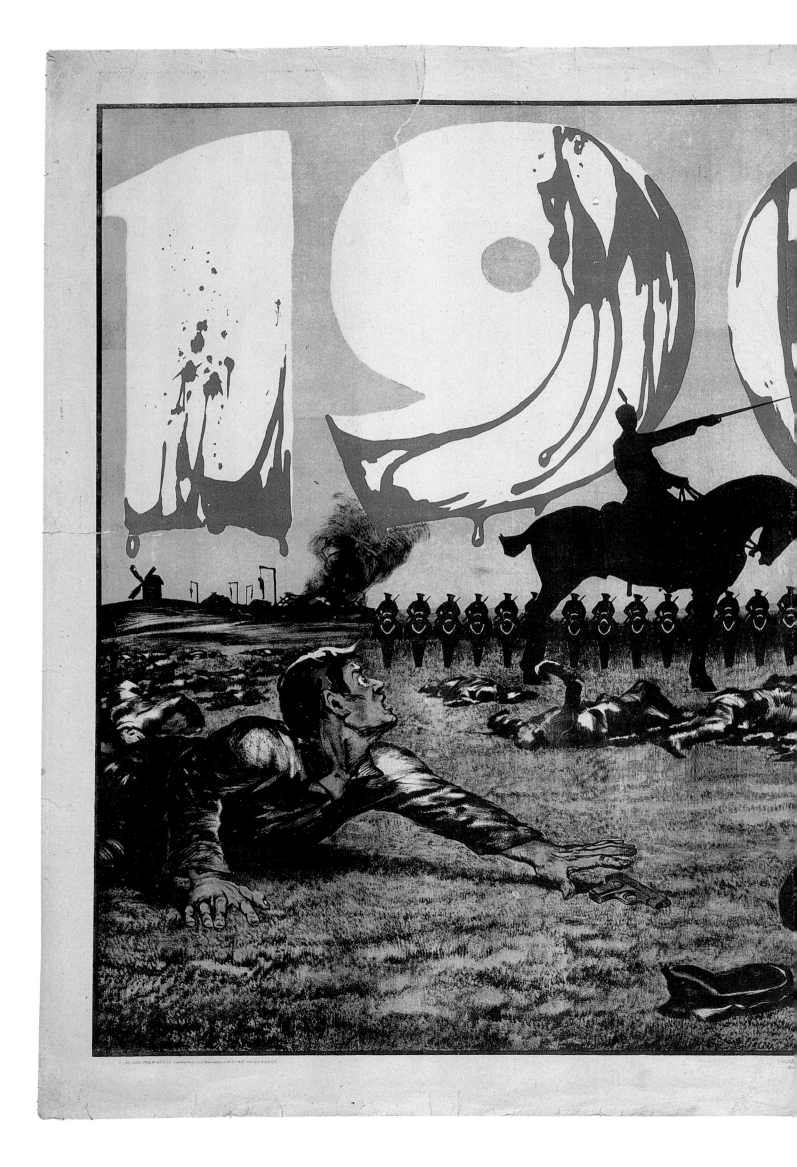

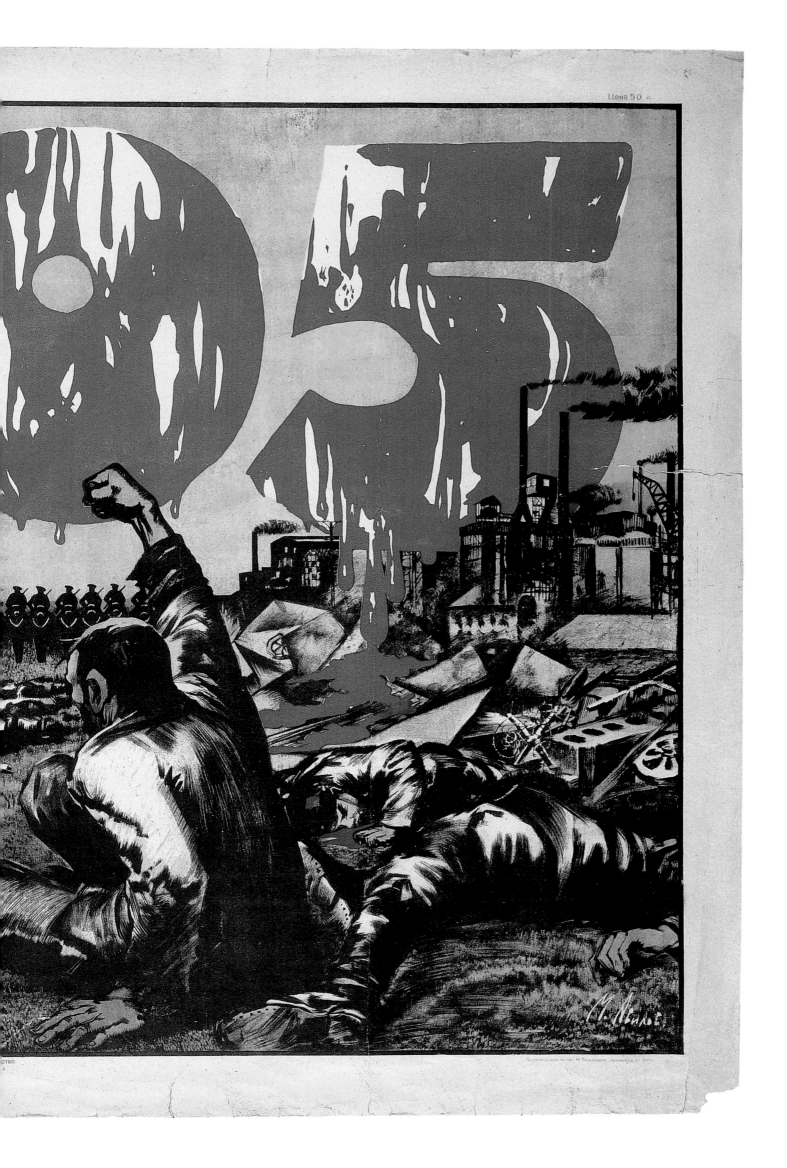

Цена 50 к

77

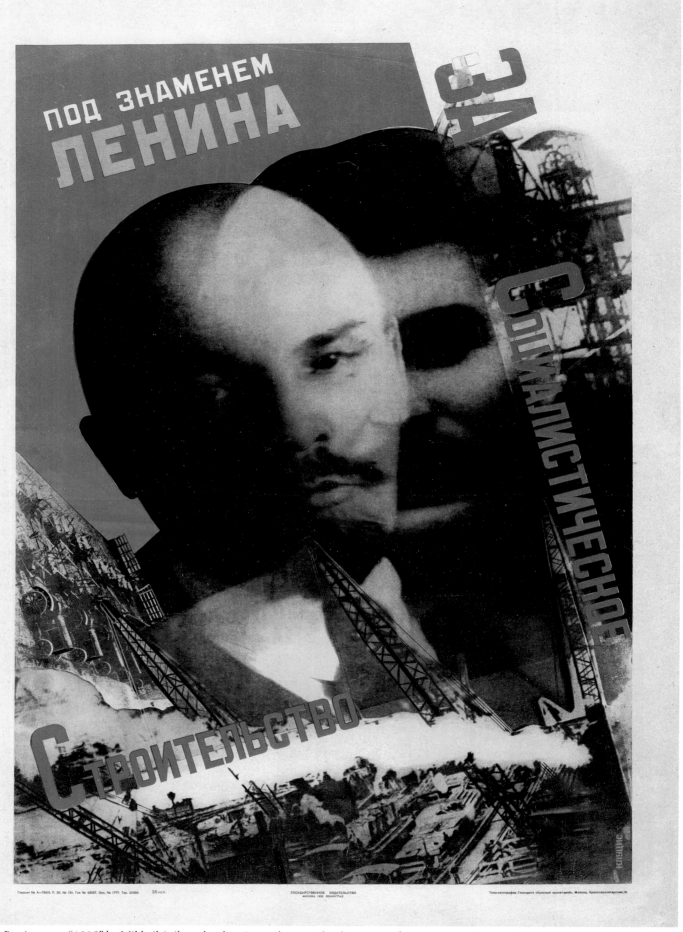

Previous page: "1905" by Mikhail Avilov, a battle painter who specialised in scenes of contemporary history. Moscow/Leningrad, 1930.
The outbreak of the 1905 Revolution, known as Bloody Sunday, took place on January 9th of that year.
Avilov's poster, a forerunner to the Hollywood epic style of the 1950s, employs artistic licence in transposing the Tsar's massacre of a peaceful demonstration from the streets and squares of Saint Petersburg to an open battlefield.

Above: "Under the Banner of Lenin for Socialist Construction". A 1930 photomontage poster by Gustav Klutsis. It is surprising that the sinister spectre of Stalin's shadowy face, looming menacingly behind an unsuspecting Lenin, went unnoticed by the censors.

Opposite page: "The USSR is the Shockworkers' Brigade of the World Proletariat". A 1931 photomontage poster by Gustav Klutsis showing Stalin's Politburo in the forefront of the world's workers. Front row, left to right: Voroshilov, Molotov, Stalin, Kaganovich, Ordzhonikidze.
Second row: Kalinin, Kuibyshev, Rudzutak, Kossior, Kirov. Third row, centre: Andreev.
As the decade progressed, Kirov would be assassinated, Rudzutak and Kossior shot by the secret police and Ordzhonikidze commit suicide.

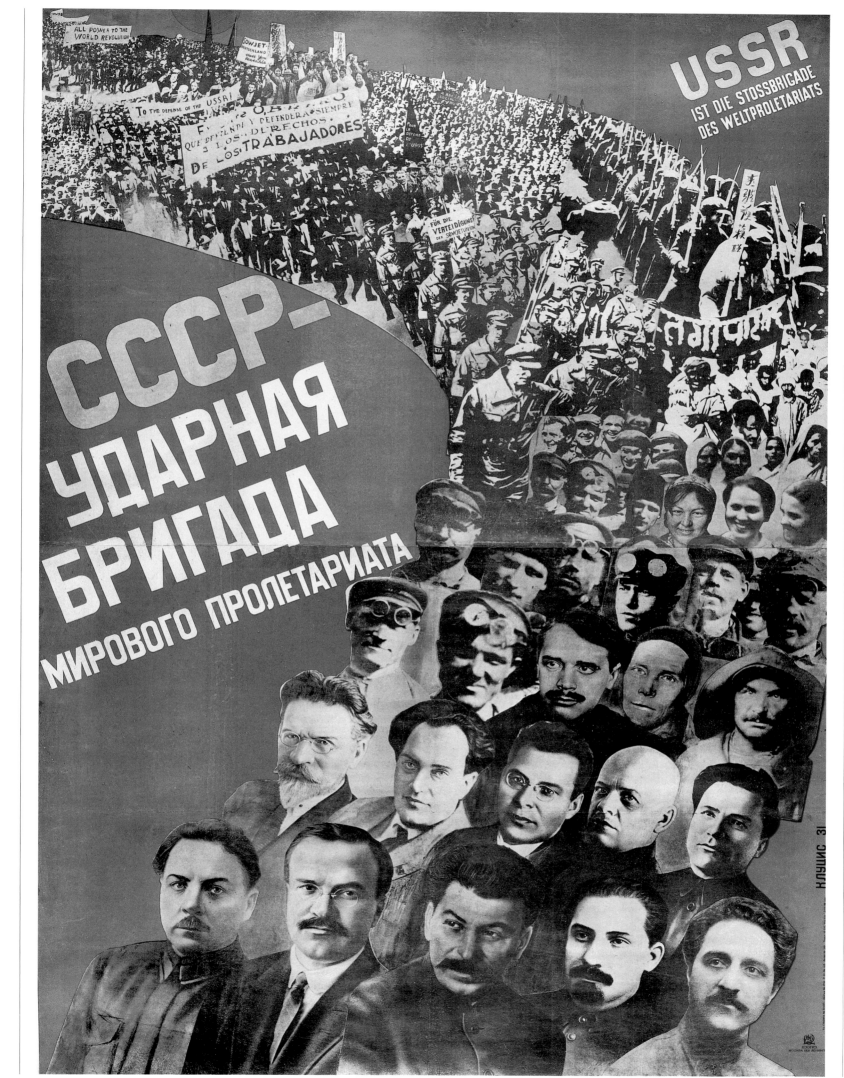

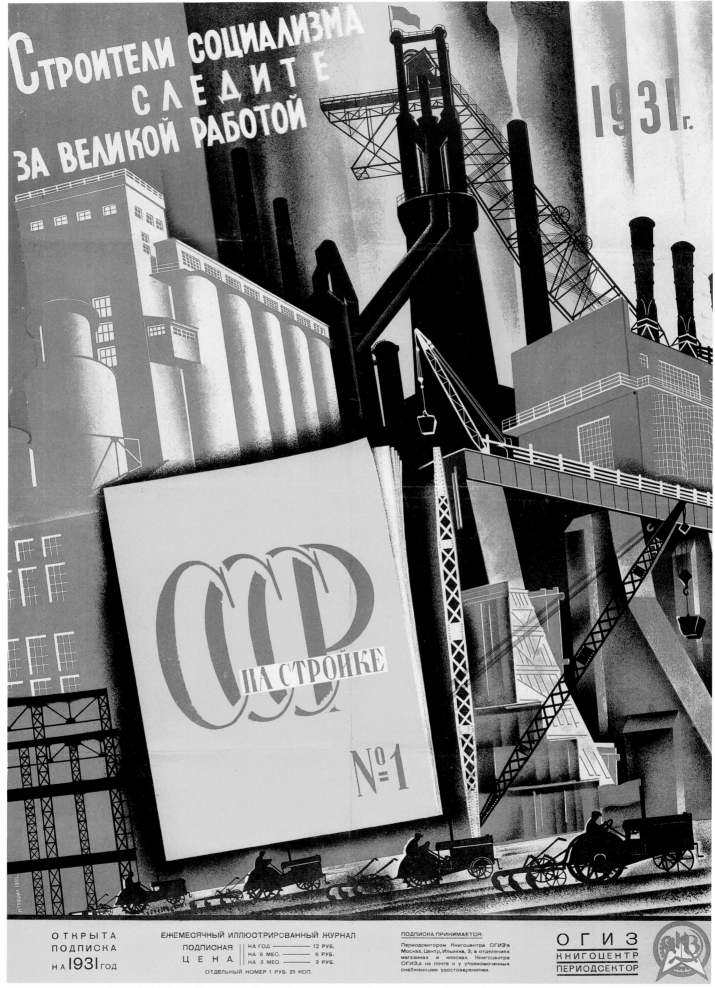

Above: "Builders of Socialism, Get the Latest News on the Great Project! USSR in Construction for 1931".
A poster designed by Nikolai Troshin who was also the resident art director of this ground-breaking photo-graphics magazine. An early graduate of Vkhutemas art school, he studied under the fauvist painter Ilya Mashkov, and was a close friend of El Lissitzky, who designed many of the greatest issues of the magazine.
Opposite page: "We are Building a Fleet of Airships in the Name of Lenin", designed in 1931 by Georgii Kibardin, another graduate of Ilya Mashkov's Vkhutemas studio.
The poster uses the Latinised alphabet, known as Janalif, in place of Arabic script.
It was imposed on all Turkic languages including Uzbek, Azerbaijan and Tatar until 1940, when it was replaced by a Cyrillic version.

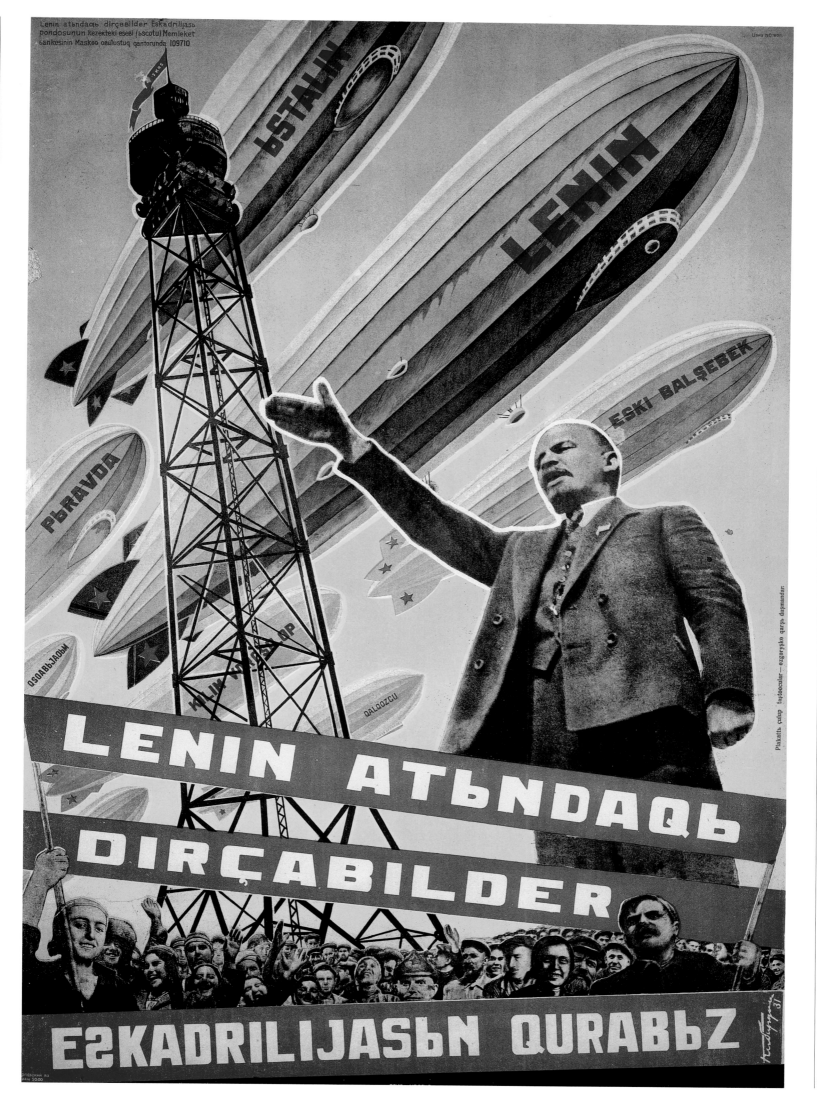

81

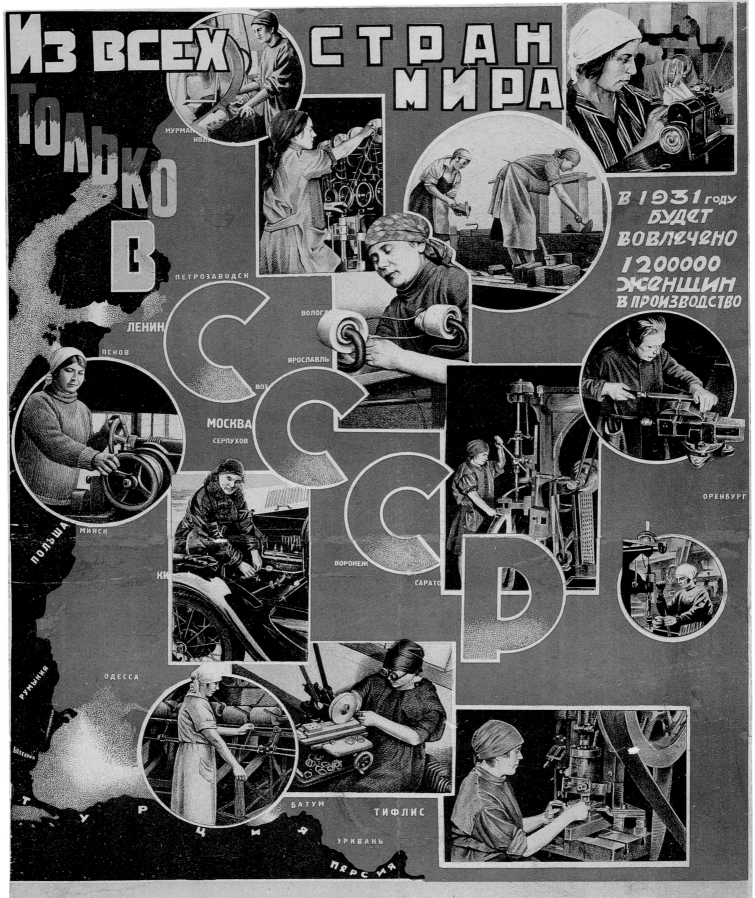

Из всех стран мира только в СССР

В 1931 году будет вовлечено 1200000 женщин в производство

"БОЛЬШЕВИСТСКАЯ СОВЕТСКАЯ РЕВОЛЮЦИЯ ПОДРЕЗЫВАЕТ КОРНИ УГНЕТЕНИЯ И НЕРАВЕНСТВА ЖЕНЩИН ТАК ГЛУБОКО, КАК НЕ ДЕРЗАЛА ПОДРЕЗАТЬ ИХ НИ ОДНА ПАРТИЯ И НИ ОДНА РЕВОЛЮЦИЯ В МИРЕ"

/ЛЕНИН./

Издательство НАРКОМСОБЕС Москва 1931 г.

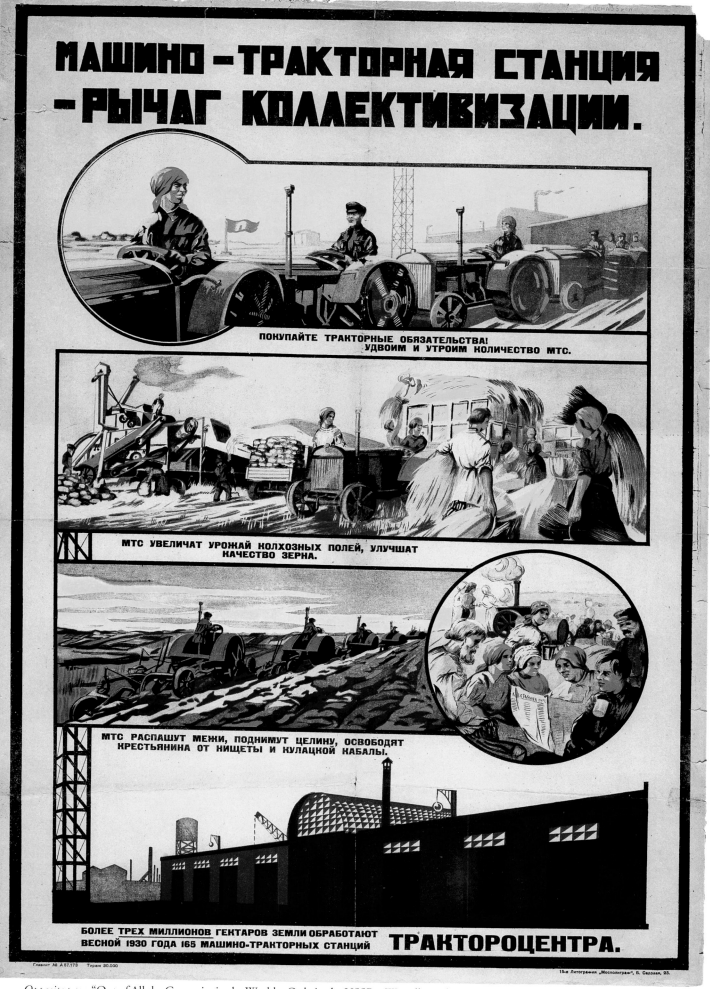

Opposite page: "Out of All the Countries in the World – Only in the USSR – We will Involve 1,200,000 Women in Production in 1931".
Moscow, 1931. Designer unknown. At the base of the poster, a quote from an International Women's Day speech by Lenin: "The Soviet Bolshevik Revolution cut the roots of oppression and female inequality more deeply than ever previously dared by any party or revolution in the world".
Above: "The Machine-Tractor Station is the Linchpin of Collectivisation. Get a Tractor! Let's Double and Triple the MTS". Artist unknown, circa 1930.
Machine-Tractor Stations were first set up in 1929 in the countryside as marshalling yards for the maintenance and distribution of agricultural machinery at the start of Stalin's notorious campaign of collectivisation.

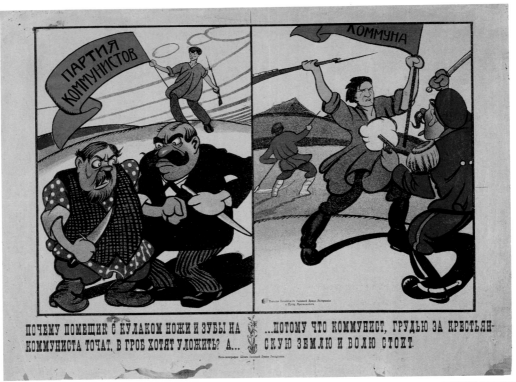

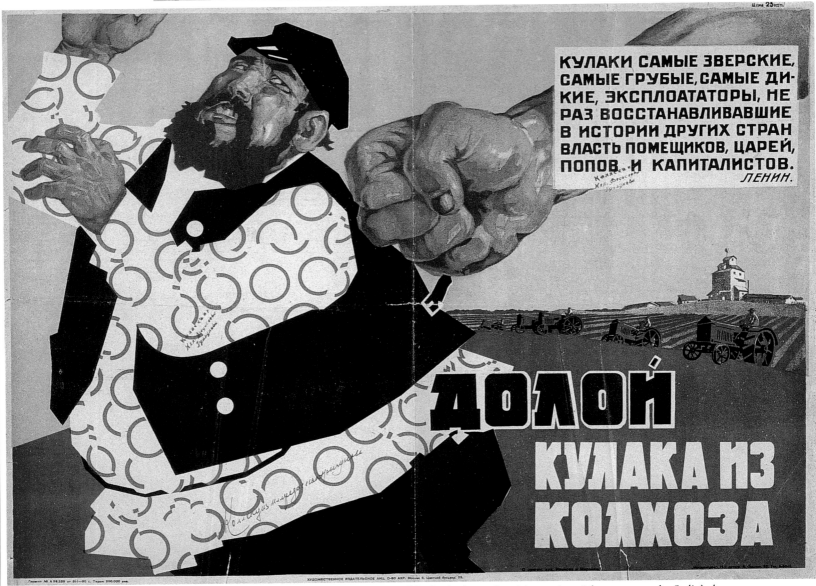

Above: "Bash the Kulak off the Kolkhoz". A poster from 1930, part of the Soviets' war of attrition against rich peasants under Stalin's slogan, "Liquidate the Kulaks as a Class". The poster features a boxed quote from Lenin: "Kulaks are the most beastly, most brutal and most savage exploiters. In the history of other countries they were often responsible for bringing the landlords, tsars, priests and capitalists back to power".

Wealthy farmers had been targeted, blamed, arrested and executed as early as 1918, during the period of forced requisitioning.

Top: A Volga District poster circa 1919 states the Bolshevik case: "Why are the landlord and kulak sharpening their knives? Why do they want to dig a grave for a communist? Because a communist will protect a peasant's life and freedom to the death!"

Opposite page: The lightning bolt spells out "GPU" (Stalin's secret police) and the headline reads "Counter-revolutionary Wrecker".

Viktor Deni draws Mayakovsky's vision of "the face of a class enemy" in this poster from 1930.

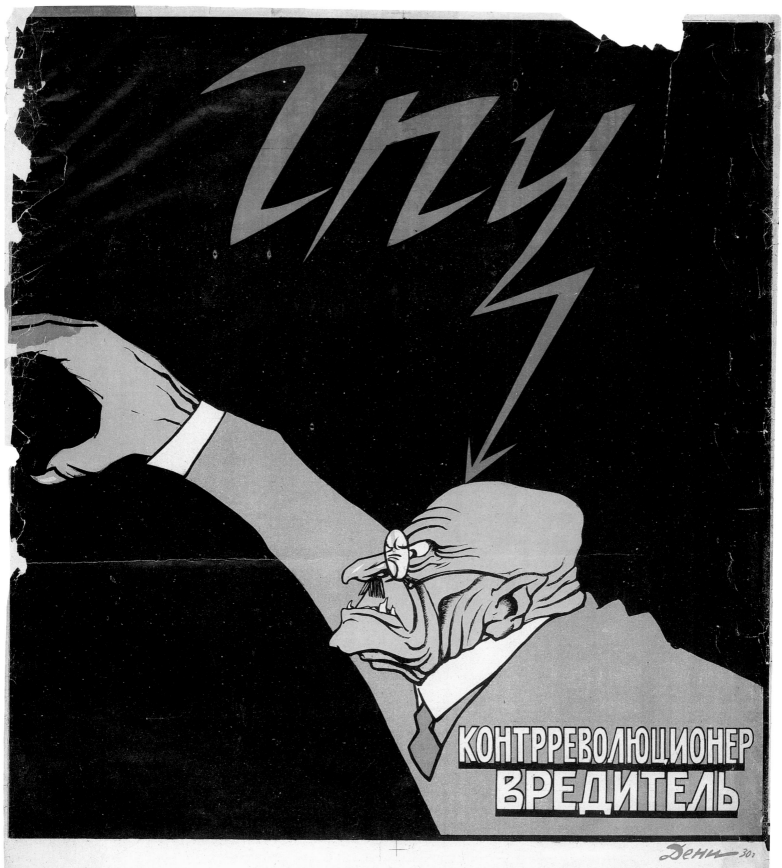

ГПУ

КОНТРРЕВОЛЮЦИОНЕР
ВРЕДИТЕЛЬ

Дени 30г

РЕВОЛЮЦИОННАЯ МОЛНИЯ.

Сверкает хищный глаз. Оскалены клыки.
Последний, острый взмах вредительской руки.
И—нет вредителя! Его настигла кара.

Его пронзила и сожгла
Неотразимая стрела
Молниеносного удара!

Знай, враг, шагающий к вредительской меже:
НАШ ЧАСОВОЙ—НАСТОРОЖЕ!

Демьян Бедный.

ГОСУДАРСТВЕННОЕ ИЗДАТЕЛЬСТВО
Москва 1930 Ленинград

Цена 30 коп.

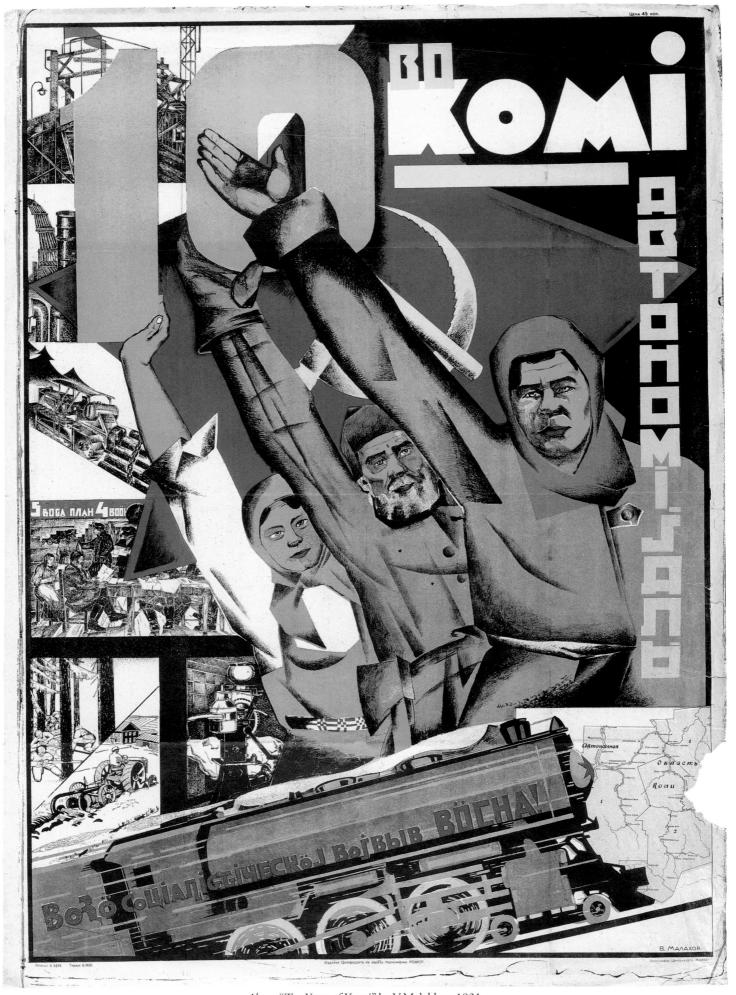

Above: "Ten Years of Komi" by V.Malakhov, 1931.
The poster celebrates the vast autonomous region in north east Russia, an area rich in oil, coal and wood, and home
to an infamous network of Stalin-era Gulags including Ukhtapechorlag, Sevlag and Vorkuta.
Opposite page: "Everybody Sign up as a Shockworker" by V.D.Gushchin, 1932.
The rectangles of colour in the poster are for workers to fill in their names and addresses to apply for the toughest and most urgent jobs
in Soviet industry. Later they became known as Stakhanovites after the legendary Donbass miner, Alexei Stakhanov.

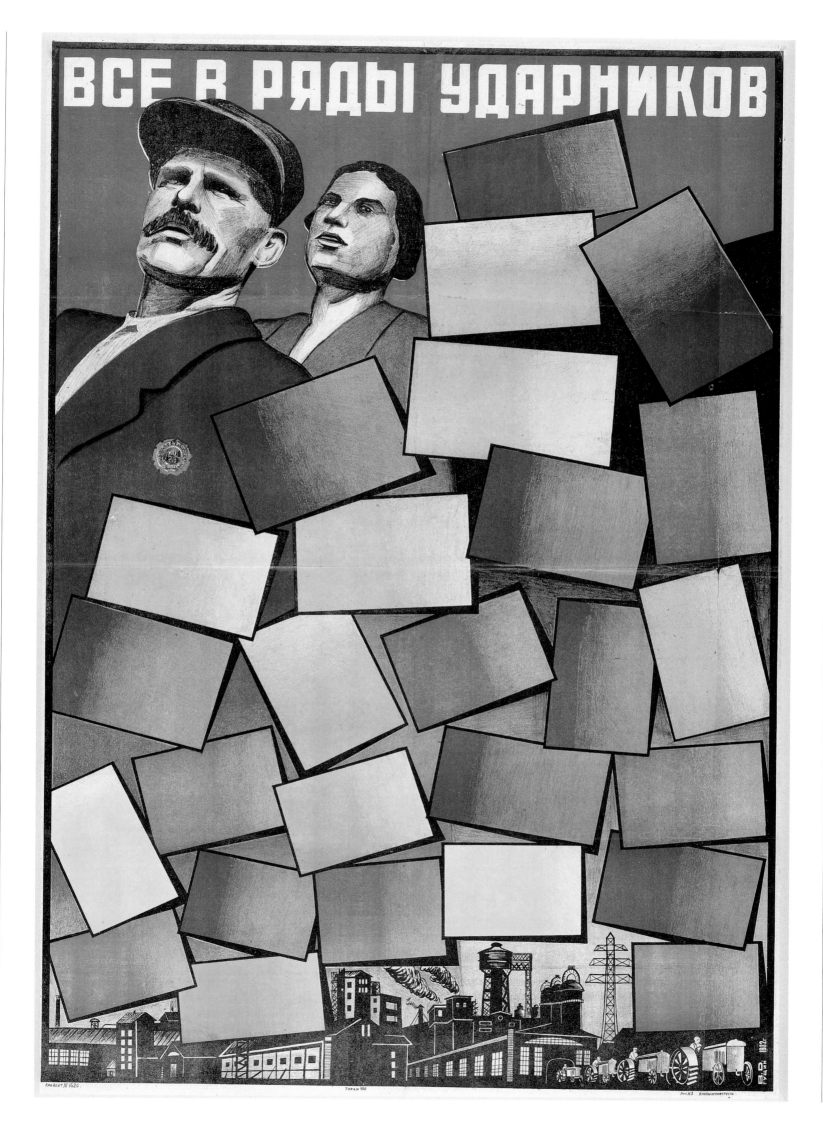

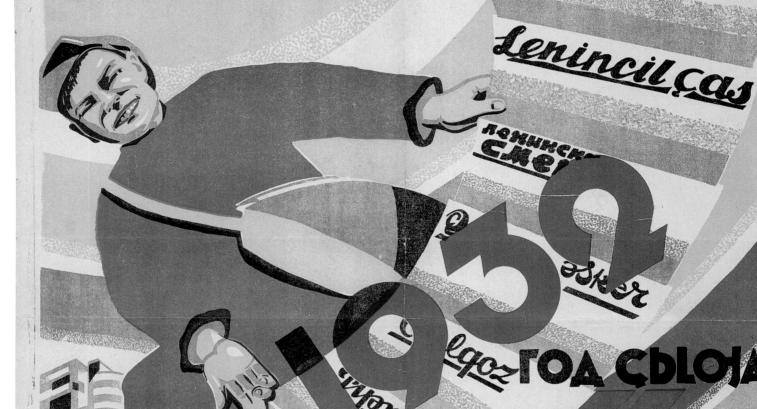

KƏZETKE ÇAZЬL

ПОДПИШИСЬ на ГАЗЕТЫ

Еnвексі qazaq.

советская степь

Lenincil ças

ленинская смена

əsker

eqoz ГОД СЬLОЈА

пионер

ПОДПИСКА
ПРИНИМАЕТСЯ
РАЙБЮРО „СОЮЗПЕЧАТИ"
ПОЧТОВЫМИ предприят.
ГАЗЕТОНОСЦАМИ
ПИСЬМОНОСЦАМИ и
КИОСКАМИ по всему
КАЗАХСТАНУ

QAZAQЬSTAN KөLEMINDEGI
„SAJOZPEÇƏT"AVDANDЬQ
BUJRASЬNDA
POÇTA ORЬNDARЬNDA
KƏZET TASUVÇЬLARDA
QATTASUVÇЬLARDA GƏNƏ
KIJOSKILERDE
ÇAZЬLUVGA BOLADЬ

Алма-Ата Географтография КУСНХ № 2 завод № 401 З заказ № 136 тираж 1000

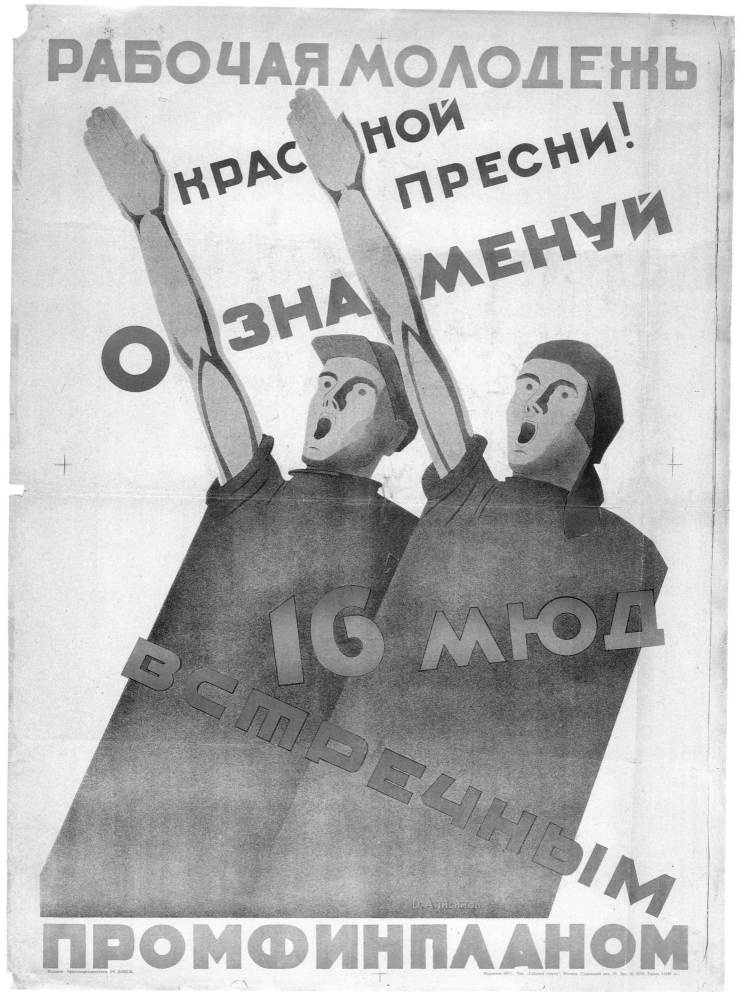

РАБОЧАЯ МОЛОДЕЖЬ
КРАСНОЙ ПРЕСНИ!
О ЗНАМЕНУЙ
16 МЮД
ВСТРЕЧНЫМ
ПРОМФИНПЛАНОМ

Opposite page: "Buy a Postal Subscription for your Newspapers in 1932", an unsigned poster from the Kazakhstan Republic.
The Kazakh population suffered a series of terrible famines between 1931 and 1933 which claimed over one million lives. The causes were Stalin's ruthless policy of collectivisation (as in Ukraine at the same time) and the forced settlement of this largely nomadic nation of shepherds.
All news of these appalling events, often described as genocide, suffered blanket censorship during the Stalinist period and for many years beyond.
Above: "Working Youth of Red Presnya! Let's Celebrate Sixteenth International Youth Day with the Industrial-Financial Counter-Plan".
Dmitrii Anisimov's poster was published by the Komsomol (Communist Youth League) of the Red Presnya district of Moscow in 1930.

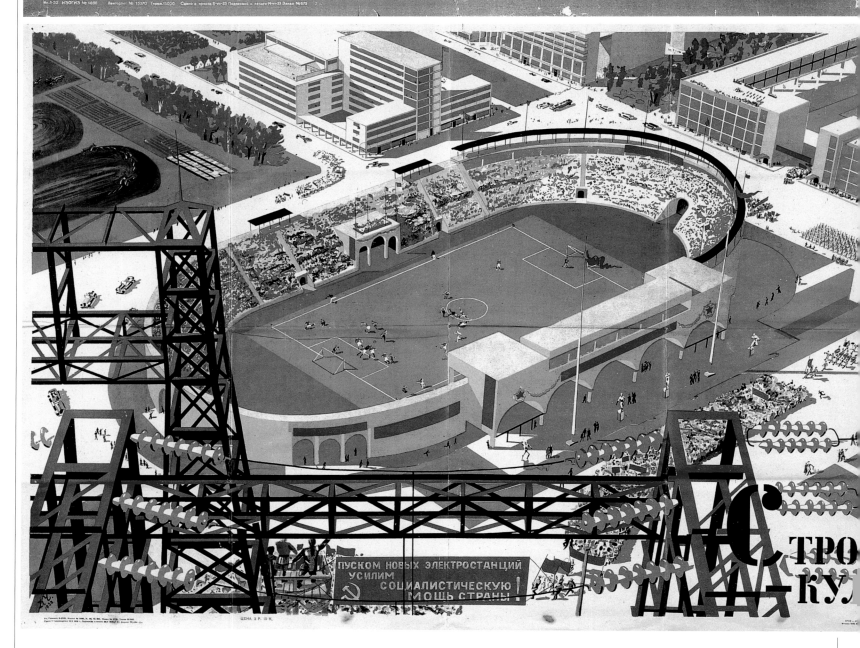

Above: "For the Builders of a Socialist Industry – Culturally Socialist Cities".
A poster by Daniil Cherkes, a film maker and animator. Moscow, 1932.
Cherkes' vision of a utopian garden city includes a 30,000 seat stadium, communal apartment blocks with balconies and terraces,
public squares and gardens with fountains, and a transport system of cars, boats, trains and trams.
The power station's banner reads: "With the Launch of New Power Stations We Will Strengthen Socialist Power across the Country!"

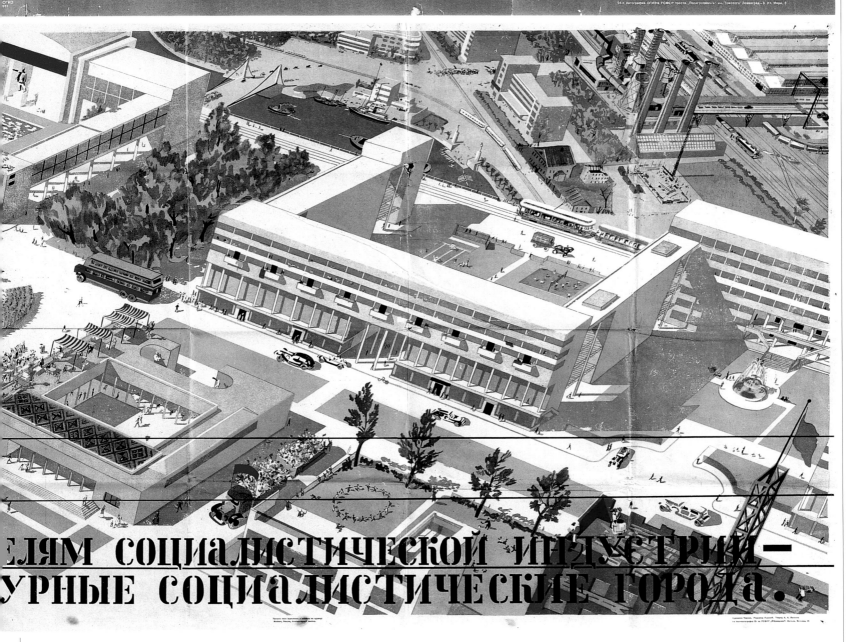

КДЫХ И ВРАЖДЕБНЫХ ЭЛЕМЕНТОВ,
ДВУРУШНИКОВ, КАРЬЕРИСТОВ,
ЛЬНО РАЗЛОЖИВШИХСЯ ЛЮДЕЙ.

ЕЛЯМ СОЦИАЛИСТИЧЕСКОЙ ИНДУСТРИИ –
УРНЫЕ СОЦИАЛИСТИЧЕСКИЕ ГОРОДА.

Top: "Cleanse the Party of Class Aliens and Hostile Elements, Degenerates, Opportunists, Double-Dealers, Careerists, Self-Seekers,
Bureaucrats and Morally-Decayed Persons". A poster from Leningrad, 1933. Typographer unknown.
This newly-added paragraph to the "Rules of the All-Russian Communist Party", institutionalising purges of the Party,
was adopted at the Seventeenth Congress in January 1934. As a result, out of the 1,961 delegates who attended the congress,
no fewer than 1,108 had been liquidated by the end of the decade.

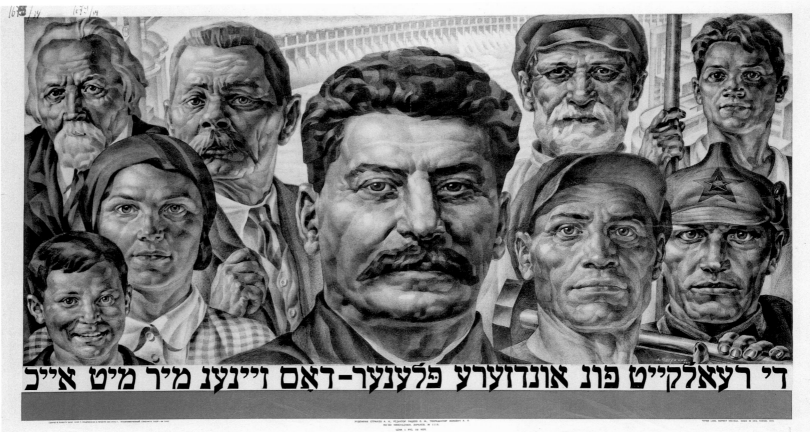

דער רעאליקיט פון אונדזערע פלענער–דאס זיינען מיר מיט אייך

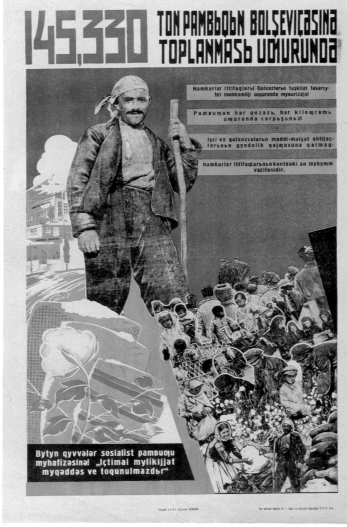

Top: "We are the Realisation of the Plan" by Adolf Strakhov-Braslavsky, Kharkov, 1933–4. The text is in Yiddish with Hebrew script. Stalin is flanked by Maxim Gorky (behind him to the left) and some idealised participants of the Second Five-Year Plan.

Above left: "145,330 Tonnes of Cotton". Azerbaijanian artist Gazanfar Alekper Ogly Khalykov's poster celebrates a new record harvest of cotton by his compatriots.

Above right: "The Reality of Our Plan of Production – Millions of Workers Creating a New Life. (Stalin)".
One of many typographical posters quoting the Leader and Teacher during the Second Five-Year Plan, this one from 1933.

Opposite page: " The Revolutionary Committee of the Mongolian Soviet People's Republic" by L.Shoenauer, 1931. Collectivisation in Mongolia was abandoned as a failure in 1932, just one year after its inception.

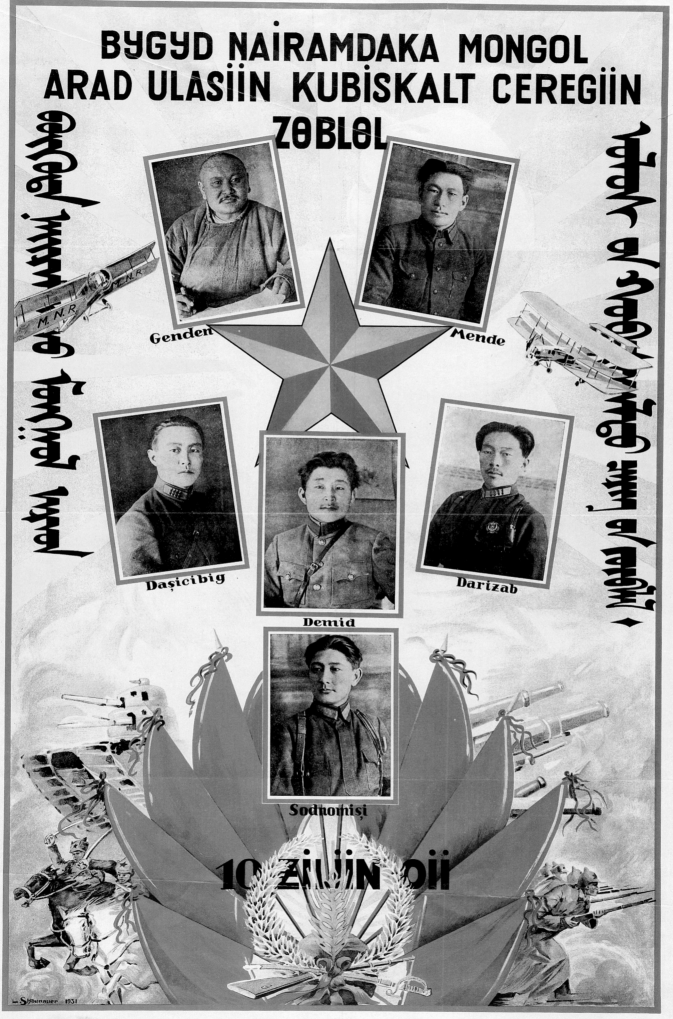

„Со знаменем Ленина победили мы в боях за Октябрьскую революцию".

„Со знаменем Ленина добились мы решающих успехов в борьбе за победу социалистического строительства. С этим знаменем победим в пролетарской революции во всем мире Да здравствует Ленинизм". (Сталин).

„История показала, что пятилетка является не частным делом Советского Союза, а делом всего международного пролетариата". (Сталин).

STOP TERROR ON CHINESE MASSE

„В странах напитала катастрофическое падение производства, массовое свертывание и остановка фабрик и заводов, неслыханное разрушение производительных сил". (Из резолюций XVII конференции ВКП(б)).

Главлит № А-90588. Сдано в производство 22/VI 1933 г. Подписано к печати 5/IX 1933 г. Заказ № 162. Тираж 50.000. Страниц 20. Печатных листов 10.

Выставка „ИТОГИ ПЕРВОЙ ПЯТИЛЕТКИ И ЗАДАЧИ ВТОРОЙ ПЯ

СССР
—БАЗА
МЕЖДУНАРОДНОГО
СОЦИАЛИЗМА

„Мы должны двигаться вперед так, чтобы рабочий класс всего мира, глядя на нас, мог сказать: вот он, мой передовой отряд, вот она, моя ударная бригада, вот она, моя рабочая власть,—вот оно, мое отечество,—они делают свое дело, наше дело, хорошо,—поддержим их против капиталистов и раздуем дело мировой революции". (Сталин).

...тилетни мобилизуют ...ные силы рабочего ...тран против ка... ...ков неоспо... ...ъединенном ...ВКП(б).

DEMAND
7/hr. day
5 day v

JUIN the
Trade Union
Unite Left

WORK
5!

JOIN the
Trade Union
Unity League

JOIN the
INTERNATIONAL
LABOR DEFENSE

„В СССР — огромный и неуклонный рост производства, все более развертывающееся строительство фабрик, гигантских заводов, новых шахт и электростанций, недосягаемый для капитализма, темп роста производительных сил,". (Из резолюций XVII конференции ВКП(б).

...О плакатов. Цена 20 руб. Издание ХПК ППЦ НКП РСФСР 24-я литография ОГИЗ'а РСФСР треста „Полиграфкнига" им. Томского. Ленинград—З. Ул. Мира, 5

Previous page and continuing to page 101:

Thirteen posters from a series of twenty published in a large portfolio as a travelling exhibition entitled "The Results of the First Five-Year Plan and the Objectives of the Second Five-Year Plan". Designed in 1933 in Moscow by an autonomous group called Artists' Brigade, the powerful photomontage graphics and slogans project the major achievements and expectations for the expansion of industry, agriculture, and propaganda on the political, educational and cultural fronts.
Previous page: "The USSR is the Centre of International Socialism". Lenin, hammer and sickle, building the USSR, international workers' struggle, and citations from Stalin and the Seventeenth Party Conference.

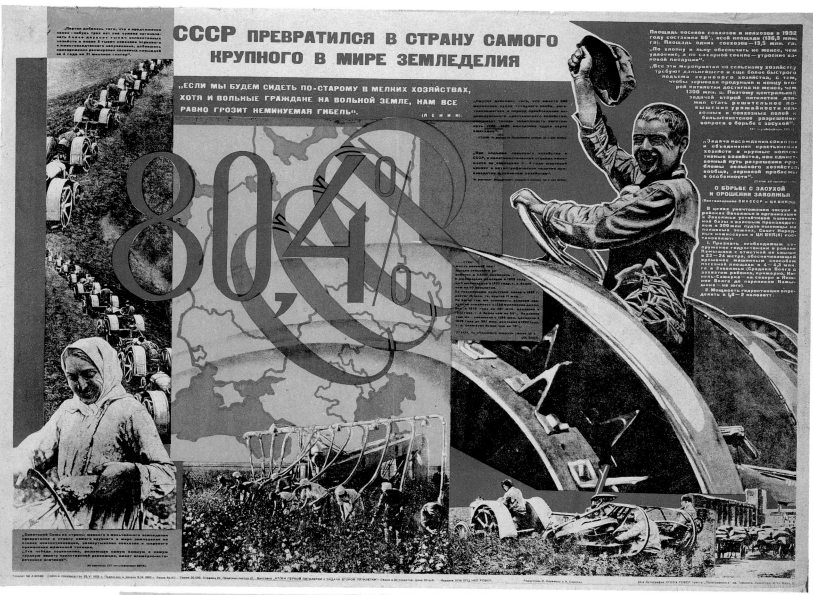

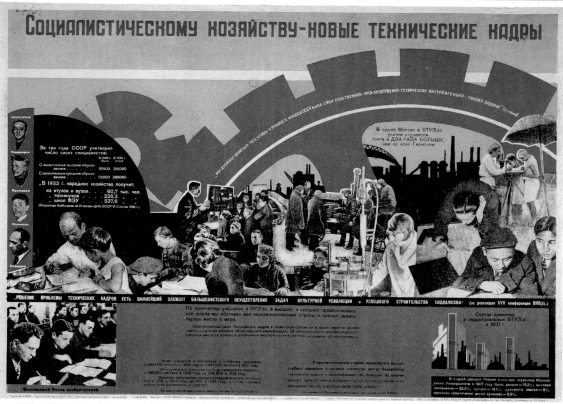

Opposite page, top: "The All-Union Communist Party (Bolsheviks) is the Assault Army of Socialism". From Lenin's Eighth Party Conference of 1919 to Stalin's Seventeenth Party Conference of 1932; montages of power and progress.

Opposite page, below: "Speed up the Output of Soviet Engineering" and in smaller type: "Before we had no tractor industry, auto plants, machine-tool construction, farm machinery, aviation plants. Now we have them all".

Top: "The USSR has become the Leading Agricultural Country in the World". No mention is made of the Ukraine famine.

Above: "The Socialist Economy Needs Newly-Trained Technicians". In smaller print: "There are twice as many students in Moscow as in the whole of Germany".

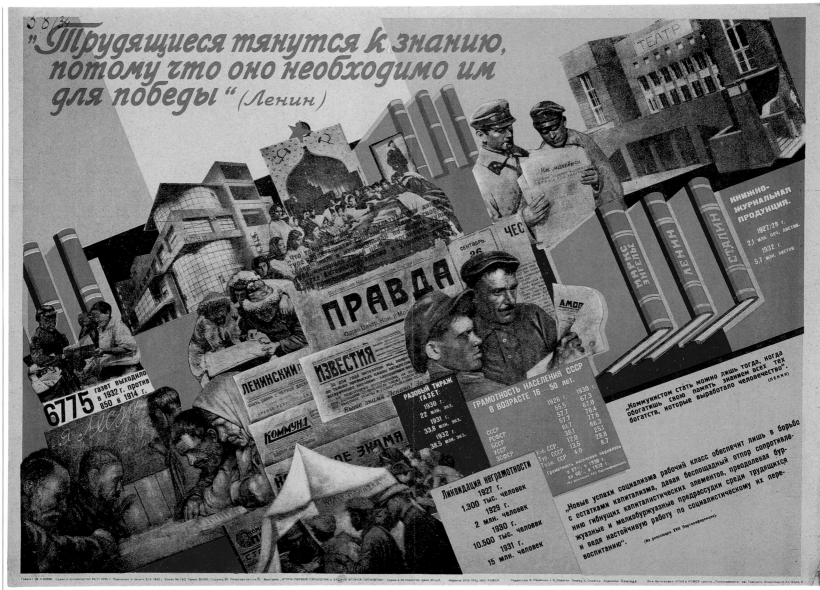

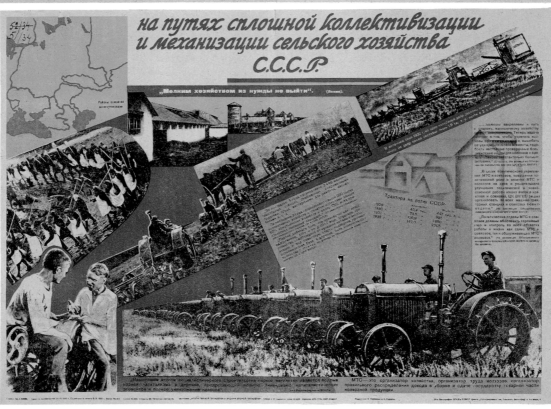

Artists' Brigade continued. *Top*: "The working classes struggle for education because they need it for victory. (Lenin)".
Soviet education provided for everyone. From basic tent clubs to a constructivist masterpiece, the Zuev Workers' Club in Moscow; from creches
to adult education centres, literacy classes, local theatres, newspapers and book clubs.
Above: "On the Continuous Path of Collectivisation and the Mechanisation of Agriculture in the USSR".

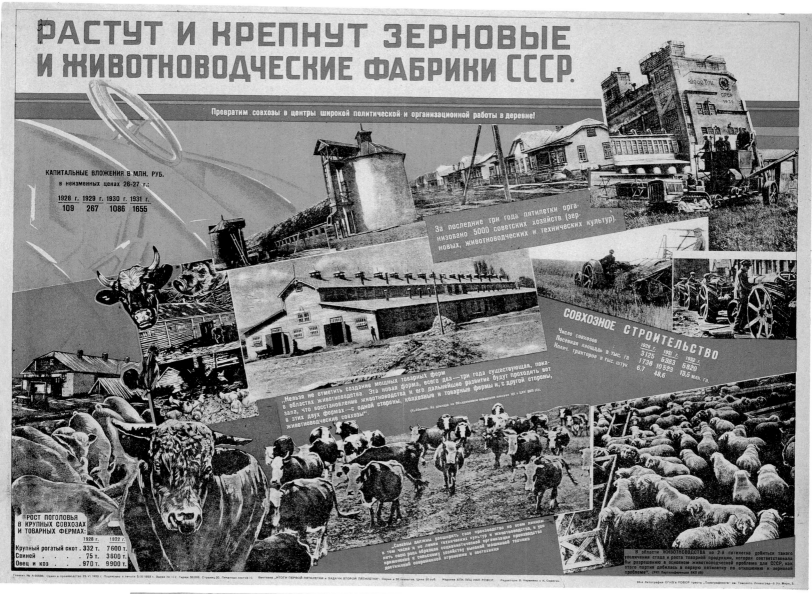

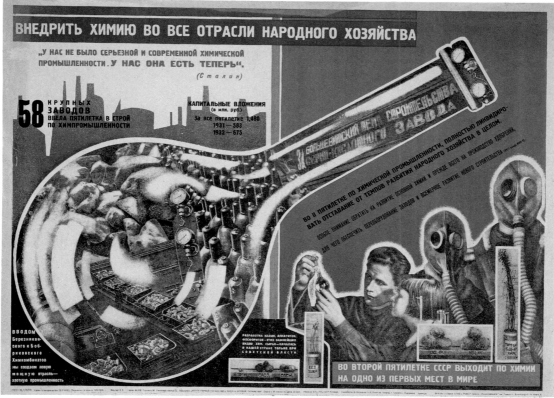

Top: "Factory Farming in the USSR's Grain and Livestock Sector is Getting Bigger and Stronger".
The poster quotes at length Valerian Kuibyshev, director of Gosplan (State Planning Committee) until 1935, when he died of heart failure in suspicious circumstances, possibly the victim of a medical murder carried out by the NKVD, just days after calling for an investigation into Kirov's assassination.
Above: "Chemistry Must be Implemented in All Branches of the Economy".

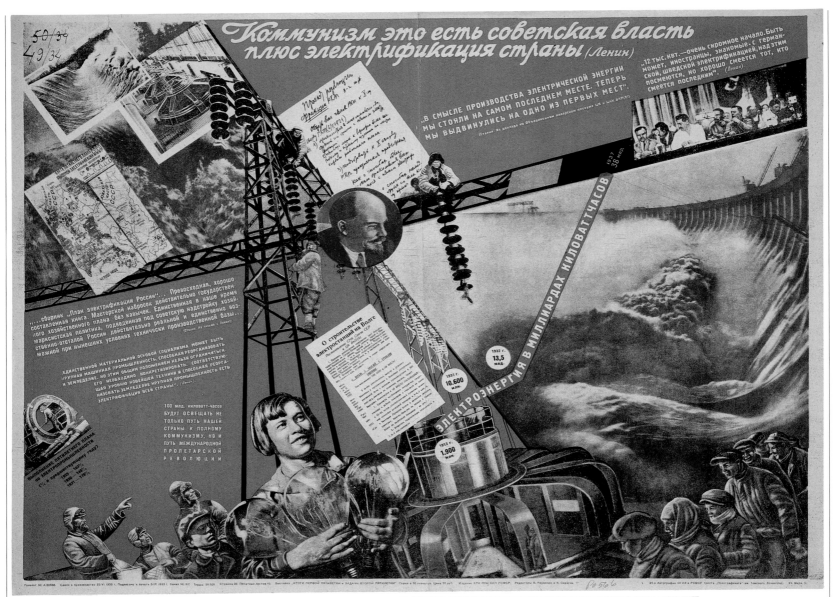

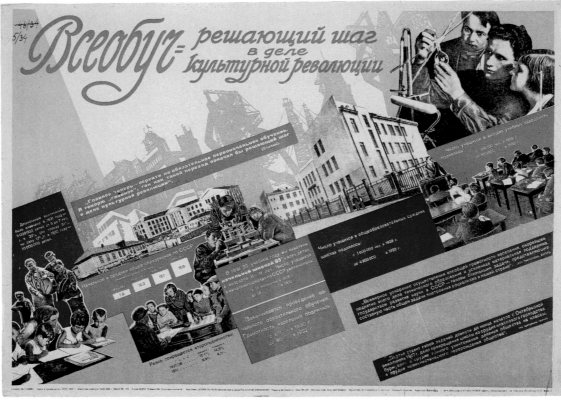

Artists' Brigade concluded. *Top*: "Communism is Soviet Power Plus the Electrification of the Whole Country. (Lenin)".
The poster features the Dniepr Dam, which Leon Trotsky had first campaigned for in 1926: "The Dniepr waits for us to harness its current, restrain it with dams, force
it to give light to the cities, power factories and irrigate ploughland. We shall compel it!" No mention is made of Trotsky in the poster; he was exiled by Stalin in 1929.
Six American engineers, including Colonel Hugh Cooper, were awarded the Red Banner of Labour for their supervision
of the project and the first five generators came from General Electric. The dam was designed by the constructivist architects, Viktor Vesnin and Nikolai Kolli.
Above: "Universal Education is a Step Forward to the Cultural Revolution".

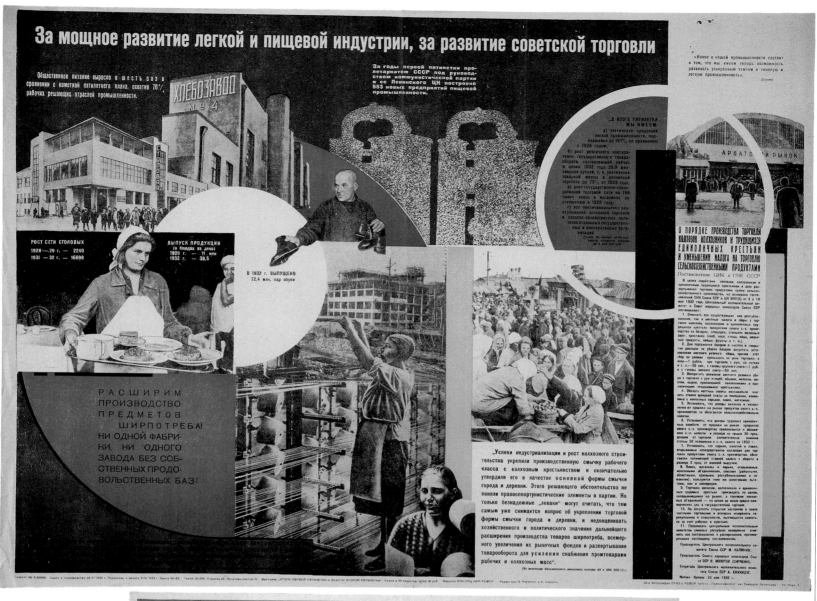

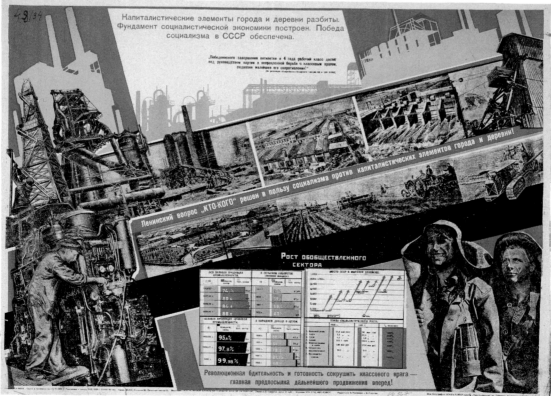

Top: "For the Strong Development of Light Industry, the Food Sector and the Development of Soviet Trade".
Throughout Soviet history there was a constant deficit of food, clothing and domestic goods that caused ordinary citizens to spend sad and painful hours queueing everyday even for the most basic necessities.
Above: "The Leninist Question 'Who Will Win?' is Decided in Favour of Socialism Against Capitalist Elements in Town and Country".
Revolutionary vigilance to fight the class enemy becomes the main premise for future development; "The victory of Socialism in the USSR is guaranteed".
And so the witch hunt against the "enemies of the people" begins.

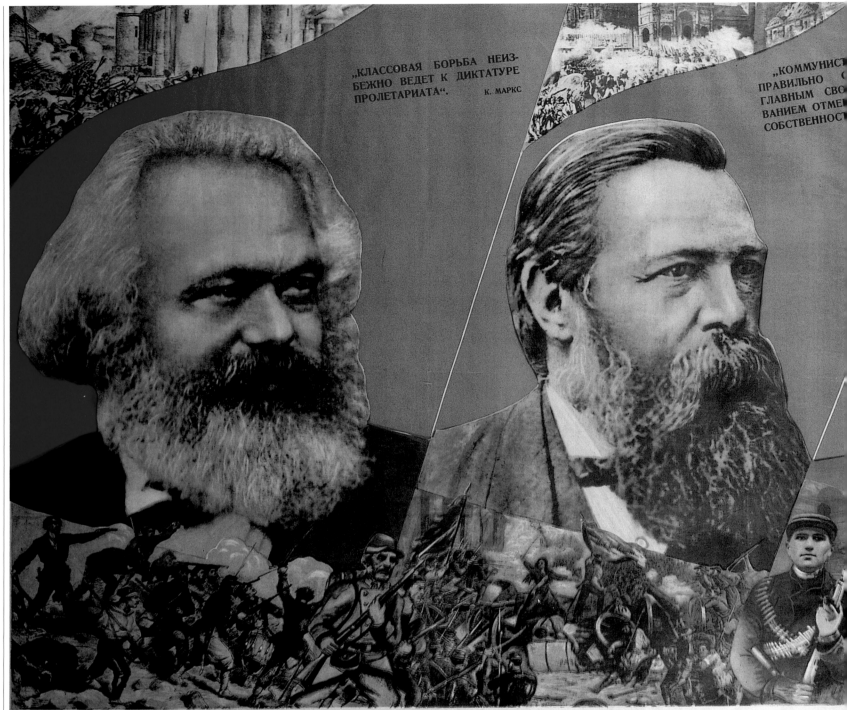

„КЛАССОВАЯ БОРЬБА НЕИЗ-
БЕЖНО ВЕДЕТ К ДИКТАТУРЕ
ПРОЛЕТАРИАТА". К. МАРКС

„КОММУНИС
ПРАВИЛЬНО
ГЛАВНЫМ СВО
ВАНИЕМ ОТМЕ
СОБСТВЕННОСТ

ВЫШЕ ЗНАМЯ МАРКСА ЭН

Photomontage was an ideal art form for Stalin. He could have his head enlarged to an enormous scale and juxtaposed with those of the great thinkers of Scientific Communism. He could also appear alongside the mass of the people, something that in reality he was too terrified even to contemplate.

Top: "Under the Banner of Marx, Engels, Lenin and Stalin!" Designed by Gustav Klutsis in 1933 to commemorate the fiftieth anniversary of Karl Marx's death. The four heads turn subtly in the direction of the viewer, but it is only Stalin whose eyes stare straight back across the decades, sizing up an enemy or facing down his critics.

Above: An earlier variant of the photomontage had Klutsis using friendlier, less saintly portraits of Lenin and Stalin. It was rejected.

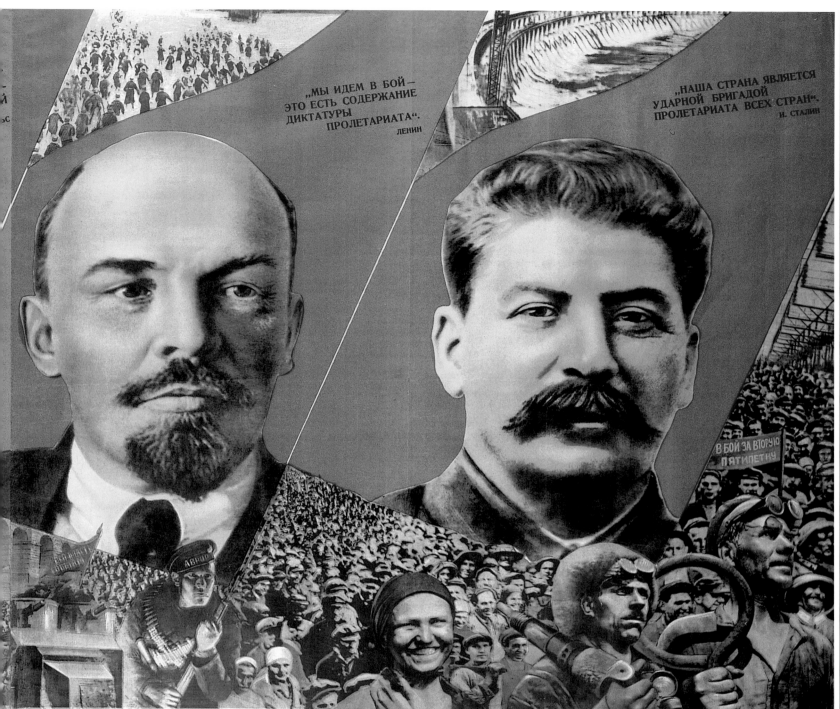

„МЫ ИДЕМ В БОЙ—
ЭТО ЕСТЬ СОДЕРЖАНИЕ
ДИКТАТУРЫ
ПРОЛЕТАРИАТА".
ЛЕНИН

„НАША СТРАНА ЯВЛЯЕТСЯ
УДАРНОЙ БРИГАДОЙ
ПРОЛЕТАРИАТА ВСЕХ СТРАН".
И. СТАЛИН

...ЕЛЬСА ЛЕНИНА и СТАЛИНА!

Above: A photograph of a demonstration in Vilnius, capital of Lithuania, to celebrate entry into the USSR in 1940 at the time of annexation.
A small version of Klutsis's poster can be seen on the placard, two years after the designer had been arrested,
tortured and shot by Stalin's secret police in Moscow's notorious Butovo prison. He had been erroneously charged with belonging to an armed gang of Latvian fascists.
Sixty-three other Latvian artists and intellectuals were shot with him on the same day (February 26th, 1938).
No designer, in his lifetime, had contributed more effectively to the Stalin Cult.

103

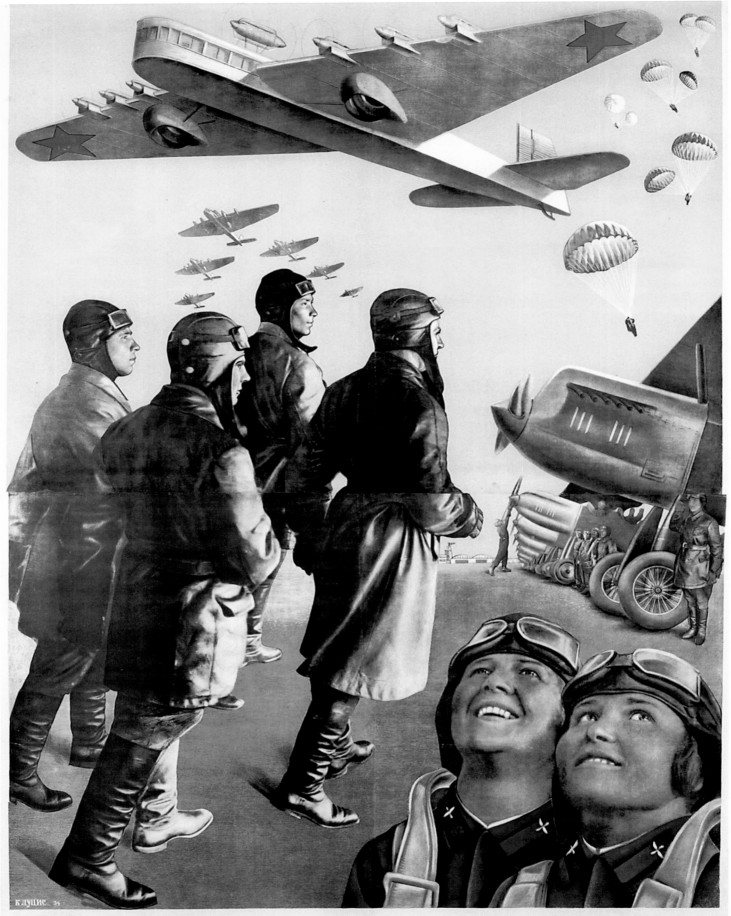

МОЛОДЕЖЬ, — НА САМОЛЕТЫ

Above: "Young People – To the Aeroplanes" by Gustav Klutsis, 1934.
Many thousands of Soviet citizens learned to fly in their spare time in the 1930s, later joining the Red Air Force during the Great Patriotic War.
Opposite page: "Long Live Our Happy Socialist Land! Long Live Our Beloved Leader, the Great Stalin!"
The apotheosis of his commitment to Stalinism, this breathtaking poster by Gustav Klutsis
from 1935 demonstrates through mindbending perspective and wild scale, the direction that the designer's late work had headed –
a parallel universe of Soviet socialist surrealism, criminally to be burst in upon by Stalin's secret police.

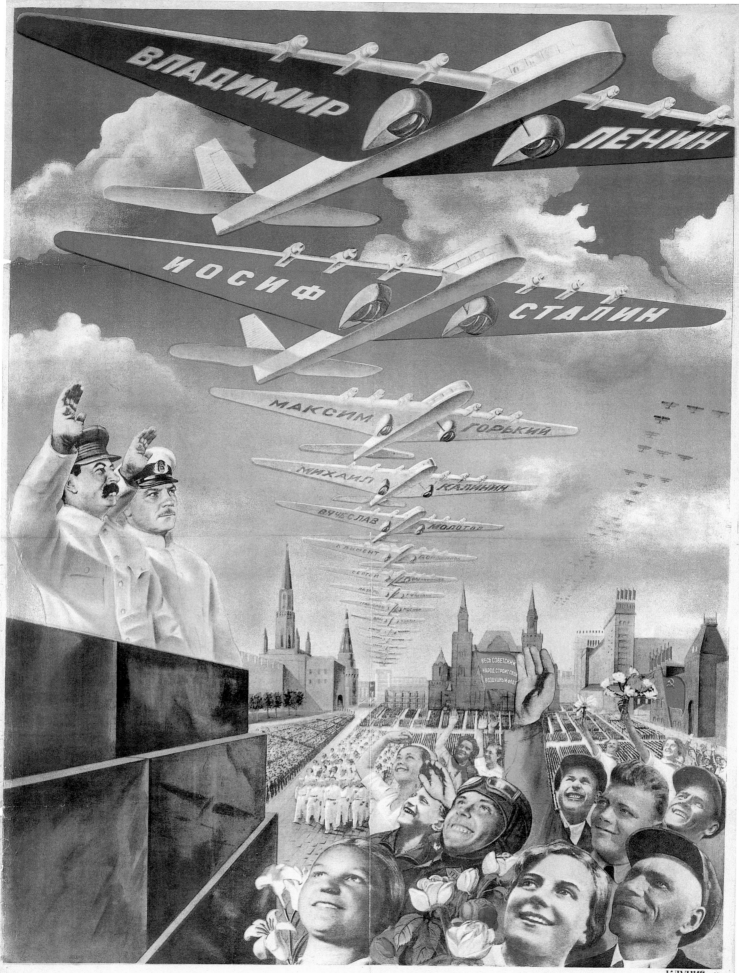

ДА ЗДРАВСТВУЕТ НАША СЧАСТЛИВАЯ СОЦИАЛИСТИЧЕСКАЯ РОДИНА.
да здравствует наш любимый великий СТАЛИН!

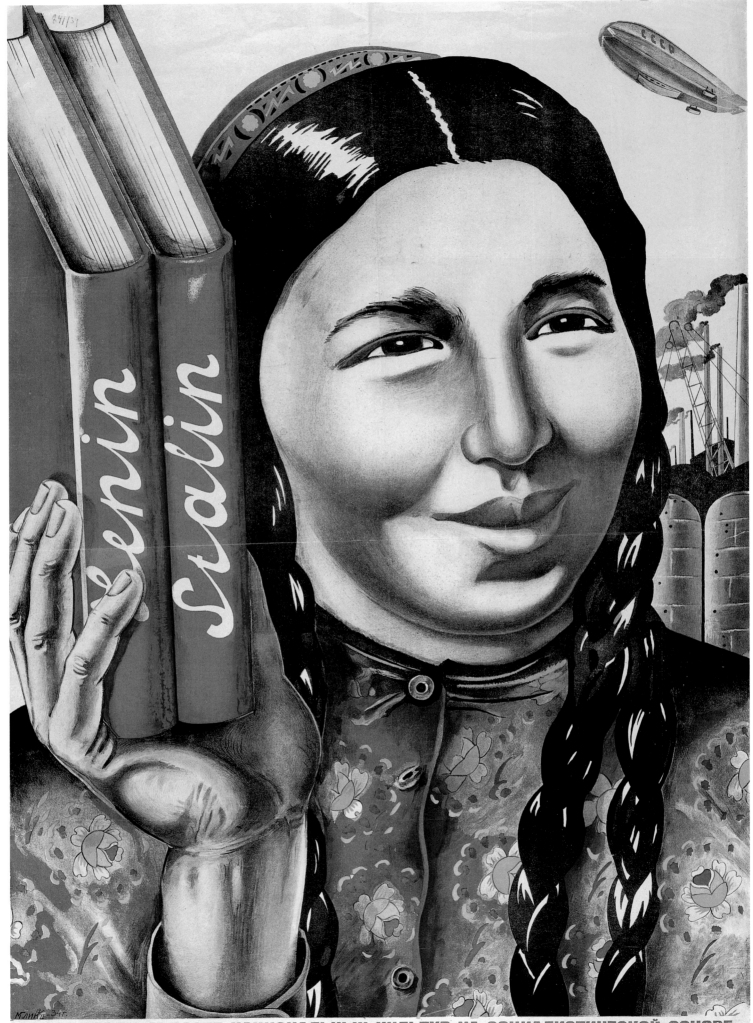

„В ГРОМАДНОМ РОСТЕ НАЦИОНАЛЬНЫХ КУЛЬТУР НА СОЦИАЛИСТИЧЕСКОЙ ОСНОВЕ

НАЙДЕТ СВОЕ ВЫРАЖЕНИЕ ПОБЕДОНОСНЫЙ РОСТ СОЦИАЛИЗМА В СССР". (МОЛОТОВ)

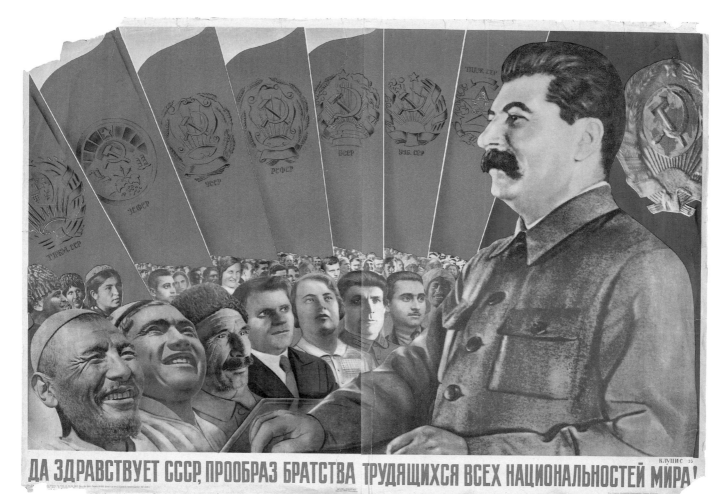

ДА ЗДРАВСТВУЕТ СССР, ПРООБРАЗ БРАТСТВА ТРУДЯЩИХСЯ ВСЕХ НАЦИОНАЛЬНОСТЕЙ МИРА !

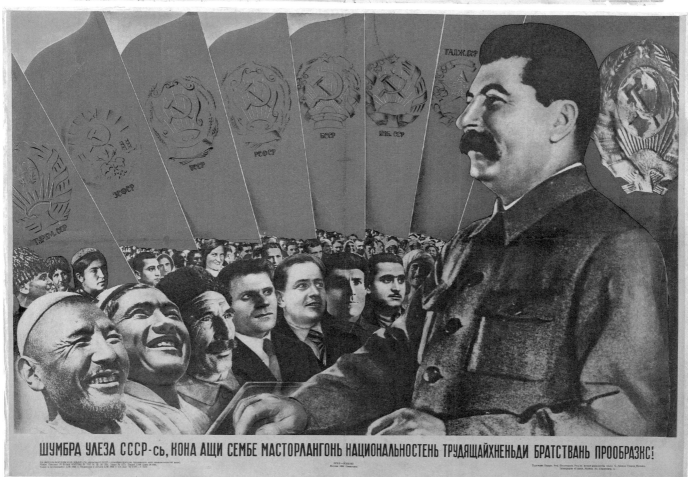

ШУМБРА УЛЕЗА СССР-сь, КОНА АЩИ СЕМБЕ МАСТОРЛАНГОНЬ НАЦИОНАЛЬНОСТЕНЬ ТРУДЯЩАЙХНЕНЬДИ БРАТСТВАНЬ ПРООБРАЗКС!

Top: "Long Live the USSR – Blueprint for the Brotherhood of All Working Classes of All the World's Nationalities!" by Gustav Klutsis, January 1935.

Above: Another edition of the poster, also by Klutsis, published in March 1935, using the same slogan in the Moksha-Mordovian language.

The two editions of the poster have a strange variation. In the front row of the photomontage in the top poster we can see – fifth from the left – the face of a woman gazing up intently at the Leader and Teacher, hanging on his every word. In the same space in the second edition of the poster, printed just two months later, the woman has been turned, inexplicably, into a man. No other changes in the montage are discernable and we can only worry what fate held in store for her.

Opposite page: "Lenin, Stalin" by M.Glik, 1934. The woman is Uzbek, the quotation is from Molotov: "The victorious development of socialism in the USSR will find its expression in the colossal development of national cultures on a socialistic foundation".

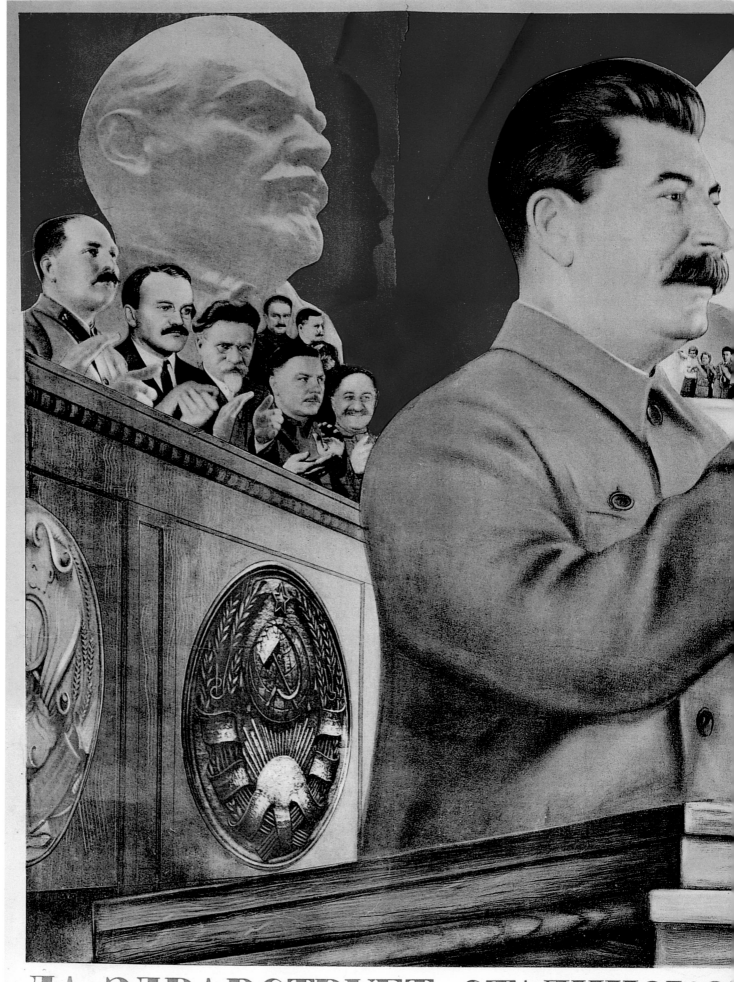

ДА ЗДРАВСТВУЕТ СТАЛИНСКО

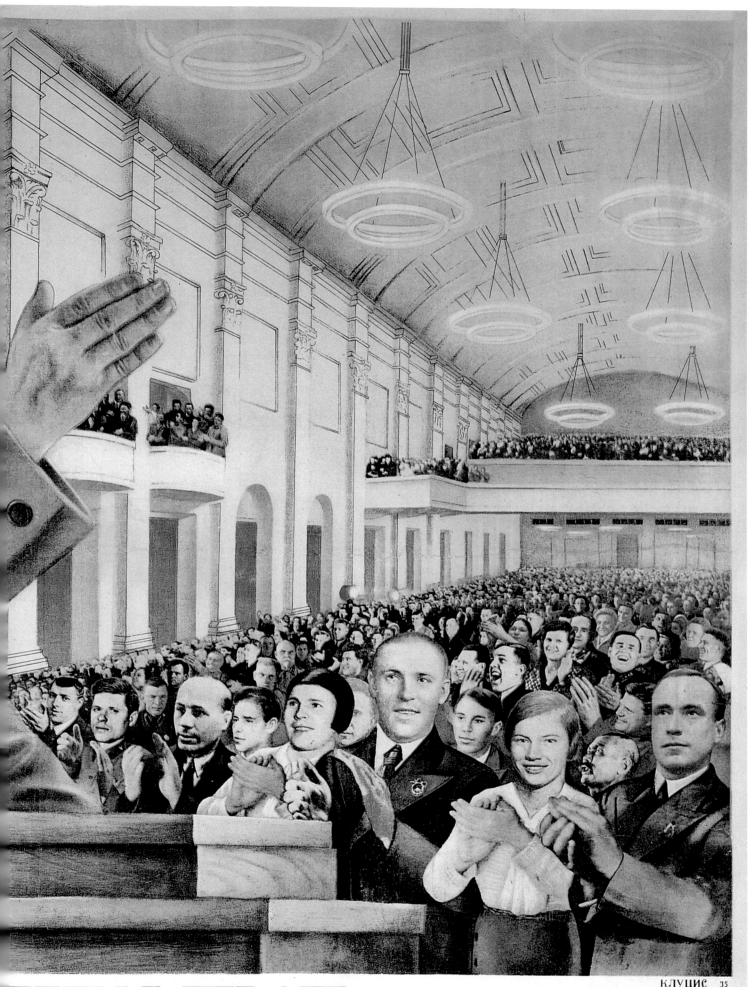

ПЛЕМЯ ГЕРОЕВ СТАХАНОВЦЕВ!

КЛУЦИС 35

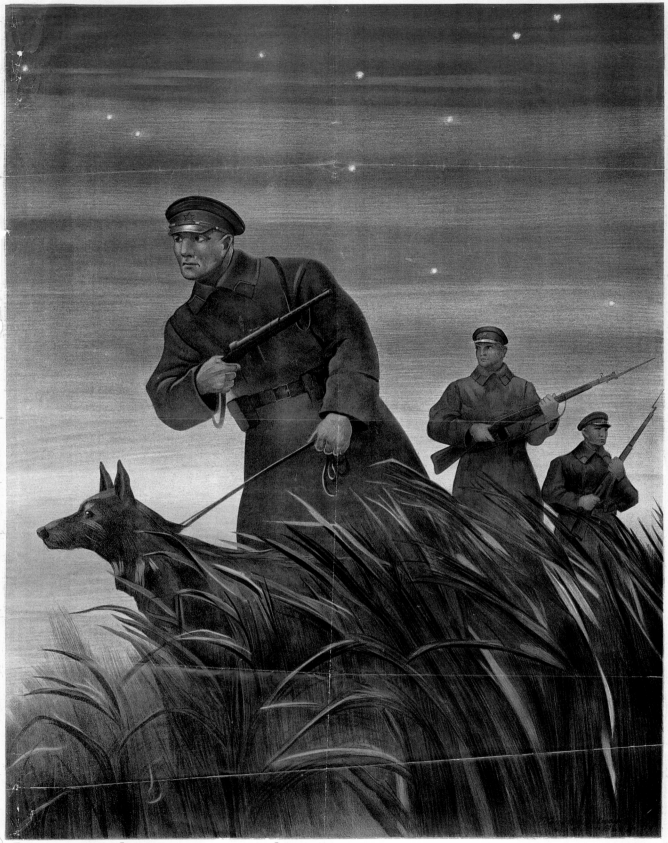

XX ЛЕТ ПОГРАНИЧНЫХ ВОЙСК НКВД СССР

От холодной чукотки, до знойного юга
Мы выходим в ночной пограничный дозор.

Previous page: "Long Live Stalin's Breed of Stakhanovite Heroes!"
More strange goings-on from Gustav Klutsis. This Stalin cult poster from 1935 with its audience of montaged heads beneath an invasion of electric haloes from outer space, seems closer to a quack religious meeting or Soviet seance than a celebration of the Stalinists' toughest workforce.
Top left corner, a pained and sickly Lenin looks away, casting a deep red and ghostly shadow.
Above: "Twenty Years of the NKVD Border Guards". Unsigned, Moscow, 1937. The NKVD (People's Commissariat for Internal Affairs), Stalin's secret police, were better known for their achievements in the fields of interrogation, torture and execution.

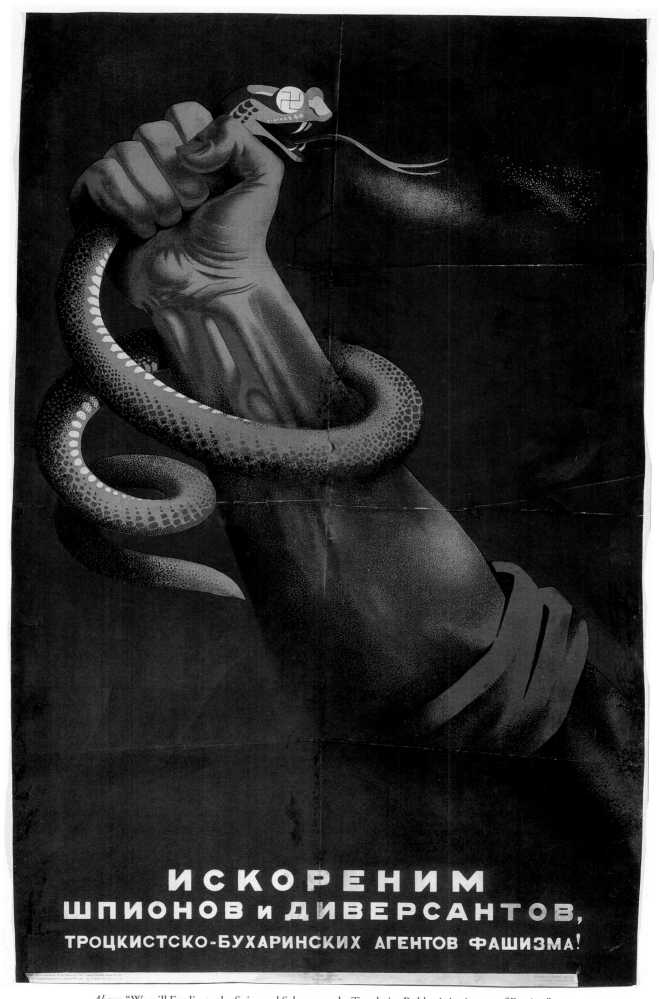

Above: "We will Eradicate the Spies and Saboteurs, the Trotskyist-Bukharinist Agents of Fascism".
A poster by Sergei Igumnov for the NKVD, published in 1937 at the time of the notorious Moscow Show Trials, a series of judicial charades
that Trotsky called "the greatest frame-up in history".
Sergei Igumnov was a graduate of Vkhutemas who specialised mainly in commercial advertisements for Vneshtorg, the Soviet's export trade organisation.
His simple composition of a red proletarian fist grabbing the Nazi serpent is eerily reminiscent of an earlier illustration
he made of a red star and sturgeon – for a caviar advertisement.

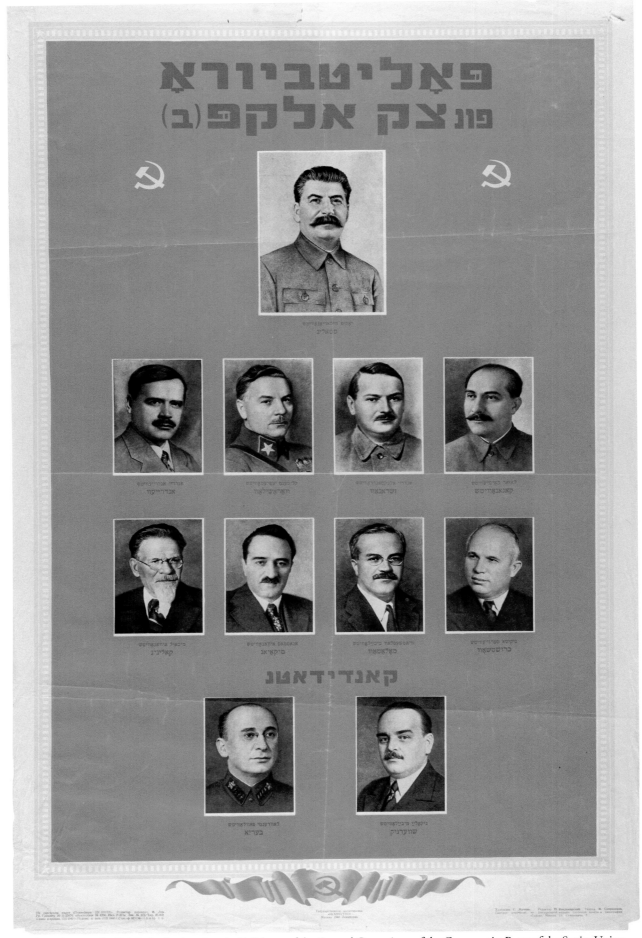

Above: A poster by G.Muchnik picturing the Politburo of the Central Committee of the Communist Party of the Soviet Union. Published in Yiddish with Hebrew script in 1940 for distribution in Birobidzhan, capital of the USSR's Jewish Autonomous Region (an unsuccessful attempt by Stalin to create a "Soviet Zion" on the borders with China).
Politburo members featured in the poster: Stalin (top). Second row: Andreev, Voroshilov, Zhdanov, Kaganovich. Third row: Kalinin, Mikoyan, Molotov and Khrushchev. Lastly, two candidate members, Beria and Shvernik.
Opposite Page: "Kolkhoz and Sovkhoz Workers, Engineers at Tractor Stations, Get into Socialist Competition, Deserve to Take Part in the 1940 All-Union Agricultural Exhibition". Viktor Koretsky's photomontage poster, published in Georgian, uses an image of Sergei Merkulov's 25-metre high statue of Stalin erected in front of the exhibition's "Mechanization" pavilion. High-ranking officials of Soviet agriculture and industry occupy the front row including, centre left, the influential "Marxist" biologist Trofim Lysenko, much later to be discredited as a total charlatan.
Six "Stalinets-60" caterpillar tractors from Chelyabinsk provide an industrial chorus line.

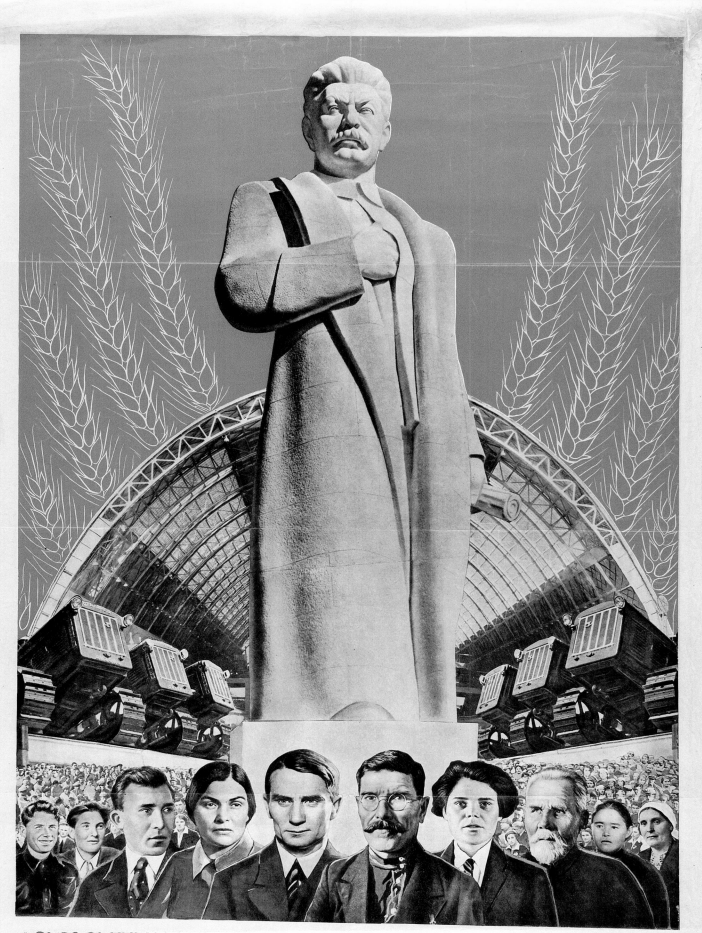

ԿՈԼՏՆՏԵՍԱԿԱՆՆԵՐ, ՄՏ ԿԱՅԱՆՆԵՐԻ ՅԵՎ ԻՈՐՀՏՆՏԵՍՈՒԹՅՈՒՆՆԵՐԻ
ԱՇԻԱՏՈՂՆԵՐ, ՀԱՎԱՍԱՐՎԵՑԵՔ ԱՌԱՋԱՎՈՐՆԵՐԻՆ, ԾԱՎԱԼԵՑԵՔ
ՍՈՑԻԱԼԻՍՏԱԿԱՆ ՄՐՑՈՒԹՅՈՒՆԸ, ՆՎԱՃԵՑԵՔ 1940 ԹՎԻՆ ՀԱՄԱՄԻՈՒԹԵՆԱԿԱՆ
ԳՅՈՒՂԱՏՆՏԵՍԱԿԱՆ ՑՈՒՑԱՀԱՆԴԵՍԻՆ ՄԱՍՆԱԿՑԵԼՈՒ ԻՐԱՎՈՒՆՔԸ

На армянском языке. Редактор перевода А. С. Оганян. Государственное издательство Художник В. Корецкий. Редактор Н. Шагровский. Техред М. Смирнова.
Колхозники, работники МТС и совхозов, равняйтесь на передовиков, «ИСКУССТВО» Ул. Гравюра № А-22665. (Татьянат № 8675. Изд. Р-24в. Зак. № 327. Тир. 1500).
развертывайте социалистическое соревнование, завоевывайте право участия в 1940 г. Москва 1940 Ленинград Ц. 75 к. С.в тираж (я Б/т 7402 г. Вика) к.275г. (3.1.1940). Стереотип 52 Х 38 = 1 б.л.
на Всесоюзной сельскохозяйственной выставке! Типография «Спарк», Москва, ул. Станкевича, 7.

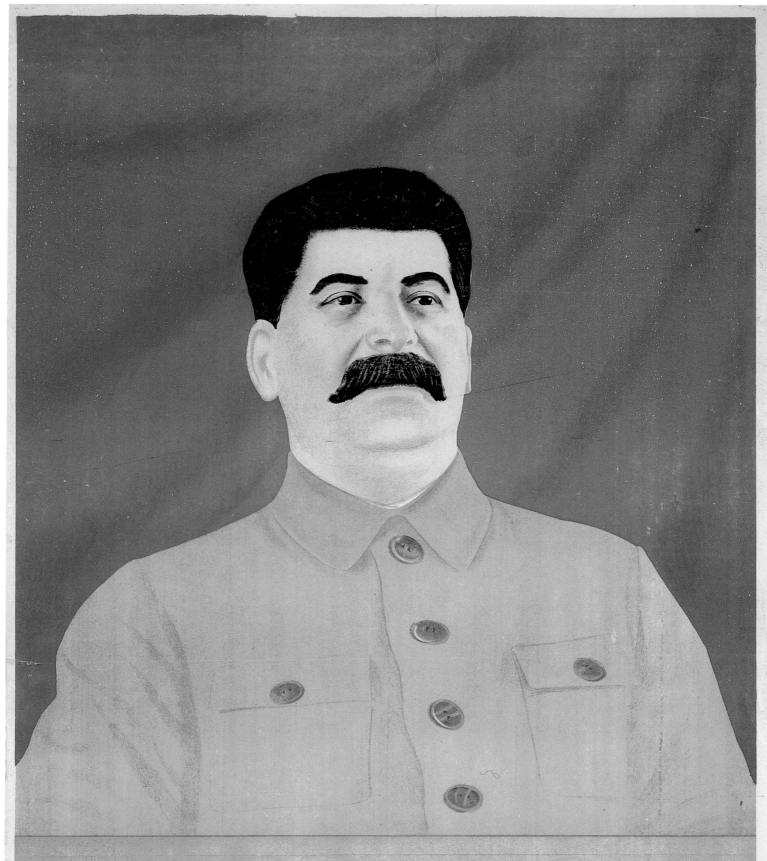

JAŞASЬN QOMMUNIZMIN
BIRINÇI MARŞALЬ
STALIN JOLDAŞ!

Baş. Mat. Myd. №530 Azərnəşr. Təsviri-şe'nə, Sifariş №22. Tiraz 5000. Azərnəşr lito-ofsetində cap edildi. Sifariş №582. Rəssamь Leneşev B. Redaqtoru Qulijev R. Çapa verildi 7/VII-39 il. Çapdan çьхdь 25/x-39 il. Qiјmətь 3 m.

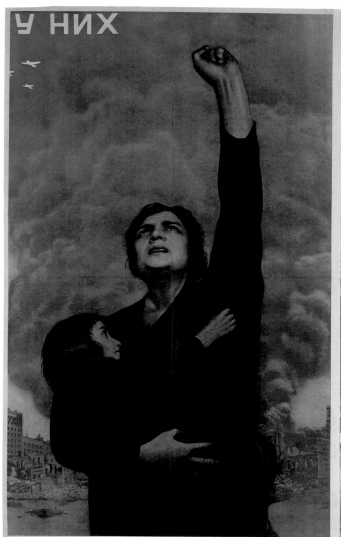

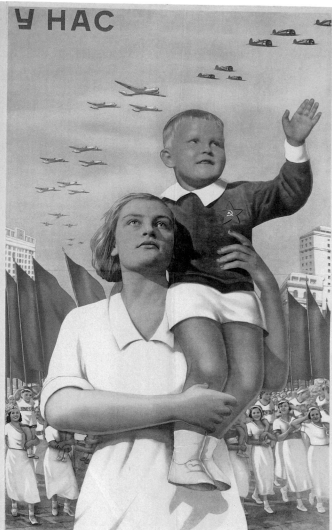

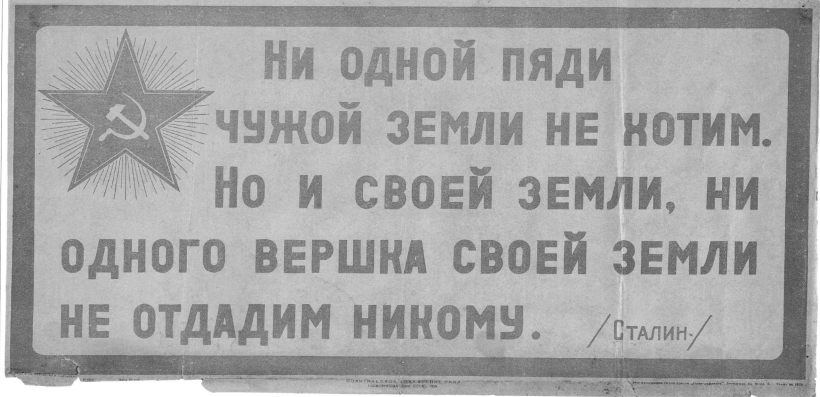

Opposite page: "Long Live Stalin, The First Marshal of Communism!" by B.Lebeshev, 1939.
One of the last posters from Azerbaijan printed in Janalif. The Latin alphabet had only been in use since 1928, following the recommendations of a congress of Turkologists in Baku. Janalif replaced Arabic script in all Tatar languages for the next twelve years until it was decreed that Cyrillic should be used instead.

Above: A typographical poster, circa 1939, with text by Stalin from a speech he made on June 27th, 1930. The slogan reads: "We do not want one inch of anyone else's land, but we will not give up one inch of our land to anyone else".
Following the Stalin-Hitler Pact made in the Kremlin late at night on August 23rd, 1939, Eastern Poland and Finland were both invaded by the Red Army, and Estonia, Latvia, Lithuania and Bessarabia were all annexed by the Soviets.

Top: "Them... Us". Viktor Koretsky's double-image poster from 1941 contrasts defiance and devastation in the West echoing the Spanish Civil War, with the sunlit and secure future Stalin had bestowed on the Motherland. Within six months of the poster's publication, the German army had invaded Russia.

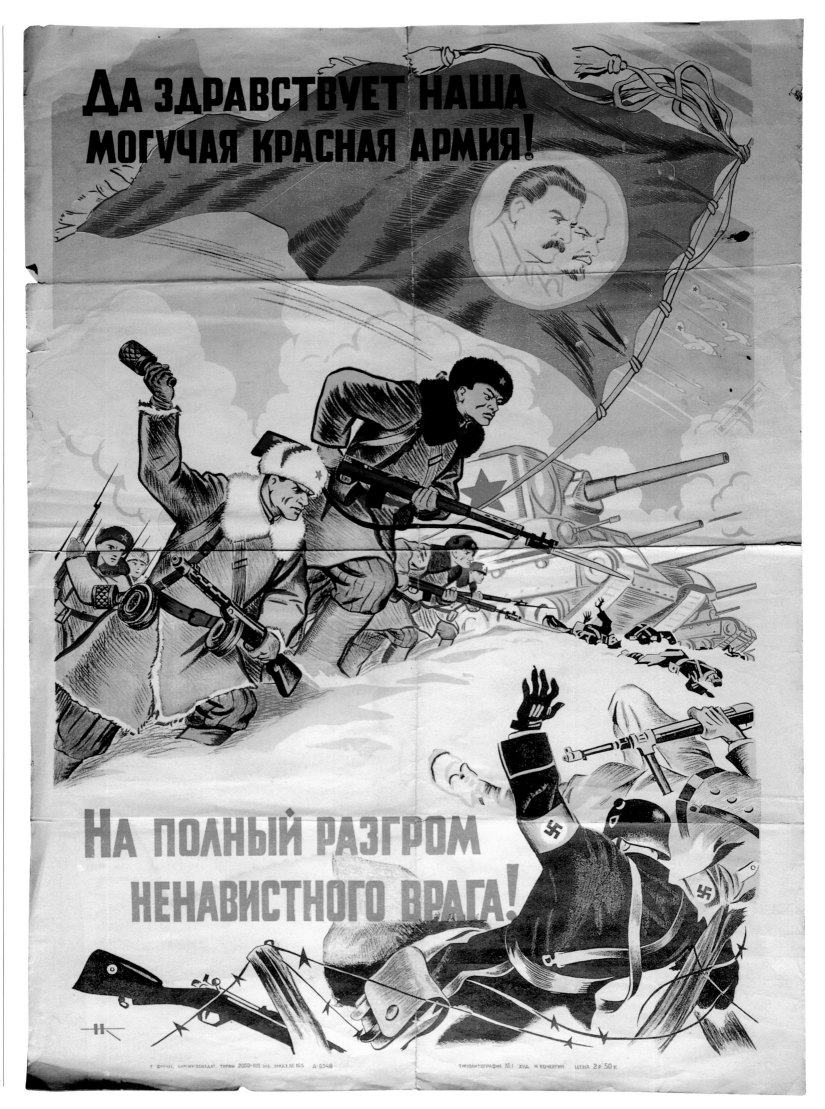

ДА ЗДРАВСТВУЕТ НАША МОГУЧАЯ КРАСНАЯ АРМИЯ!

НА ПОЛНЫЙ РАЗГРОМ НЕНАВИСТНОГО ВРАГА!

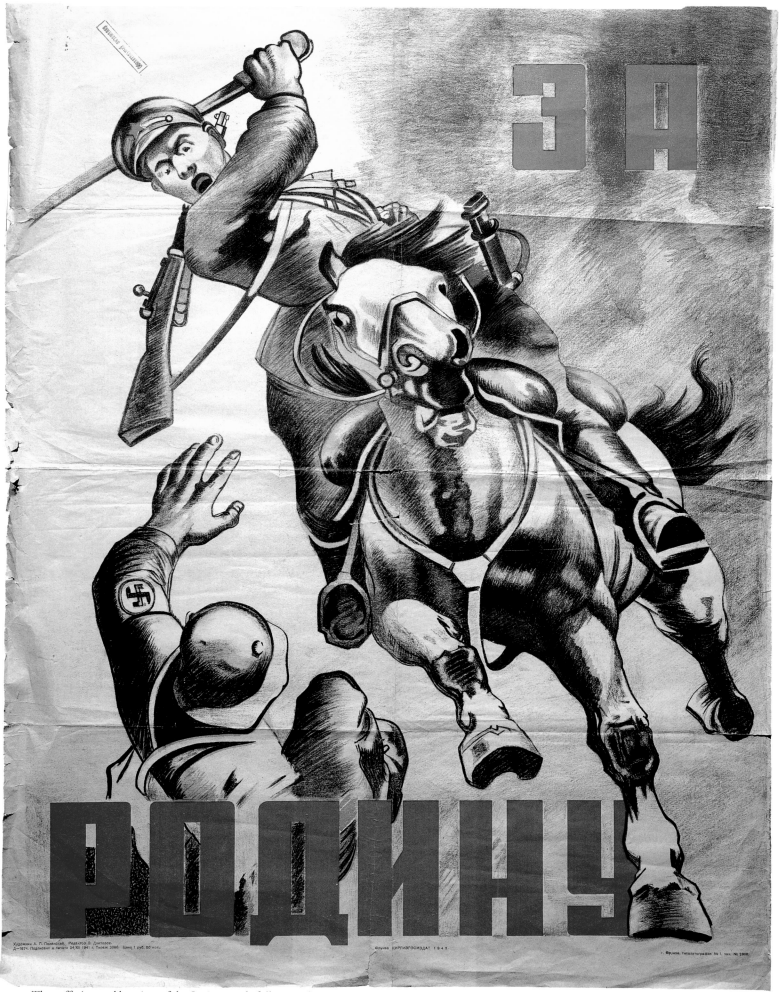

The suffering and heroism of the Soviet people following the Nazi invasion of June 1941 cannot begin to be satisfactorily conveyed in just a few pages.
But a few examples from the vast number of Russian posters produced during the Great Patriotic War might at least give some idea of the remarkable work their artists did to educate, explain, beseech and encourage the Soviet people in their struggle for victory.
Opposite page: "Long Live our Mighty Red Army! Let's Totally Defeat the Hated Enemy!" by Nikolai Kochergin published in Frunze, 1941. Images of Stalin were practically absent from Soviet posters during the war; ordinary citizens couldn't easily forget how many innocents he had killed or incarcerated in peacetime.
Above: "For the Motherland!" by A.Polyansky, 1941. The victorious reputation of the Red Cavalry symbolises Russian might in a world of tanks, planes and katyushas.

С ГОРОДОМ ЛЕНИНА— ВЕСЬ НАРОД, К ГОРОДУ ЛЕНИНА— ВРАГ НЕ ПРОЙДЕТ!

25-IX-1941 г.

ДА ЗДРАВСТВУЕТ НАША СЛАВНАЯ РОДИНА ЕЕ СВОБОДА, ЕЕ НЕЗАВИСИМОСТЬ! СМЕРТЬ НЕМЕЦКИМ ОККУПАНТАМ!

(СТАЛИН)

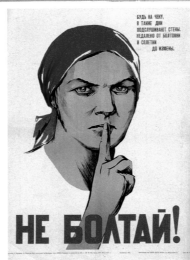

БУДЬ НА ЧЕКУ,
В ТАКИЕ ДНИ
ПОДСЛУШИВАЮТ СТЕНЫ.
НЕДАЛЕКО ОТ БОЛТОВНИ
И СПЛЕТНИ
ДО ИЗМЕНЫ.

НЕ БОЛТАЙ!

Top: "All the People are with the City of Lenin, the Enemy will not Enter the City of Lenin!" dated September 25th, 1941 from the siege of Leningrad.
Centre: "Long Live Our Motherland, Her Freedom, Her Independence! Death to the German Invaders!" A wartime typographical flier quotes Stalin's speech at the Red Army parade on November 7th, 1941. That day the troops marched directly from Red Square to the frontline.
Above: "Don't Chatter". Nina Vatolina's famous poster from 1941 on the subject of careless talk costing lives. The small text reads: "Be alert. In days like these, the walls have ears. It's a small step from gossip to treason".
Opposite page: The Azerbaijanian version of "Don't Chatter", K.Kazymov's poster from 1942. The Baku oil fields played a key role in the war against the Nazis.

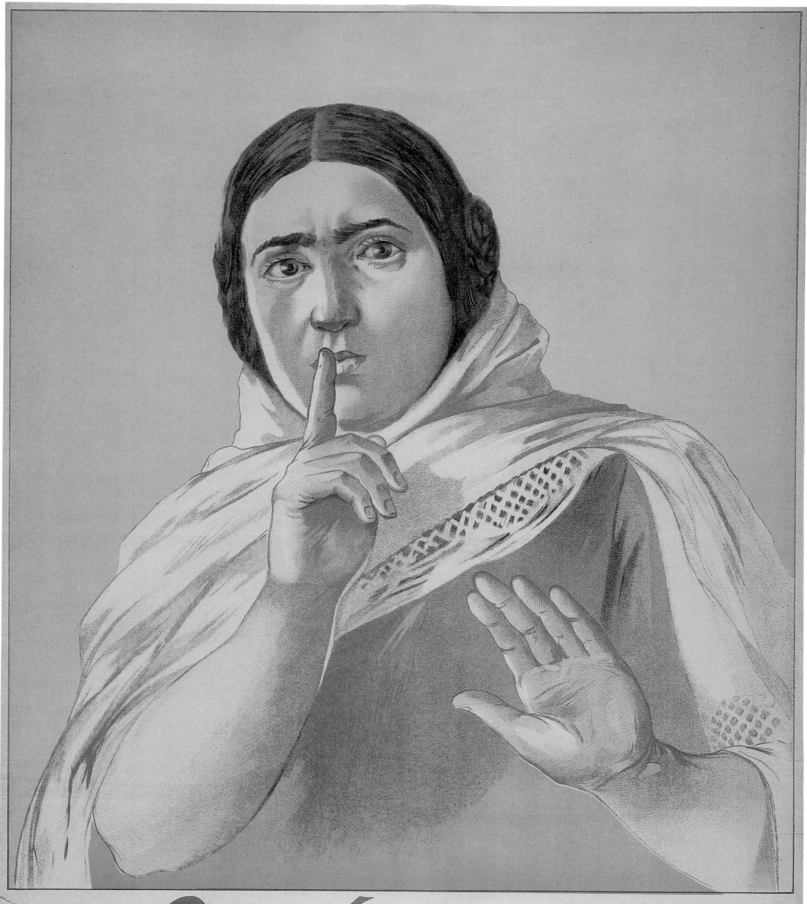

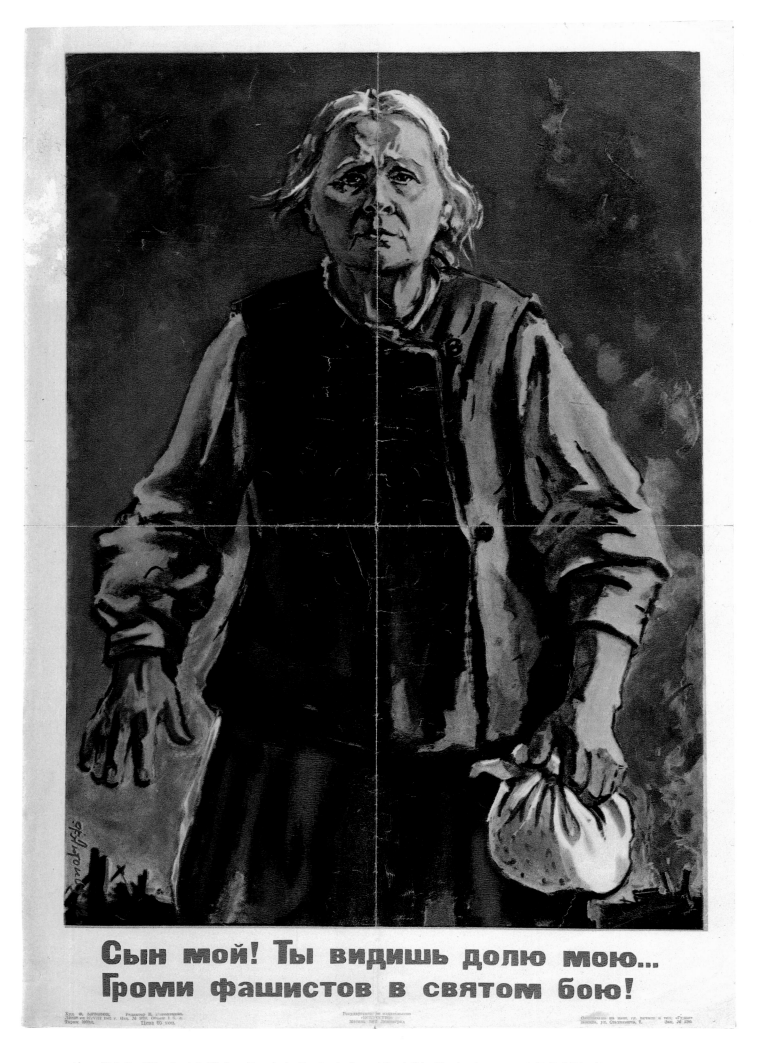

Сын мой! Ты видишь долю мою...
Громи фашистов в святом бою!

Above: "My Son! You See My Plight... Smash the Fascists in Sacred Battle!" by Fyodor Antonov, 1942. Published in 200,000 copies.
Opposite page: "Soldier, Liberate Your Belorussia!" by Viktor Koretsky, 1943. Published in 50,000 copies.

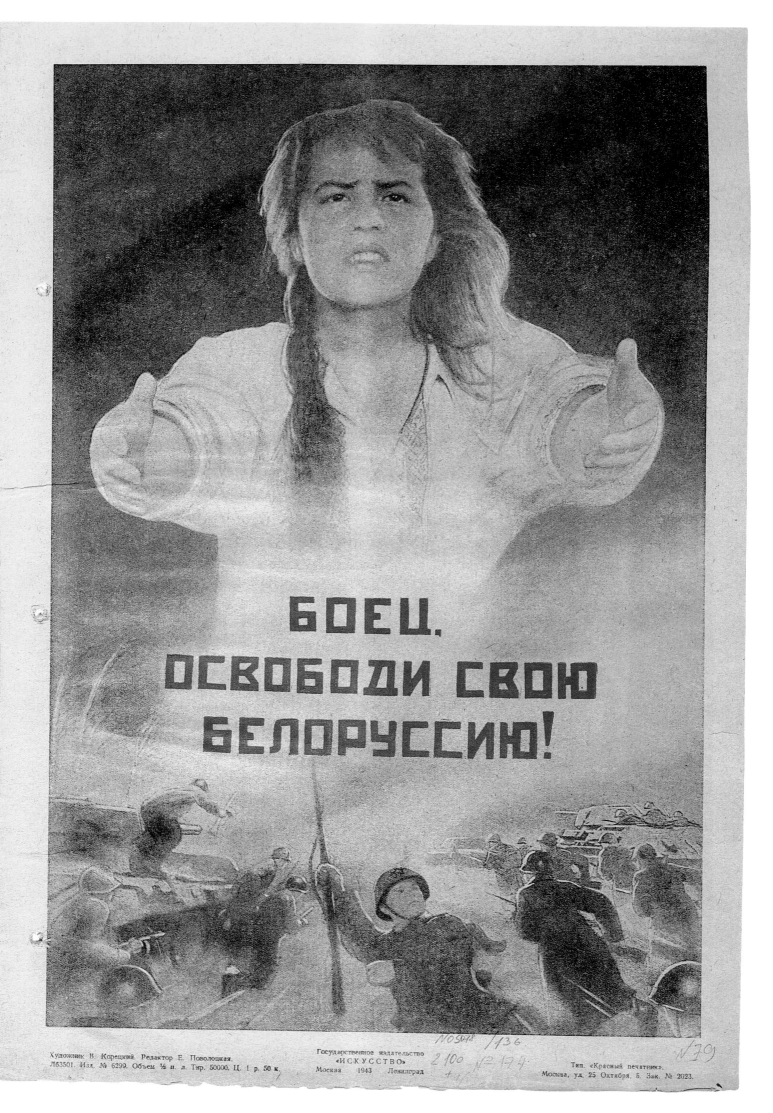

БОЕЦ,
ОСВОБОДИ СВОЮ
БЕЛОРУССИЮ!

Художник В. Корецкий. Редактор Е. Поволоцкая. Государственное издательство Тип. «Красный печатник».
Л63501. Изд. № 6299. Объем ½ п. л. Тир. 50000. Ц. 1 р. 50 к. «ИСКУССТВО» Москва, ул. 25 Октября, 5. Зак. № 2023.
Москва 1943 Ленинград

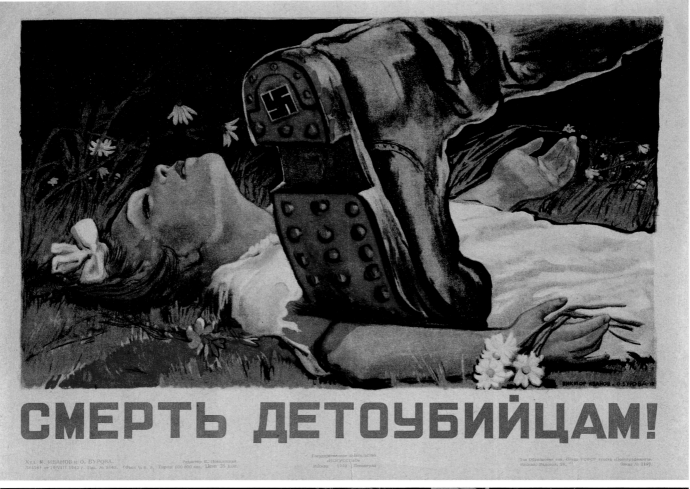

СМЕРТЬ ДЕТОУБИЙЦАМ!

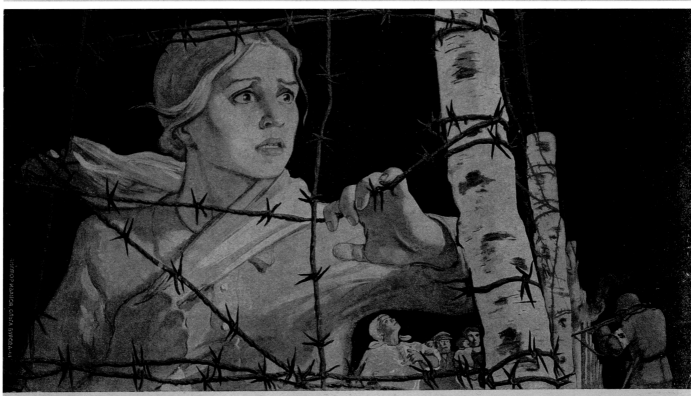

ВСЯ НАДЕЖДА НА ТЕБЯ, КРАСНЫЙ ВОИН!

Top: "Death to the Child Killers" by Viktor Ivanov and Olga Burova, dated 1942.
Every Red soldier had a child left at home, be it daughter or son, brother or sister, niece or nephew.
Above: "All Hope Lies With You, Red Soldier!" by Viktor Ivanov and Olga Burova, 1943.
The Nazis rounded up women and children as young as ten years old. If they were not murdered on the spot, they were deported to Germany and worked to death as slave labourers.
Opposite page: "Red Army Warriors, Save Us!" by Viktor Koretsky, 1943 (First edition published in 1942).
Koretsky's poster was known as the "Soldier's Madonna". He received letters from troops in the battlefield saying they kept his poster folded in the left-hand top pocket of their uniform, next to their heart, just as icons had been kept by their fathers before them.

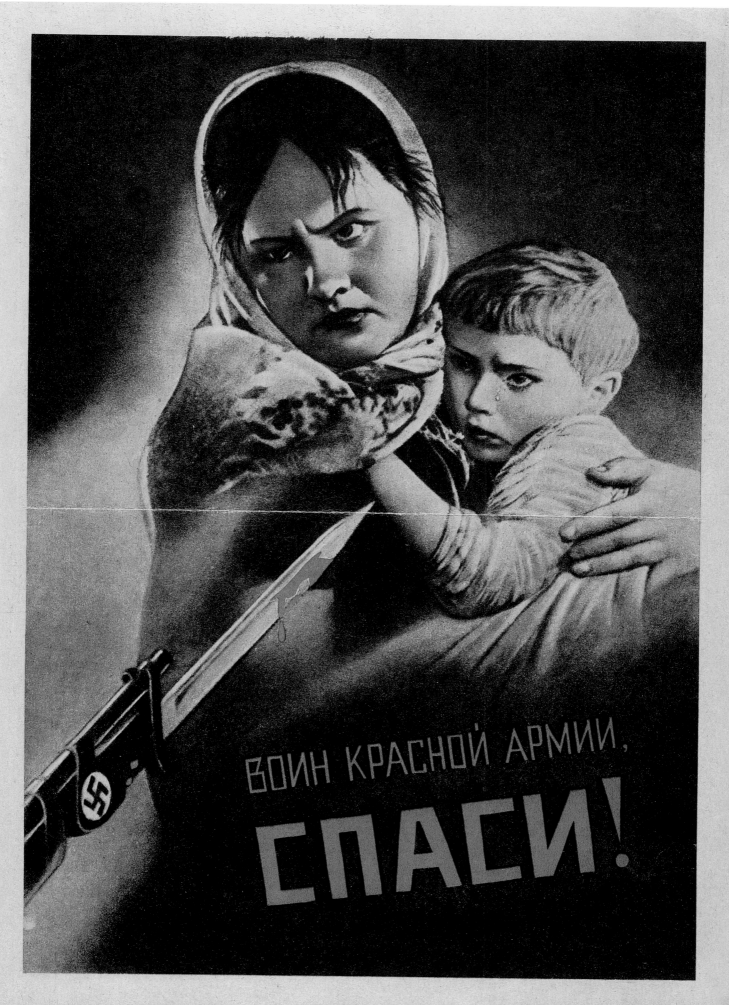

ВОИН КРАСНОЙ АРМИИ,
СПАСИ!

Художник В. КОРЕЦКИЙ. Редактор Е. ПОВОЛОЦКАЯ.
Л38195 от 12/V 1943 г. Изд. № 6112. Объем ½ п. л.
Тираж 100 000 экз. 2-е изд. Цена 35 коп.

Государственное издательство
ИСКУССТВО
Москва 1943 Ленинград

Отпечатано на машине глубокой печати в тип. «Гудок»,
Москва, ул. Станкевича, 7. Заказ № 1468.

123

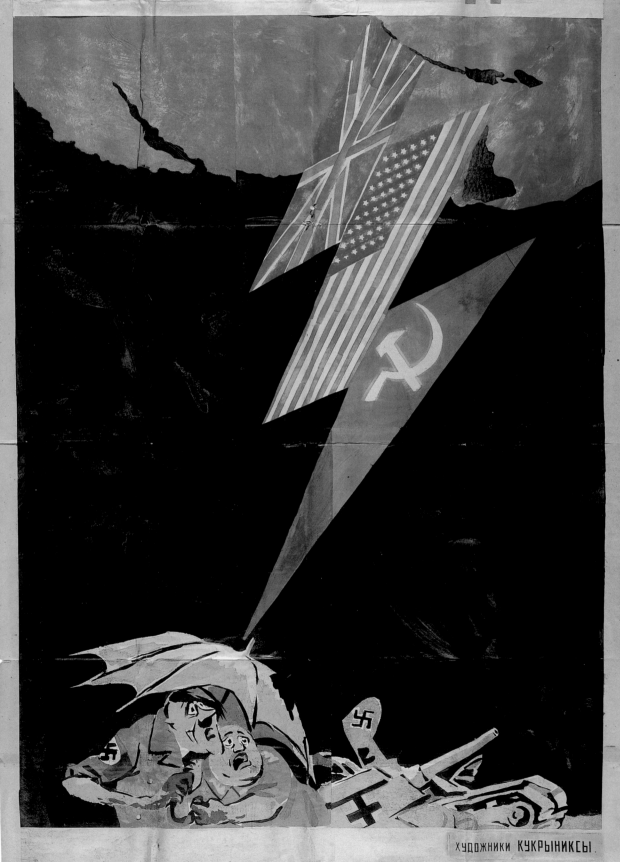

ОКНО
ТАСС № 469

МОЛОДАЯ ПАРТИЗАНКА

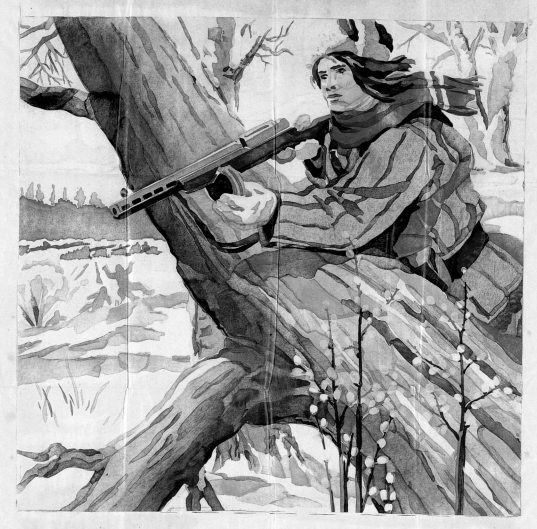

КАК ЧАПАЕВСКАЯ АНКА,
И УПОРНА И СМЕЛА
МОЛОДАЯ ПАРТИЗАНКА
ИЗ СОЖЖЕНОГО СЕЛА.

НАШУ КРАСНУЮ КУКУШКУ
ФРИЦ БОИТСЯ, КАК ОГНЯ,
КТО ПОПАЛСЯ ЕЙ НА МУШКУ-
ТОТ ПОКОЙНИКАМ РОДНЯ!

ЗРЯ, БЕЗ ТОЛКУ, НЕ РИСКУЕТ,
ВЫБИРАЕТ, СМОТРИТ, ЖДЕТ,-
А УЖ ЕСЛИ „ПРОКУКУЕТ"-
ВРАГ, КАК КОЛОС, УПАДЕТ!

И В РАЗВЕДКЕ И В ЗАСАДЕ,
НА ПРИВАЛЕ У КОСТРА
ВСЕ СУМЕЕТ, ВСЕ НАЛАДИТ-
ПОВАР, СНАЙПЕР И СЕСТРА.

ПАРТИЗАНКА БОЕВАЯ
УЛЫБНЕТСЯ НАЛЕТУ:
-„Я СБИВАЮ-НЕ СЧИТАЮ,
ПОБЕДИМ-ТОГДА СОЧТУ.

Я В ОТРЯДЕ НЕ ОДНА ВЕДЬ,
ЕСТЬ ДЕВЧАТА ПОСИЛЬНЕЙ!"...
КАК ТАКУЮ НЕ ПРОСЛАВИТЬ,
ПЕСНЮ КАК НЕ СПЕТЬ О НЕЙ.

Худ. А.Бубнов

Текст-Вас. ЛЕБЕДЕВ-КУМАЧ.

Opposite page: "Thunderbolt". TASS window poster No.504 hand-painted by the Kukriniksy, a famous trio of Soviet caricaturists. TASS (Telegraph Agency of the Soviet Union) windows were used for propaganda displays in the same way as ROSTA windows had been back in the Civil War.
Above: "Young Partizanka". TASS window poster No.469 hand-painted by Alexander Bubnov with a poem by Vasilii Lebedev-Kumach.
Overleaf, left: "The Red Army is an Army of Liberation". TASS window poster hand-painted by Georgii Savitsky, 1944. Savitsky was the son of the famous 19th century "Wanderers Group" painter, Konstantin Savitsky. Text by Stepan Shchipachev, who was awarded the Stalin Prize twice for his front line lyrics.
Overleaf, right: "Let's Rebuild Stalingrad!" TASS window poster No.698 hand-painted by Fyodor Antonov with text by Alexei Zharov.

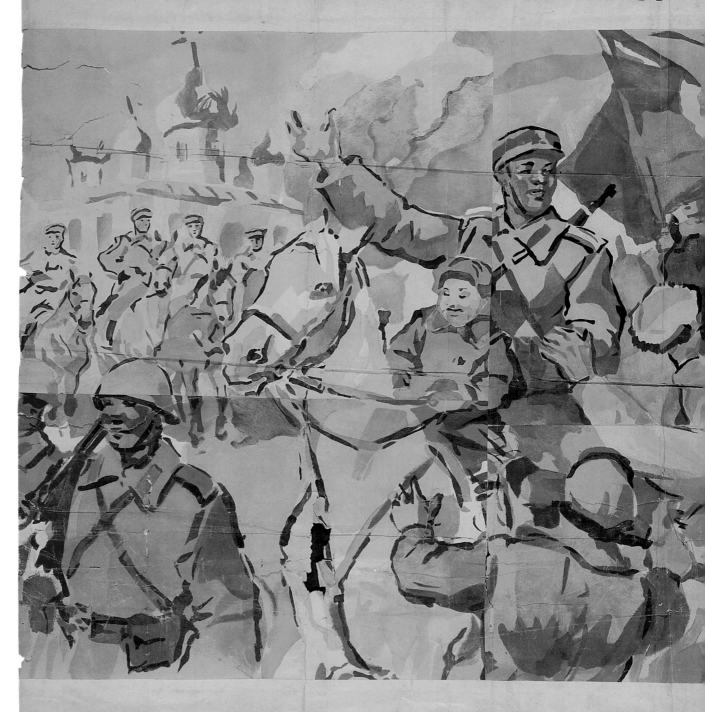

КРАСНАЯ АРМИЯ—ОСВОБОДИТ

ГДЕ ПРОХОДЯТ НАШИ ТАНКИ,
СТАЛА ВОЛЬНОЮ ЗЕМЛЯ,
ГДЕ СТУПАЮТ НАШИ КОНИ,
РАСЦВЕТУТ ОПЯТЬ ПОЛЯ.

ХУДОЖНИК—Г.Савицкий ТЕКСТ—Степан Щипа

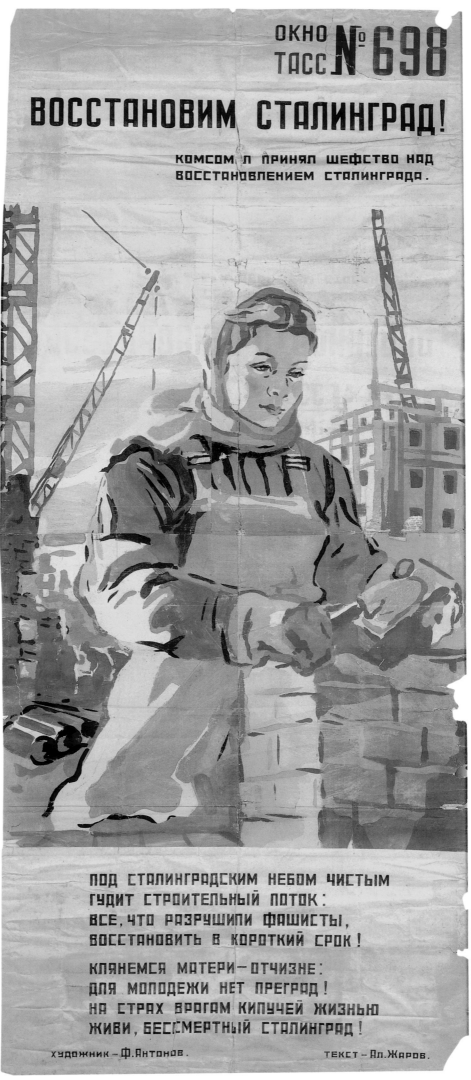

ОКНО ТАСС № 698

ВОССТАНОВИМ СТАЛИНГРАД!

КОМСОМОЛ ПРИНЯЛ ШЕФСТВО НАД
ВОССТАНОВЛЕНИЕМ СТАЛИНГРАДА.

ПОД СТАЛИНГРАДСКИМ НЕБОМ ЧИСТЫМ
ГУДИТ СТРОИТЕЛЬНЫЙ ПОТОК:
ВСЕ, ЧТО РАЗРУШИЛИ ФАШИСТЫ,
ВОССТАНОВИТЬ В КОРОТКИЙ СРОК!

КЛЯНЕМСЯ МАТЕРИ—ОТЧИЗНЕ:
ДЛЯ МОЛОДЕЖИ НЕТ ПРЕГРАД!
НА СТРАХ ВРАГАМ КИПУЧЕЙ ЖИЗНЬЮ
ЖИВИ, БЕССМЕРТНЫЙ СТАЛИНГРАД!

ХУДОЖНИК —Ф. АНТОНОВ. ТЕКСТ — Ал. ЖАРОВ.

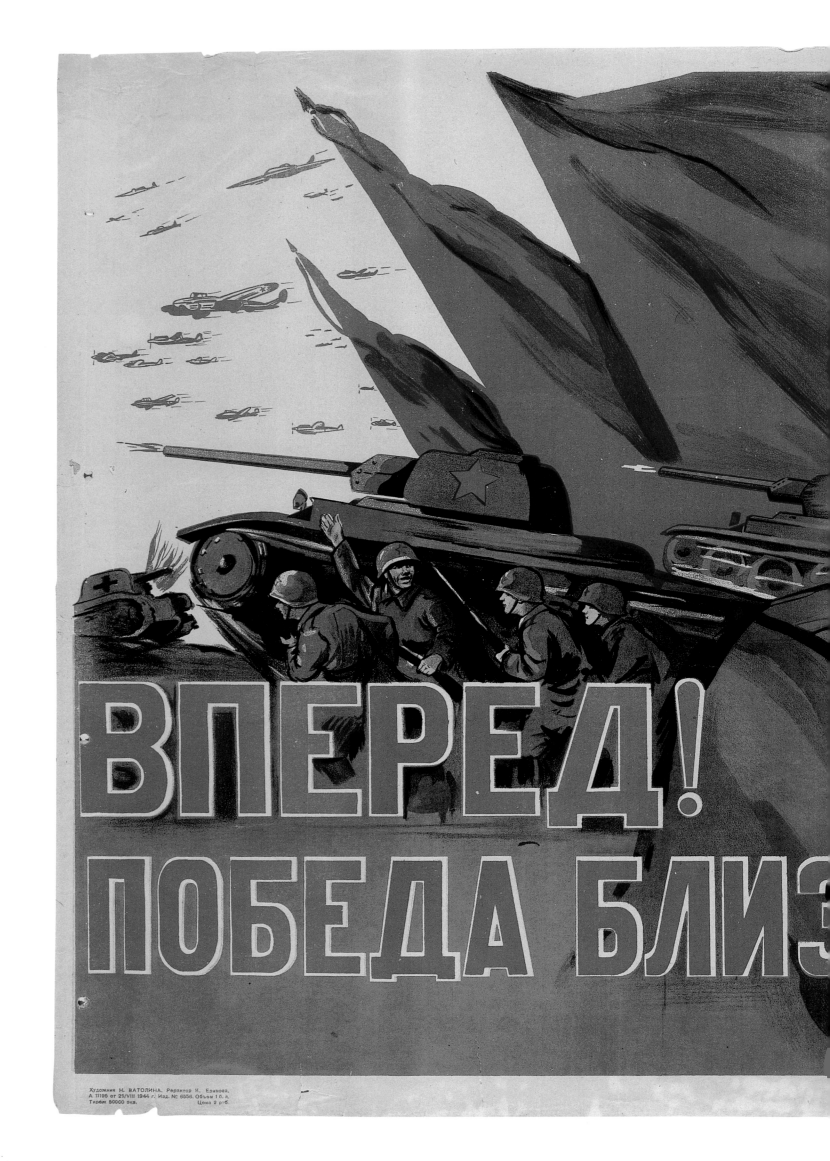

ВПЕРЕД!
ПОБЕДА БЛИЗ

Художник Н. ВАТОЛИНА. Редактор И. Единова.
А 11196 от 25/VIII 1944 г. Изд. № 6856. Объем 1 б. л.
Тираж 50000 экз. Цена 2 руб.

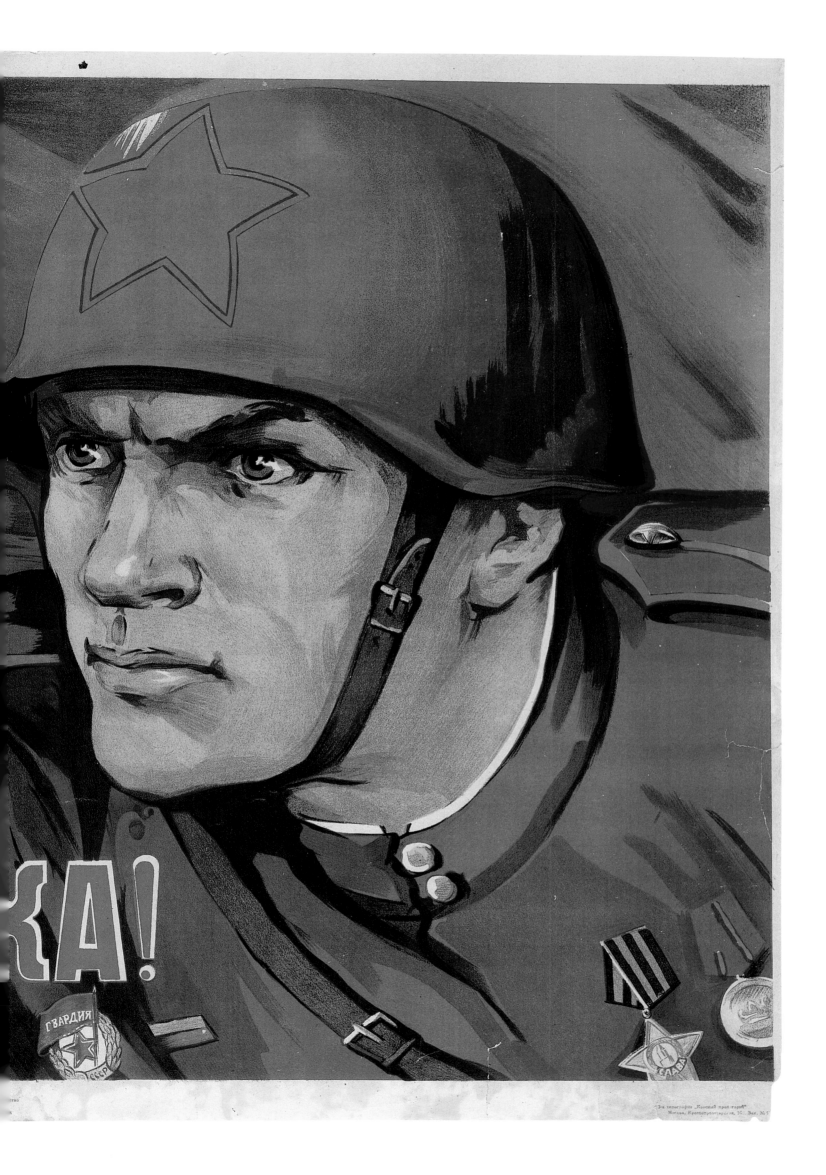

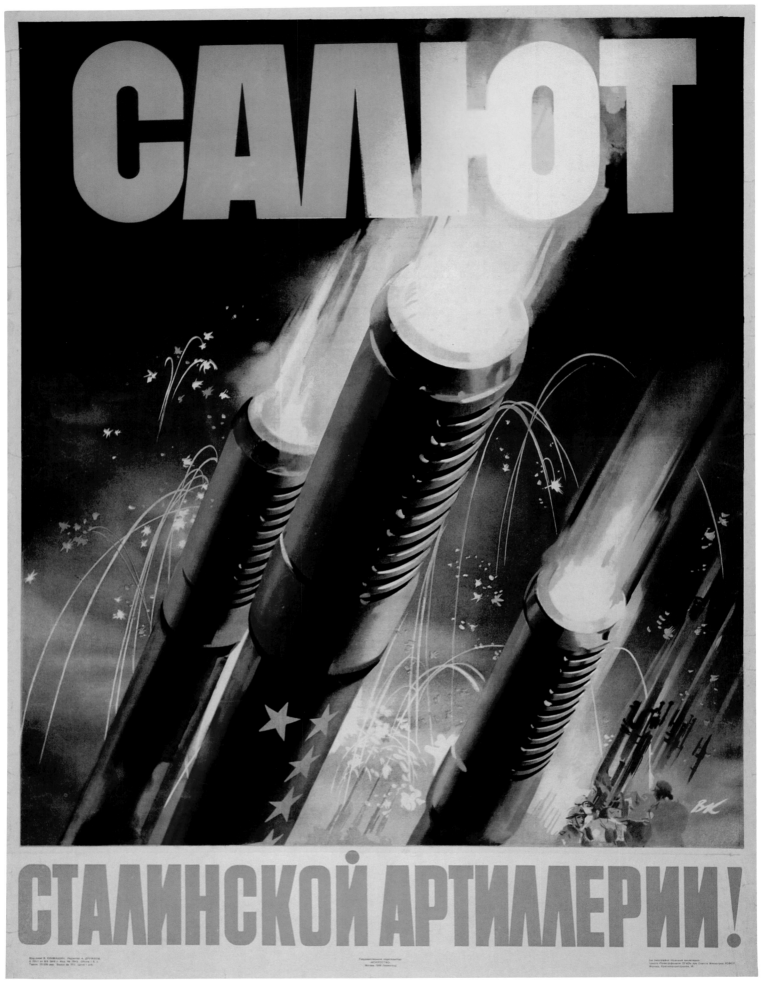

Previous page: "Forward! Victory is Close at Hand!" by Nina Vatolina, 1944. January of that year saw the siege of Leningrad finally broken, Ukraine and Belorussia liberated in the spring, with Moldova and the Baltic states following in the summer. At last the territory of the USSR was free of the Nazi invaders and the Red Army could push into Poland, Romania, Bulgaria and Yugoslavia, and eventually on to the final victory in Berlin.
Above: "Saluting Stalin's Artillery" by Viktor Klimashin, 1946.
Opposite page: "Long Live the Victorious Nation, Long Live Our Dear Stalin!" by Viktor Zinov. The "Generalissimo of the Soviet Union" started to make a reappearance on his nation's posters almost as soon as wartime hostilities had ceased, as this slightly demented example from Sverdlovsk clearly shows. He is haloed by the Order of Victory, which he received twice, each one encrusted with 174 diamonds.

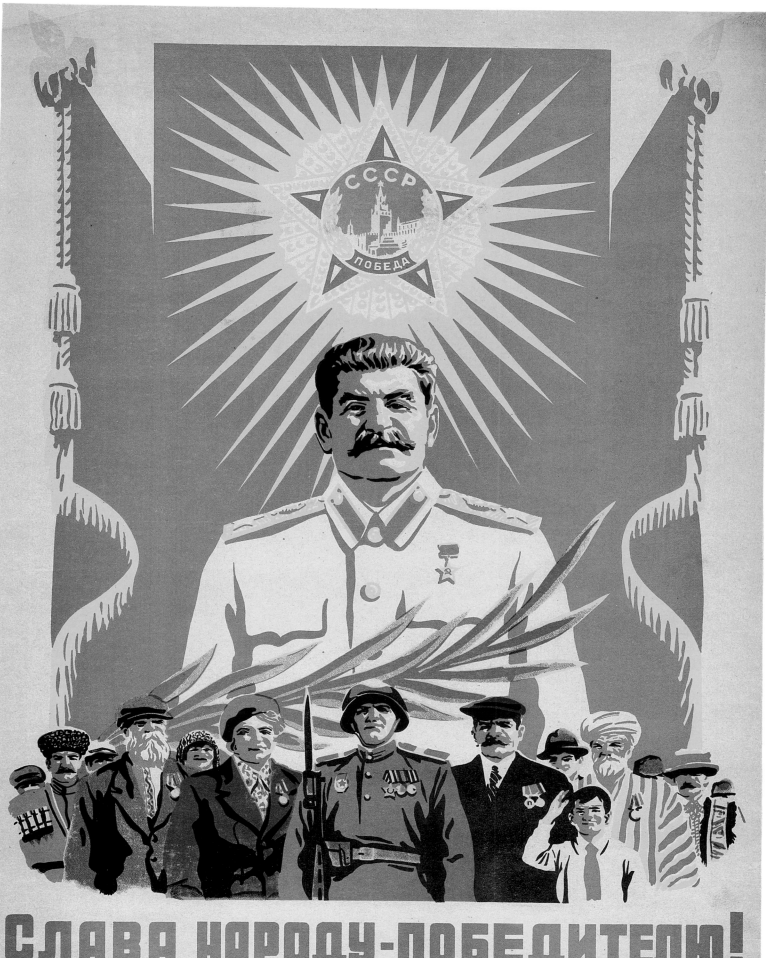

СЛАВА НАРОДУ-ПОБЕДИТЕЛЮ!
СЛАВА РОДНОМУ Сталину!

НС 12822 Издание Сверд. отд. худож. фонда. Редактор Благих А. А. Художник Зинов В. С. Свердхромолитография. Зак. 720 Тираж 12 тыс. Цена 1 р. 50 к.

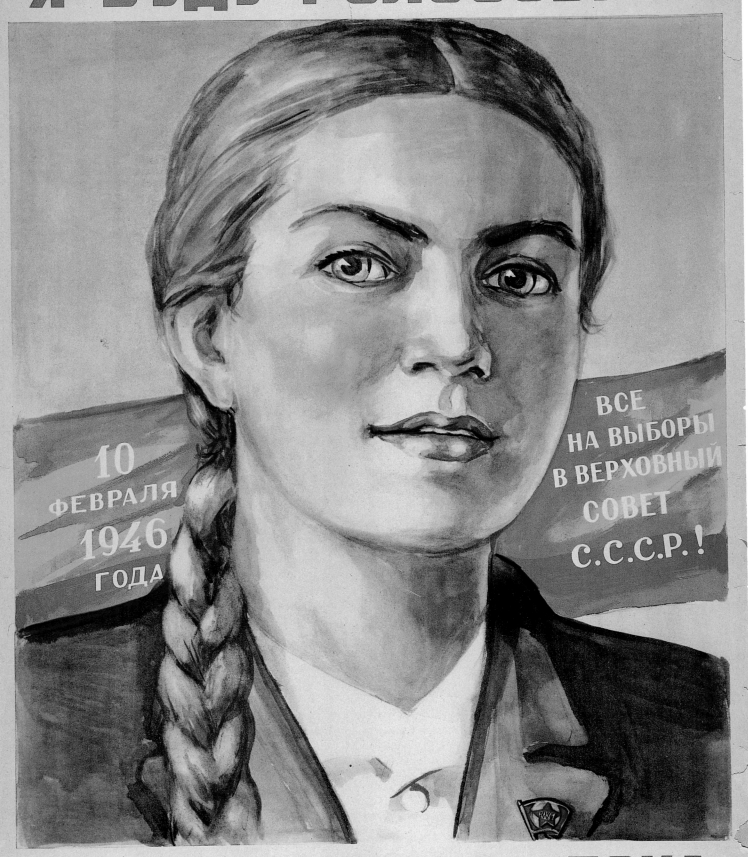

Я БУДУ ГОЛОСОВАТЬ

10 ФЕВРАЛЯ 1946 ГОДА

ВСЕ НА ВЫБОРЫ В ВЕРХОВНЫЙ СОВЕТ С.С.С.Р.!

ЗА КАНДИДАТОВ БЛОКА КОММУНИСТОВ И БЕСПАРТИЙНЫХ!

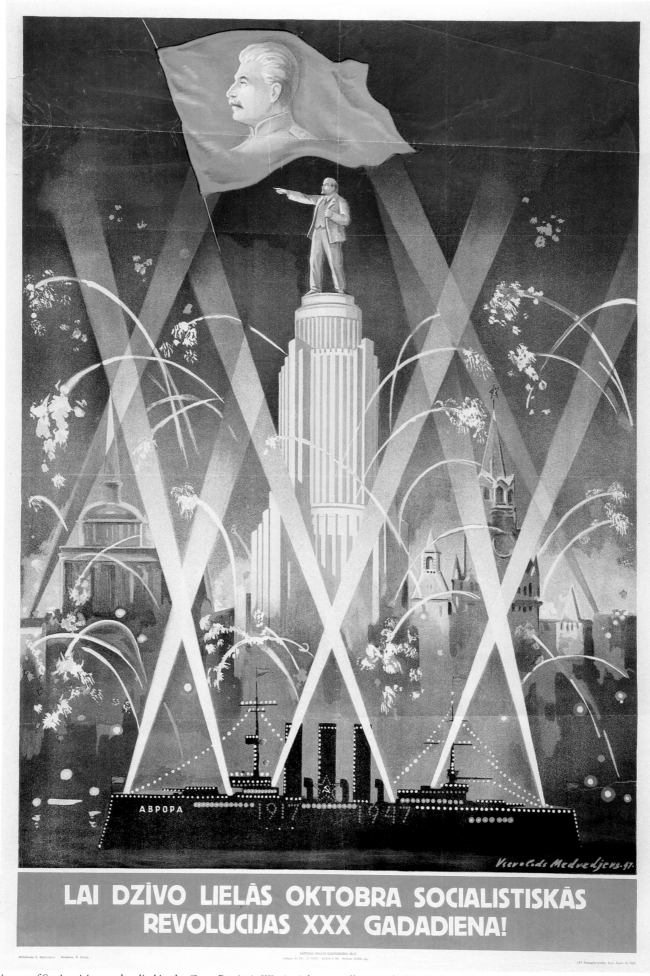

LAI DZĪVO LIELĀS OKTOBRA SOCIALISTISKĀS REVOLUCIJAS XXX GADADIENA!

The lowest estimate of Soviet citizens who died in the Great Patriotic War is eighteen million, including eight million military losses. Some calculations have said over twenty-four million. The country's infrastructure was in ruins, life had to be rebuilt from scratch.

Opposite page: "I will Vote for the Candidate's Bloc of Communists and Non-Party Members". The young woman in Nina Vatolina's poster expresses great confidence in the elections to the Supreme Soviet of the USSR, February 10th, 1946. It was the first such election since 1937. Every candidate on the official list was returned.

Above: "Long Live the Thirtieth Anniversary of the Great October Revolution" by Vsevelods Medvedjevs. Riga, 1947. Text in Latvian.

Montage run riot: The cruiser "Aurora", permanently moored in Leningrad, has suddenly appeared in front of the Palace of Soviets in Moscow, a gigantic Stalinist architectural project from the 1930s that never got further than its foundations.

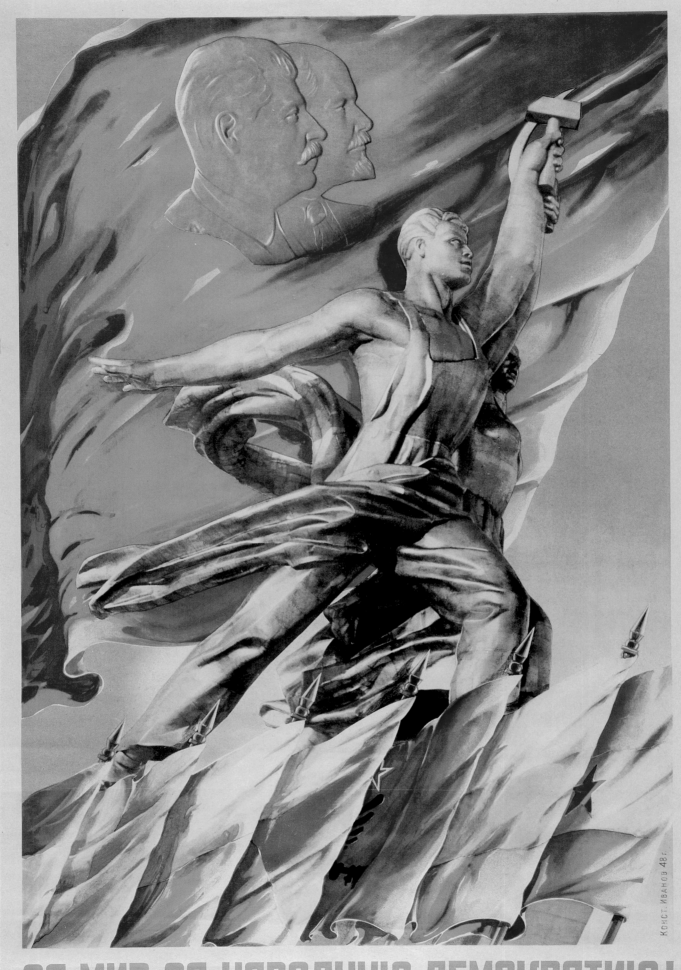

На плакате снизу (справа-налево). — Государственные флаги:
Югославии, Болгарии, Албании, Чехословакии, Польши, Румынии и Венгрии.

ЗА МИР, ЗА НАРОДНУЮ ДЕМОКРАТИЮ!

Государственное издательство
„ИСКУССТВО"
Москва — 1948 — Ленинград

Художник К. ИВАНОВ. Редактор А. ДРУЖКОВ.
А-00003. 2 л.-л. Цн-0. Цена 1 руб.

134

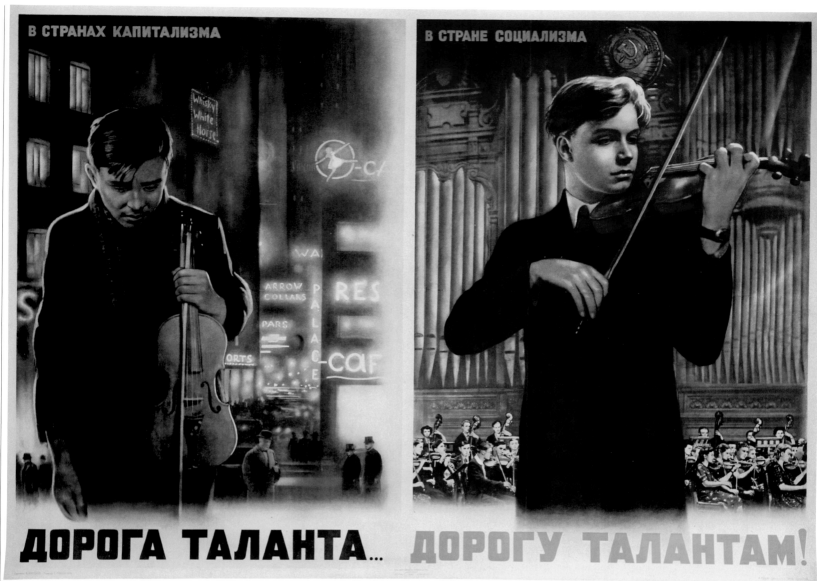

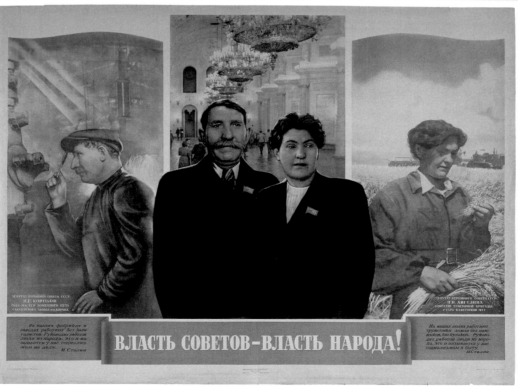

Opposite page: For Peace, For People's Democracy!" by Konstantin Ivanov, 1948, featuring Vera Mukhina's sculpture "The Worker and the Collective Farm Girl".
The flags represent Yugoslavia, Bulgaria, Albania, Czechoslovakia, Poland, Romania and Hungary –
seven Eastern Bloc countries who signed the Warsaw Pact for mutual defence after West Germany had joined NATO.
Top: "In the Land of Capitalism... In the Land of Socialism. The Destiny of their Talent... The Destiny of our Talent!" A remarkable poster by Viktor Koretsky
printed in Moscow in 1948, right at the beginning of the Cold War. Note "Whisky White Horse" in Times Square.
Above: "Soviet Power – The Power of the People" by Viktor Koretsky, 1947. I.Korobov, a chief foreman of the Kirov Metal Foundry (shown at the blast furnace)
and P. Angelina, head of the Staro-Bashensk Village Tractor Brigade, are also deputies
of the People's Soviet of the USSR. The poster follows the postwar Party line: "The country must know its heroes".

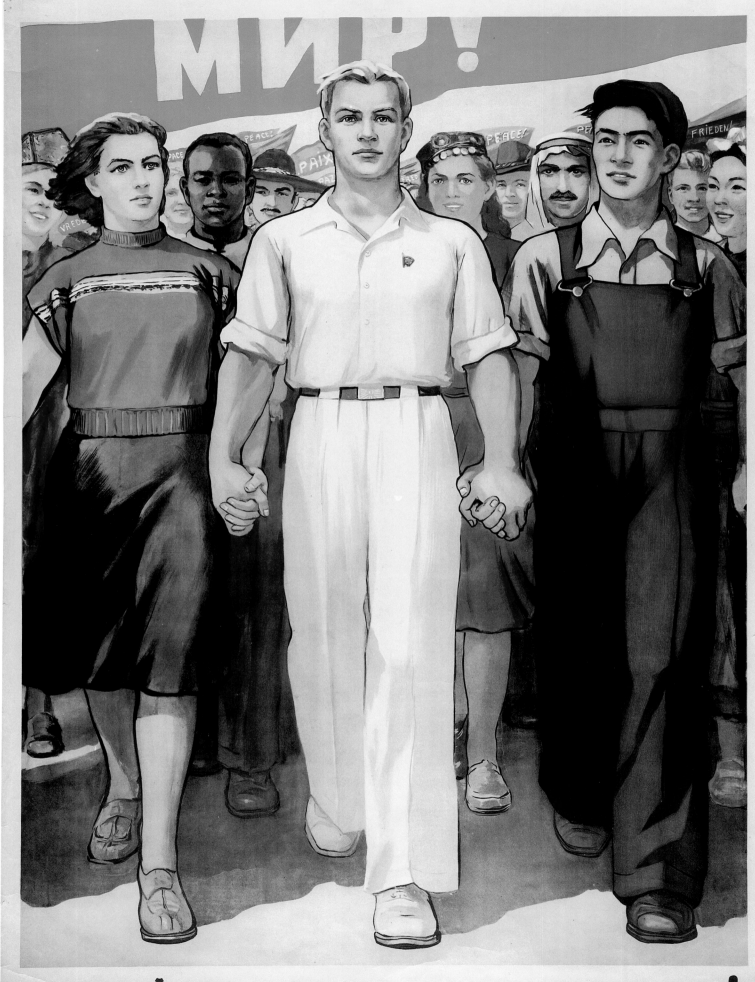

МИРУ!

КАЖДЫЙ, КТО ЧЕСТЕН, ВСТАНЬ С НАМИ ВМЕСТЕ!

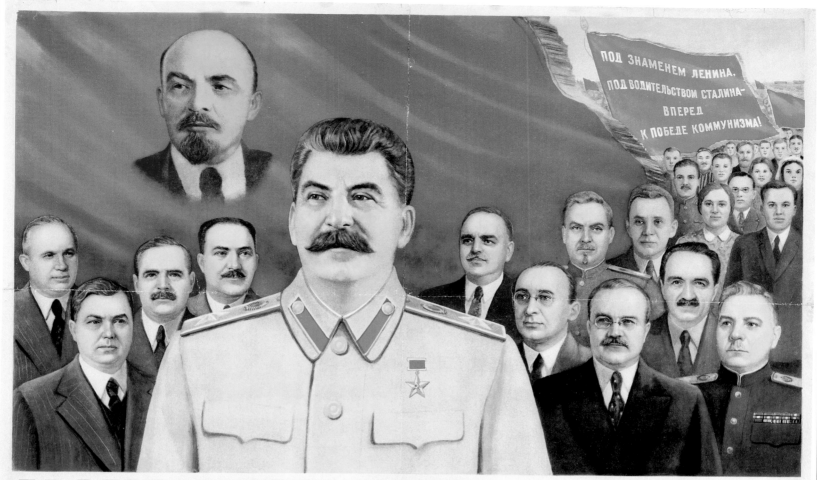

ДА ЗДРАВСТВУЕТ ПАРТИЯ БОЛЬШЕВИКОВ,
ПАРТИЯ ЛЕНИНА-СТАЛИНА, ЗАКАЛЕННЫЙ В БОЯХ АВАНГАРД СОВЕТСКОГО НАРОДА, ВДОХНОВИТЕЛЬ И ОРГАНИЗАТОР НАШИХ ПОБЕД !

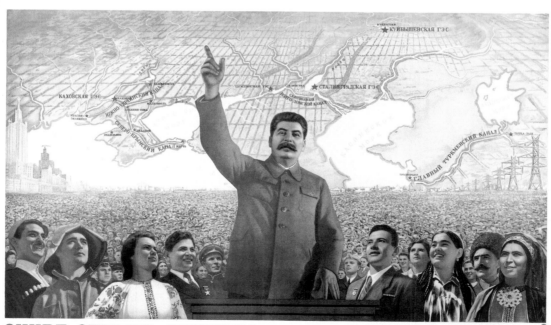

SUURE STALINI JUHTIMISEL-EDASI KOMMUNISMILE !

Opposite page: "Every Honest Citizen – Join Us!" by Nina Vatolina, 1952.
Published in Moscow in a print run of 300,000 copies. The slogan is taken from "The Hymn of Democratic Youth" and the big Russian banner reads "Peace".
Top: "Long Live the Bolshevik Party. The Party of Lenin and Stalin, the Battle-Hardened Vanguard of the Soviet People, the Inspiration and Organiser of Our Victory!"
by Vladislav Pravdin, 1950, printed in a record one million copies. Left to right, flanking Stalin,
can be seen high-ranking members of the Politburo: Khrushchev, Malenkov, Andreev, Kaganovich, Shvernik, Beria, Molotov with Bulganin and Kosygin
behind him, Mikoyan and Voroshilov. In the background a column of communists march
"Under the Banner of Lenin, Under the Inspiration of Stalin – Forward to the Victory of Communism!"
Above: "Under the Leadership of the Great Stalin – Forward to Communism" by Boris Berezovsky, Ivan Shagin and M. Solovev. Text in Estonian, 1948.

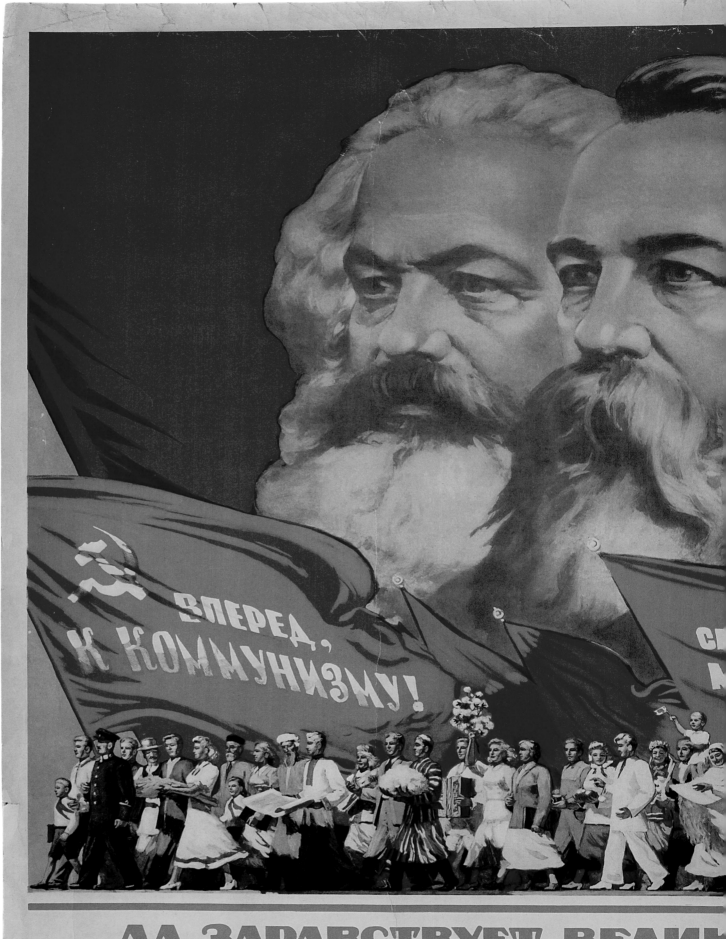

ВПЕРЕД, К КОММУНИЗМУ!

ДА ЗДРАВСТВУЕТ ВЕЛИК

МАРКСА-ЭНГЕЛЬСА

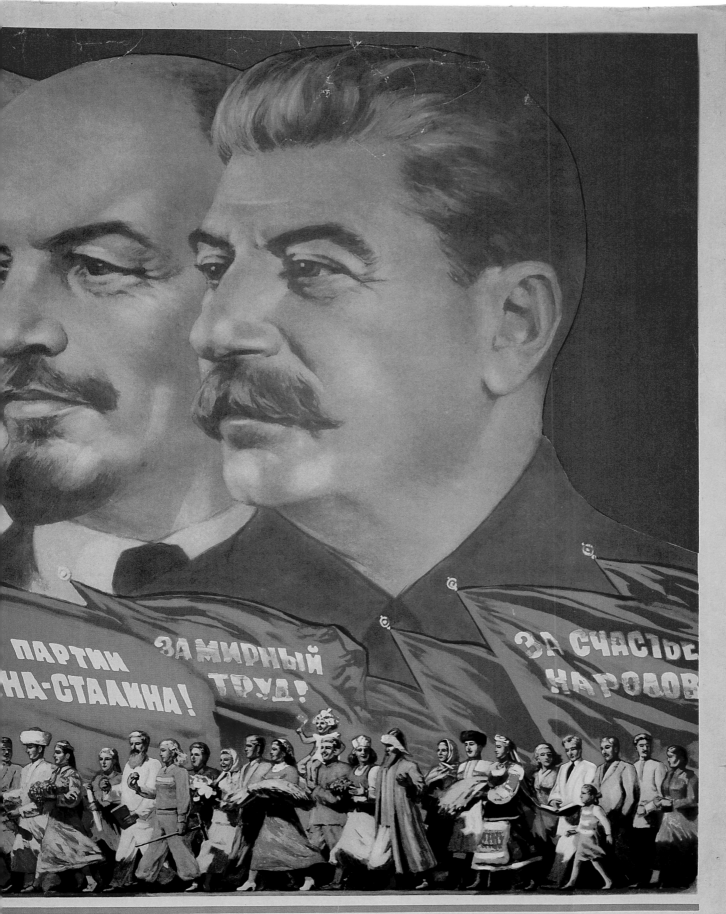

...НЕПОБЕДИМОЕ ЗНАМЯ
...ЕНИНА-СТАЛИНА!

СЛАВА ВЕЛИКОМУ СОВЕТСКОМУ Н

Previous page: "Long Live the Great and Invincible Banner of Marx-Engels-Lenin-Stalin by A.Kossov, 1953.
The nationalities of the Soviet Union, dressed in their traditional costumes, march under banners proclaiming "Forward to Communism",
"Long Live the Party of Stalin-Lenin", "For Peaceful Labour" and "For the Happiness of the People".
Postwar Stalinist reality was rather different. Entire ethnic groups were accused of "collaboration with the enemy"
and large numbers of them were uprooted from their traditional homelands. Kalmyks, Chechens, the Ingush, Crimean Tatars and inhabitants
from the Baltic states were deported to distant parts of the USSR, and an anti-semitic campaign was in full swing across the country accusing the Jews of
"rootless cosmopolitanism". This suffering was finally cut short on March 5th, 1953, with the announcement of Stalin's death.
Above: "Long Live the Great Soviet People – The Builders of Communism!" by Viktor Koretsky, Oleg Savostuk and Boris Uspensky, 1955.
Written on the ribbon tied to the wheatsheaf: "The Improvement of the Welfare of the People – This is the Law of Socialism".

ACKNOWLEDGEMENTS

In May 2002, the distinguished sovietologist Erika Wolf looked on
in amazement as we hung the first display at Tate Modern of almost one hundred
Russian posters, dating from the time of the Revolution to the death of Stalin.
Surveying the room she whispered:
"Only at Tate Modern! No other art museum in the whole world would be
able to put on an exhibit like this; look at it, it's wonderful!"
Since then there have been further, almost continuous, displays of original
Soviet posters from the David King Collection at Tate Modern, and many posters
from those displays are now reproduced in this book.

★ ★ ★ ★ ★

I would particularly like to thank my dear friends Valerie Wade, Judy Groves,
Francis Wyndham, Miklos Kun, Andrew Spira, Susannah Clapp
and Clive Boutle for their never ending help, advice and encouragement.
This book would not have been possible without them.
I would also like to thank Natalia Sidlina for her highly intelligent
contributions on the research and translation fronts,
and Kate Tattersall deserves great praise for her advice, skill and utmost patience in
transforming the maquette into a document ready for printing.

★ ★ ★ ★ ★

Special thanks are due to Nicholas Serota (Director, Tate), Frances Morris

(Head of Collections, International Art), Matthew Gale (Head of Displays,
Tate Modern), and Chris Stephens (Head of Displays,
Tate Britain), for their wonderful support and encouragement over the last decade.
Chris Dercon (Director, Tate Modern) and Nicholas Cullinan (Curator,
Tate Modern) have both joined Tate more recently, and thanks are due to them
for their wonderful enthusiasm for the project.

★ ★ ★ ★ ★

I would also like to thank everybody at Tate Publishing for their great expertise
and for making the project so exciting. In particular, Roger Thorp
(Publishing Director), James Attlee, Anna Ridley, Francesca Vinter, Judith Severne,
Bill Jones, and the Tate photographers David Lambert and Rodney Tidman.

★ ★ ★ ★ ★

Many thanks are due to the following people (some sadly passed away) who
have also been so helpful. They are, in alphabetical order:
Stephen Cohen, Mark Fairman, Natan Federovsky, Robin Fior, Walter Goldwater,
Anita and Ron Gray, Anthony C. Hall, Charles Curtis
and Wayne Seabrook at Hanway Print, Michael Katanka, Heinz Klimmer
and Ernst Volland, Alexei Ladyzhensky and Galina Panova,
Alexander Lavrentiev, Sasha Lurye, Howard Garfinkel and Larry Zeman
of Productive Arts, Michael Rand, Wolf Ryzhik,
Tony Scanlon, Howard Schickler, Alexander Snopkov and Pavel Snopkov.

РОСТ БЛАГОСОСТОЯНИЯ НАРОДА — ЗАКОН СОЦИАЛИЗМА

ОДУ – СТРОИТЕЛЮ КОММУНИЗМА!

Page 142: "Long Live the All-Union Day of Physical Culture" by V.Khrapovitsky, Moscow, 1947.
Page 143: "USSR – Long Live the All-Conquering Banner of Leninism" by Maria Nesterova-Berezina. Moscow, 1957, post de-Stalinisation.
Page 144: "KPSS – Glory!" by Boris Berezovsky, 1962. KPSS stands for Communist Party of the Soviet Union.
The first four cosmonauts in space. Left to right: Yuri Gagarin (the first man in space), Gherman Titov (the first person to spend an entire day in space),
Adryan Nikolayev and Pavel Popovich. Nikolayev married Valentina Tereshkova (who had become the first woman in space on June 19th, 1963)
and Nikita Khrushchev presided at their wedding four months later.
In contrast, Sergei Korolev, legendary designer of the Vostok rockets featured in the poster and the scientist responsible for getting the cosmonauts into space
was a designated "Closed Person". Confined to a secret scientific base, he was known only as "Chief Designer"; his name could never be mentioned.
Khrushchev prevented him from receiving the Nobel Prize and he was not allowed to attend the worldwide Gagarin celebrations, so he had to watch them on television.

First published 2012
by order of the Tate Trustees by Tate Publishing,
a division of Tate Enterprises Ltd, Millbank, London SW1P 4RG
www.tate.org.uk/publishing
★ ★ ★ ★ ★
© David King 2012
All photographs and artworks are from the
David King Collection, London, unless otherwise stated
www.davidkingcollection.com
davidkingcollection@btopenworld.com
★ ★ ★ ★ ★
A catalogue record for this book is available from the British Library
Distributed in the United States and Canada by Abrams, New York
Library of Congress Control Number: 2012931254
ISBN 978 1 84976 019 5

The author and publisher have made every effort to contact
copyright holders wherever appropriate,
and apologise for any omissions that have inadvertently been made.
Konstantin Ivanov: © DACS 2012. Viktor Klimashin: © DACS 2012
Gustav Klutsis: © ARS, New York and DACS, London 2012
Viktor Koretsky: © DACS 2012. Vladimir Kozlinsky: © DACS, 2012
Alexander Rodchenko: © A. Rodchenko and V. Stepanova Archive, Moscow 2012
Alexander Samokhvalov: © DACS 2012. Vladimir Stenberg: © DACS 2012
★ ★ ★ ★ ★
Designed by David King
Layout by Kate Tatersall at THS, London
Colour reproduction by DL Imaging, London
Printed in Hong Kong by Printing Express

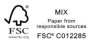

MIX
Paper from
responsible sources
FSC
www.fsc.org
FSC® C012285

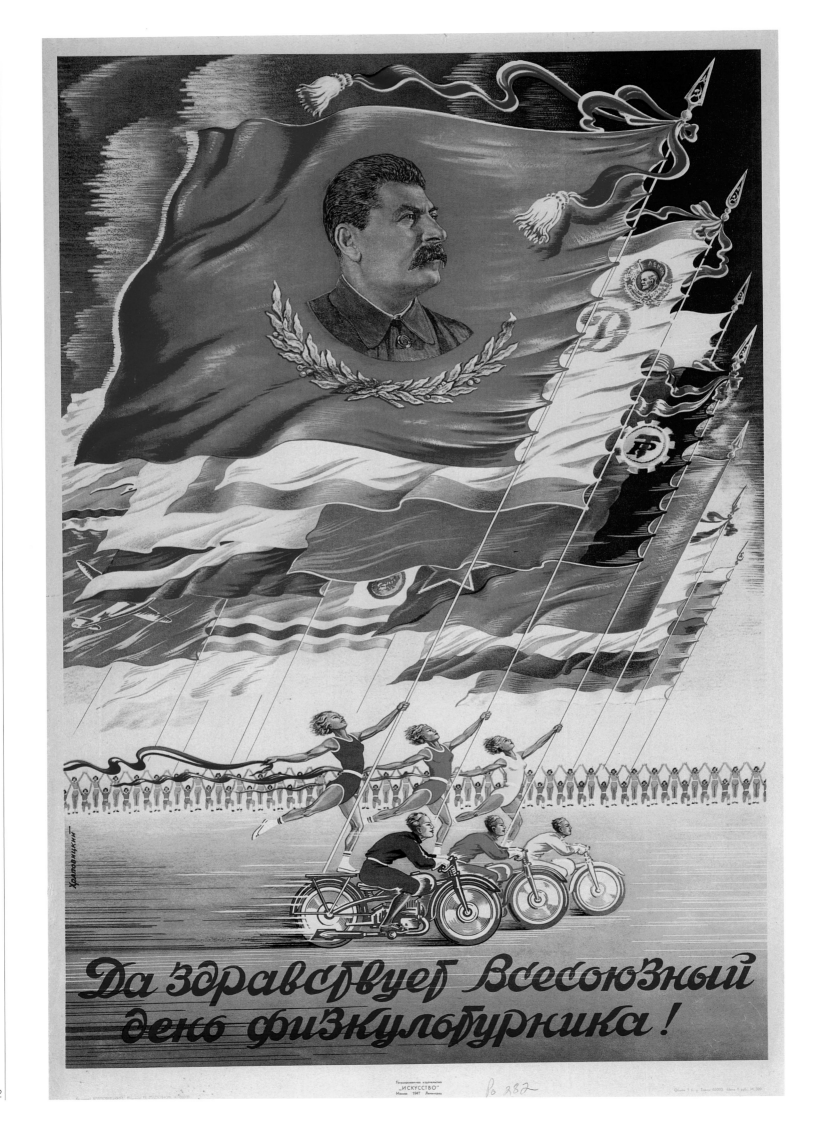

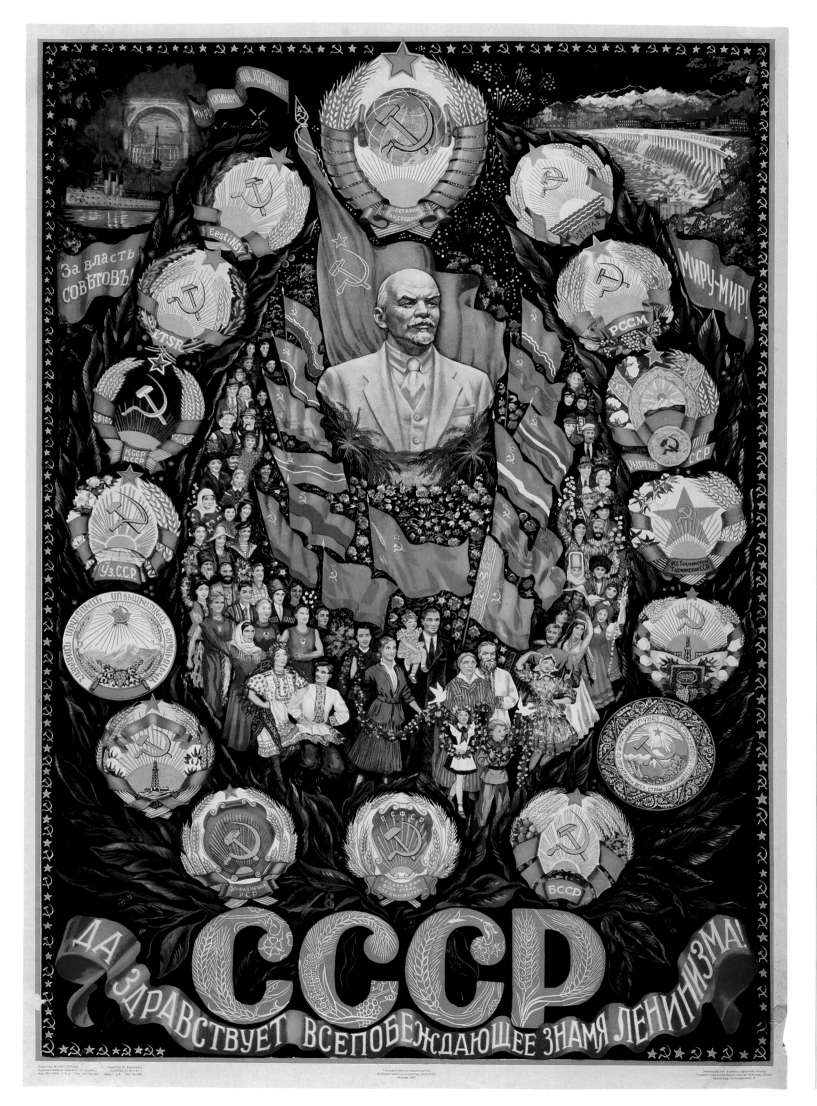